Terra Cognita

CHAD DAVIDSON

Terra Cognita

DISPATCHES
FROM AN
OVER-TRAVELED
ITALY

Louisiana State University Press
Baton Rouge

Published by Louisiana State University Press
lsupress.org

LSU Press Paperback Original

Designer: Barbara Neely Bourgoyne
Typeface: Chaparral Pro

Cover photograph by John Poch, 2021.

Library of Congress Cataloging-in-Publication Data are available
at the Library of Congress.

ISBN 978-0-8071-7787-7 (paperback) | ISBN 978-0-8071-7825-6 (epub) |
ISBN 978-0-8071-7826-3 (pdf)

Contents

Acknowledgments

Many friends and editors helped usher this book into being, and I wish to thank them individually. Eric Smith, over the course of a few years, shaped each essay here into the form it now possesses. Marella Feltrin-Morris, Susannah Mintz, Gregory Fraser, John Poch, William Giraldi, Lia Purpura: your stamp, too, is upon the well-traveled valise this book has become.

To Joe Oestreich, Pam Murphy, Dionne Irving Bremyer, Aaron Bremyer, Sal Peralta, Kevin Casper, Jeffrey Thomson, Vince Verna, Muriel Cormican, Micheal Crafton, Matt Donovan, Allen Gee, Randy Hendricks, David Newton, and Ben Granger-Holcombe: you provided the correct support and encouragement at the precise time I needed it.

To Megan Sexton, Mark Drew, David Yezzi, Ernest Suarez, Mike Mattison, Sven Birkerts, William Pierce, and Adam Vines: your editorial scrutiny and belief in these essays as they made their way into your various publications remain bound to the very ink of them. And to James Long at Louisiana State University Press: thank you for your constant championing of this book.

Meanwhile, across the Atlantic, *un gran ringraziamento* aimed at all those who helped, in ways both familial and professional, make these essays possible. Bologna will always be a second home, with Mina Galloni and Dino Magri as parents; Luigi Magri, my brother; and Antonella Galloni, my doting, older sister. In Spoleto, *un saluto alla ciurma:* Elisa Bassetti, Daniela Cittadoni, Luca Magna, Andrea Tomasini, *e così via.*

Rome, thankfully (at least for me), is the *terra* of Damiano Abeni and Moira Egan. In *Postignano e dintorni*, I give thanks to Michele Chiabolotti, Mafy Pappalardo, Francesco Clementi, Maria Massimiani, and Nino Di Bonito; and of course, Gennaro Matacena and Matteo Scaramella, without whom our summer *relais* and the entire Postignano project would have remained, like one of Calvino's *città, invisibile*.

To my sister and brother, no better companions could I ask for, traveling back through the past. To Gwen: everything good, always, is also because of you. And to my parents (at least the memory of them), who suffered my obsession with this land, who even once visited me there, your generosity and love reside in these pages.

Grateful acknowledgment is made to the editors of the following publications, in which essays from this book originally appeared (though in sometimes slightly different form):

Agni: "Spoleto / Mutatis Mutandis"; *Birmingham Poetry Review:* "Postignano / On Ruins"; *Five Points:* "Teulada / Not Taking Pictures" and "Bologna / On Relics"; *Gettysburg Review:* "Assisi / The Imperfect"; *Hopkins Review:* "Venice / On Exile"; and *Literary Matters:* "Ischia / Not Being Original."

"Teulada / Not Taking Pictures" was also listed as a "notable essay" in *Best American Essays* (2015). "Ischia / Not Being Original" won the Meringoff Nonfiction Award, conferred by the Association of Literary Scholars, Critics, and Writers (2016).

A portion of "In Dispraise of Poetry" (1982) by Jack Gilbert, *Monolithos: Poems '62–'82*, appears in the chapter "Rome / The Maintenance of Ghosts" and is used by permission of Alfred A. Knopf, an imprint of the Knopf Doubleday Publishing Group, a division of Penguin Random House LLC. All rights reserved.

Terra Cognita

Prologue

"Beautiful," I say to myself and no one in particular, as I study the busy facade of the Duomo in Spoleto, its mosaic of God in the act of bestowing upon Mary an immaculate hand. Beautiful, too, the bell tower with its Tetris-like, tightly fitting stones—those on the lower levels large and uniform, giving way to a mishmash of beige and ivory ascending to the belfry. Not uniform but pleasant, much more so than the church's portico (a later addition) framing the entrance. And more than its blandly baroque (it sounds impossible, I know) interior, whitewashed and ponderous. As pleasant as the uneven floor of the nave, which, beside its ornate patterns of multicolored stones, also reveals the plan of the original (and much smaller) tenth-century structure. Encoded there, a string of violent histories: earthquakes and Lombard razings; fault lines and Frederick Barbarossa; papal expansions, constructions, reconstructions. This church is the index of its own survival.

But then again, where is beauty not generated out of such ache and distortion, such daring vulnerabilities? Where doesn't history transform a place, yes, but also warp the air around it, the way a desert highway trembles in heat? Those patterns in the floor break and resurface in waves of muted greens and reds—all pleasant to behold, if not wholly uniform. Pleasant *because* not wholly uniform. The distances we travel for imperfection.

Fifty million of us, in fact, arrive in Italy each year. This in a country of just sixty million. On average, nearly 150,000 tourists enter each

day, on their way to spending a total of 193 million nights ensconced in luxury hotels on the Costa Smeralda of Sardinia, climbing the cypress-lined drives of Tuscan villas, or holed up in hostels in the Eternal City. Streams of travelers course through the historic centers of Bergamo and Verona, admire the crags and gnarled lemon trees of the Amalfi Coast, ogle all the slender shoes behind thick glass in Milan boutiques, even stand right here, in this characteristically misshapen piazza in Spoleto, admiring this Romanesque church but also something beyond it, invisible but just.

What is contained in that invisible Italy depends on the viewer, for there are as many versions of this country as there are people to behold them, each iteration narrowly defined, exquisitely calibrated. Italy is a pliable paradise. There's one for the high school group littering the steps of the Duomo in Florence, another for newlyweds negotiating a gondola ride down a side canal of Venice. And even if the itinerary includes some ideal stopover, some place not locatable on the typical tourist map, *off the beaten track,* we say—a hilltop wine town, perhaps, in southern Tuscany or the formidable fog carrying the Chiesa di San Luca on its back in the hills outside Bologna—we understand how quickly the track becomes beaten, the quaint town discovered New World like, fog dissipating in the frenzy of our footsteps. All of us latter-day Columbuses, we claim the already-claimed as our own. This is my cobblestoned antiquity; my charmingly outdated, subterranean tour with an Etruscan well at its center; my shabby Roman trattoria serving tripe. This, finally, is my *terra cognita:* this foreign place strangely familiar, familiarized, if only by my imagination.

I hardly know the country at all if these representations are true, which is why I keep returning. I have spent a quarter-century trying to strip away the various projections and misinformation, which inevitably includes saying farewell, too, to versions of myself, travelers who went by my name but who share little with me now. The dispatches inside this book record those systematic dispossessions, all those glorious goodbyes.

This scene at the Duomo in Spoleto, though, occurs late in my travels to Italy, is reliant on much else that remains invisible. Even my

starting here, then, is outside of history, shuffled. I begin with this moment in Spoleto and thus create another fissure. But fissures are also openings. A goodbye, too, can prove a nuanced form of greeting (which the Italian *ciao* confirms), if only we understand whom we're talking to and why.

"I took a trip to see the beautiful things," begins Susan Sontag's "Unguided Tour," a dialogue between two unnamed characters. "And do you know?" the first speaker continues, "They're still there."

"Ah," responds the second, "but they won't be there for long."

"I know," says the first. "That's why I went. To say goodbye. Whenever I travel, it's always to say goodbye."

Meanwhile, I have made my way inside the Duomo. My eyes seek out evocative asymmetries in that floor and in Filippo Lippi's gilt mosaics, left unfinished at his death. I give thanks for such snags and botches. I praise God for His shoddy work.

Spoleto / Mutatis Mutandis

Spoleto, the first days of summer, and the sky—slate gray, immovable, foreboding—silences the swifts who bank into a small, interior court-yard outside my apartment, then spiral out again. We have arrived for our five-week university program: three professors and eighteen drowsy, hungry students, all of us currently occupied with unpacking, settling down, understanding, if imperfectly, where we are in the world at this hour. Phones ping and find their bearings. Computers offer views of a flattened globe striped in zones, ask if we want the local time. Where is time anything else?

Rain pattering on the high window. Somewhere a television drones: news, maybe, indecipherable from this distance. A truck backfires in the alley, or was that distant thunder? Could even be a worker chucking scrap in a heap next to the scaffolding I saw outside my door.

"What a dream," friends say about my summer each year in Italy, and mostly they're right. Leading up to the trip, I find myself counting down giddily with the students. Two months to go, one month, ten days, see you tomorrow, we're off. And yet part of me—the needling, self-doubting, fidgety part—asks, "Why? What's the point?" I pass that anxiety on to my students, too, starting my travelogue class by asking them (and myself) a series of simple questions: "Why are you here? Why did you choose to participate in this program? You have spent a great deal of money to do this. Why?"

Among the stock answers—"to open up new vistas," "to experience

the world"—some stand out: "to disorient myself," "to feel strange." Mostly, though, they are not quite sure why they're there. They may have a sneaking suspicion that it's all some well-choreographed performance of class and privilege (one must travel in order to say that one has traveled) and that they're doing it because it's just what they are supposed to do.

And then there's the fact that I can no longer avoid all the ways in which Spoleto looks the way it is *supposed* to look: the artful ruins, the hodgepodge of facades and moss-webbed alleyways, the glut of shops with local products on display: truffle, oil, wild boar. Everything, really—the town and all its inhabitants—on display. Have we traveled to this town or a *version* of this town, which we helped—however unwittingly—invent? Are we seeing Italy or the American idea of Italy or—perhaps most problematic—an Italian copy of the American idea of Italy? And how could we know the difference?

✈

Italo Calvino's *Invisible Cities* imagines a series of dialogues between Marco Polo and Kublai Khan, leader of the Mongol Empire in the thirteenth century. In Calvino's telling, the Venetian traveler relays knowledge of the emperor's vast domain through vignettes, descriptions of the fantastical and, often enough, strangely modern cities he has visited throughout the Great Khan's land. Thekla, for instance, is a place perpetually concealed behind construction fences and scaffolding. If asked why the work is taking so long, the residents simply reply, "So that its destruction cannot begin."

Preparing for the trip a few months ago, I assembled some images to show to the students at our orientation. One featured the Arch of Drusus, a first-century monument to Tiberius's son and a landmark in Spoleto. The photos, by then a few years old, showed more scaffolding than stone on the arch's eastern flank. Construction netting and metal rods. My first thought was, *I wish I had better images; better*, here, meaning "more beautiful"—more exhibition and less getting ready; more stage lights, less dressing room. "Give me the city," I wanted to say, "as it should be, not as it is." I apologized at the meeting, assured the

students that the scaffolding would not be there when we arrived. ("It will always be somewhere," I should have said, "probably right outside your windows.")

But why not celebrate that renewal, that continual polish? All the fuss and frenzy of the cleaning crews and renovation squads, the ceaseless jackhammers of Spoleto afternoons? (Italian construction favors thick, concrete walls. Remodeling means jackhammering.) Someone's always monkeying with a facade, painting (yet again) a door or storefront. How much paint has this town absorbed? Everyone hard at work, maintaining a place in which to remain hard at work.

"If, dissatisfied with the answers," Calvino continues in his profile of Thekla, "someone puts his eye to a crack in a fence, he sees cranes pulling up other cranes, scaffoldings that embrace other scaffoldings, beams that prop up other beams."

What lies beyond the maintenance of Spoleto? Some afternoons it seems the only city here is the one under constant reconstruction. I remember the story my father told me as a kid about the crews that paint the Golden Gate Bridge. Because it takes so long, as soon as they finish they have to start again. I remember being frightened by that possibility, that Sisyphean endlessness.

"What meaning does your construction have?" the traveler asks of Thekla's workers. "What is the aim of a city under construction unless it is a city? Where is the plan you are following, the blueprint?" The workers, probably too busy to entertain what they feel are pointless questions, simply tell the prying visitor to return when their workday is over. Then, they say, they will reveal the plan.

"Work stops at sunset. Darkness falls over the building site. The sky is filled with stars. 'There is the blueprint,' they say."

—

There are no maps in Spoleto. Built into the side of Sant'Elia—a monolith cleaved long ago from the grander Monteluco behind—Spoleto unfurls its mostly medieval, cobbled streets down the hill. Like rivulets, they crisscross the one drivable route, itself serpentine, until the only navigation aid we have is up or down. Initially, I ask all students to meet

for our various classes and events at Piazza della Libertà, where the bus first dropped us off. The one known point in town for all of them (at least for those first few days), the piazza also sports the most popular pizzeria, where all the students quickly learn to congregate.

There *are* maps, but they contort the streets, hopelessly wrench them into grids possessing no likeness at all to the town. How, in two dimensions, can one hope to portray accurately the drama of these convoluted passages and alleyways? How could anyone, with a piece of paper, help us navigate this city?

In class today, my students glanced at the schematic to Dante's *Inferno*—the cross section of the nine circles, little beasts, like stick figures, peering into the abyss. They had difficulty with the obsessive order of it all, preferred Dante and Virgil as guides through that landscape, not the awkward drawing. Plus, they have quickly embraced the idea of wandering in their adopted town. Many readily venture out, get lost.

Odd feeling: getting lost in a foreign country. The senses heightened, stomach in knots, we search for anything that shocks us into recognition. Once, in Bologna, late at night, just a kid then, and drunk, I spent what must have been an hour reeling through the quarter around Santo Stefano, desperate to find my rented room in that small apartment with the severe landlord and her quiet teenaged daughter, with the cat who peed on all my clothes, behind a door that looked like a hundred others on those porticoed streets. I remember almost—just almost—lying down on the wide, stone arm of a church entrance. *I just need to rest a second,* I'd thought to myself. I didn't do it, but I really don't remember *how* I didn't. I awoke the next morning hungover but home, or whatever passed for that abstraction.

We conceive of happiness in terms of light; sadness, dark. Emotions are meteorological, imagined as isobars, patterns projected on a green screen behind us. *You seem sunny today,* but *She's got a dark cloud over her.* And yet it might just be the opposite. Joy, pleasure, contentedness: they are absences in their own ways: voids, foreclosures, vacuums, various states of unconsciousness, ways of scrubbing bare our minds. We don't have to think because we're happy.

If happiness is a narcotic, then sadness, depression, doldrums, mel-

ancholy—these are states of hyperawareness. We are stone-cold sober, even when we're drunk. We are lost in the labyrinth of porticoes in Bologna, in the snake of alleys on the side of Sant'Elia. No wonder our memories persist of those nights that went wrong, the things we said that proved quickly and exquisitely stupid, the moment we understood that we were lost, really lost, in a foreign country. Happiness is the absence of thought, self-doubt, depression, anxiety—all those states that make us imperfect and, so, human. Otherwise, we are under repair. We are indices, too, of our own persistence through those storms.

Still, the students quickly understand how to find the pizza place. The owners offer discounts and immediately start calling our shy university kids by their names. The place features pizzas with just about any topping; *arancini* (little oranges), fried risotto balls with a bit of ragù inside; even burgers and fries. I see the students munching contentedly on food characteristic of our own country, right in the middle of this Umbrian city of boar and black truffle, vibrant green olive oil as thick as honey, prosciuttos and cave-aged sheep's milk cheeses. "It's not great," they say of the burger, "but it tastes like home." The restaurant is called Zeppelin.

✈

"I saw the most amazing blouse yesterday." Almost two weeks into our stay, and the group has not only grown more comfortable with the geography but now also experiments, venturing into boutiques and cafés. "I tried it on," the student continues, "and it was magical: perfect fit, ideal color."

She's smiling widely now, eyes closed, miming the act of smoothing out the blouse's shoulders with her hands.

"Problem is, it cost about half of what I budgeted for this entire trip."

By now, a few other students have gathered around our table outside a small café in the lower part of town.

"So, what did you do?" one of them asks. "Did you buy it?"

She pauses, raises her eyebrows.

"I bought two."

I do not want to endorse heedless consumerism, but something about this strikes me as beautiful. No, one need not purchase anything

to be happy while traveling or to gain some sort of access to the culture. In fact, money might just make assimilation more difficult, offering as it does a buffer between ourselves and what we presumably travel for. What the air-conditioned hotel room with minibar and CNN in English do; what the savvy English-speaking guides and McDonald's charging twice the rates at home do: they insulate, protect, provide a coating built of recognition, a second skin between two cultures, which otherwise might rub each other raw.

Still, I can't help thinking that the student purchased more than two overpriced blouses. For whatever the cost, they allowed her an immense feeling of joy, far greater than if she had bought two equally pricey garments back home. No, what she purchased was more complicated. Perhaps a notion of belonging, a temporary registration in the annals of the town? And for that feeling—which has an amazing shelf life—she was willing to pay. Rather, for that feeling of belonging to another culture, she understood—if perhaps only in a hazy, imprecise way—that money is only a catalyst. She bought herself out of caring about what she bought.

But who am I kidding? Maybe I'm making more of it than I should. Maybe it really is just senseless, reckless spending. And they *were* expensive blouses.

"Yeah," she says, "but they feel like a million bucks."

Besides, beauty, too, is senseless, reckless. It cares nothing for the future.

‹✈›

We are known by traces, deformations, distortions. We are constructed out of moments in which something or someone reminds us of ourselves, particularly our less-than-glamorous, less-than-intelligent iterations. Yesterday in our film class, while watching Fellini's *8½*, I noticed a small imperfection—a stray hair probably—floating on the celluloid. The Criterion Collection copy of the film: sophisticated technology and pedigreed curators, the best version available. Suspended forever above the scene, though, that small intrusion, a castaway, forever embalmed and replicated on every copy sold. I couldn't take my eyes off it.

My friend Luca, sweeping up the cigarette butts that litter the landing outside his café, bemoans his fellow Italians and their behavior, tells a friend sitting next to me at a table a bunch of half-truths deeply rooted in the personal.

"Americans," he says with something close to wistfulness, "now there's a polite, cordial people. You never see this in the States."

"Not always my experience," I say.

He recalls scenes, anecdotes from his honeymoon abroad; how, even in a New York subway station, people seemed always eager to help him, to lend a hand—and they never littered.

Utopia, I know, etymologically, means "nowhere." Distorted, the way we look at each other too. Do I see cigarette butts on the ground or some nostalgia for smoking, which I have always possessed, even (perhaps especially) if I have never smoked? Something about the way Marcello Mastroianni flicked his ashes in 8½ yesterday, that nonchalant finger tap; the way he slowly lowered his head and peered over the rims of his sunglasses. Something about the tight group of men huddled around a flame behind a van at the antique bazaar last Sunday morning or the girl with the pink hair rolling her own on the stoop of the church today. Can I be nostalgic for something I never did? Is that what nostalgia really is? Home pain, homesickness, yes, but *home* probably as some conceit, some idealized place we will really never access because we never really knew it?

✈

"Every explorer," wrote Walker Percy, "names his island Formosa—beautiful." Perfect form. Unspoiled. New. Discovery counts most when it meets the idea of discovery we carry with us. What is beautiful confirms our own sense of beauty, conforms to it. Could it be that Italy is at its best when it simply validates the Italy we already think we know, the Italy given to us by all the Italys we see and read about and dream we will one day visit? Yes, we want the romantic café. Yes, the barber in his wood-paneled shop, sharpening his razor on a strop. Yes, also, the geraniums in window boxes but only certain colors—bright pink, violet, yellow—and always in bloom.

The cobbler in town occupies a storefront more front than store, maybe ten feet square, on the main north-south pedestrian walkway, just outside the old Roman gates. The muzzle of the stone lion by his shop is worn to a nub. And the cobbler's shop, too, is worn: just a chair, a workbench, and piles and piles of shoes. Odd tools lie about. Sandpaper and buffing wheels litter the floor. He's there most days, worn himself but in a pleasant way. Not like that lion: disfigured, deformed. No, more like the way the human hand—the very oils of the body— can, over time, round the marble toes of a saint's foot or darken the hull of a little wooden boat. He's like a little boat, afloat on such deep nostalgia: diminutive, darling, and quaint.

I've been thinking about that word *quaint,* the damage it can do. Why is that cobbler "quaint"? Or the butcher in all white, carving thin slices of roast pork for a sandwich? The pensioner in matching suit and newsboy cap drinking his darling coffee out of a darling demitasse in a darling bar down the street? Even that use of the English word *bar* as a catchall for café, coffeehouse, pub, and everything in between. And that pensioner's cap, its very name, "newsboy"; the profession of the cobbler; the butcher's garb; the words themselves. *Quaint:* a relative of *knowing* and the Italian verb *conoscere,* with all the English cognates: *cognition, cognito,* even *cognate* itself but also (via French) *acquaintance*—getting to know someone or something. *Have you made the cobbler's acquaintance?*

Two years ago, the rubber covering on the heel of one of my boots detached. I was almost gleeful to have a reason to visit the cobbler, as though with that act I could shed the quaint and enter his shop unburdened by all this machinery of beauty and memory. He appraised the boots, relatively new but already scuffed and showing inordinate signs of wear. He mumbled something about their needing two new heels (he would have to replace both for symmetry's sake) and then the price, which was quite reasonable.

"Queste scarpe" (These shoes), he said to me, before I left, moving his head from side to side, lips pursed, turning one of the boots around in his hand as a jeweler might a piece of coal, "non sono ben fatte" (they're not very well made).

Quaint: "old-fashioned, charming, cute." I've been thinking about that word because it reorders our vision here in Italy, distorts and warps it, as so many words do. It constructs a frame around what we see and remember: that ramshackle Christmas fair in the belly of the fortress in Perugia already sixteen years ago (*precious!*); the street sweepers with their brooms made literally of twigs wound tightly together (*how charming!*); the cobbled streets wending round the corner, keeping their endpoints just out of reach (*darling!*); the cobbler looking up from his hunch over a pair of worn, leather loafers, mending them (*that is so cute!*); the word *mend;* the word *loafer;* the word *cobbler;* this entire, beautiful town.

✈

Deformis: Latin for "ugly." The opposite of form, literally "unformed."

"Ti vedo in forma oggi," Luca says to me in the bar. (You're looking fit today.) Three weeks in, and I have grown a bit lazy. Just back from a short run in my ludicrously cheery neon, sweaty and panting, I roll my eyes at him. Form, fit, health. The way we *should* be. Deformed, unfit, sick. That's not the way.

And yet here in Spoleto, torturously steep walkways meander around Roman ruins and sixteenth-century buildings, twelfth-century monasteries, even a ghastly mid-twentieth-century bank complex. Paths flank the hips of basilicas, thread through openings no wider than a single person akimbo. Or they spiral majestically up twin staircases and underneath a high porticoed catwalk in Piazza Pianciani, climbing to the Duomo, the spiritual center of town. Looking out over the rooftops from Luca's bar, I marvel at the inviting, sumptuous mess of it all. The pleasant deformations, such absolute asymmetry.

"We can admire perfection," the poet Miller Williams once said to a friend of mine in workshop, "we just can't *love* it." But by what mechanism does Spoleto's tumble of stone and mortar, its feast of architectural histories, embody beauty? What makes its deformities, its countless improvisations over millennia, not only forgivable but striking? What stops the students in their tracks, compels them to raise their cameras at an alleyway or flowerpot, a deli's decked-out storefront window in the stark piazza? Could it be that we simply revere the age,

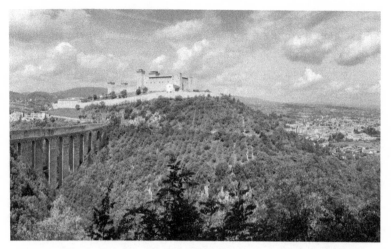

Aqueduct in Spoleto. Photo courtesy Julianna Olson.

the fact that these places have endured, these deformities and scars we visitors now imbue with our own invented nostalgias? Towns like Spoleto are museums people live in, the muses having long ago departed. Given time, these places fall into a kind of cultural amber, locked in some antique iteration. The thirteenth-century aqueduct, though, still works, still carries water to the city, still features prominently in all of the town's marketing materials.

Then again, I think of what Wallace Stevens said about death, how it is the mother of beauty. How can this town, which endures, which outlives all its inhabitants, which will outlive us—how can Spoleto, if it doesn't die, be beautiful? And what I see as timelessness here—that aqueduct still functioning, that convent carved out of the oval of a Roman theater—is really just perpetual rebirth anyway, which means it had to die before, that all it does is die, again and again. We think of these Italian cities as unimaginably old and unchanging, and yet they are more like monuments to continual change, mutation, de- and transformation.

The aqueduct, it would appear, carries much more than just water.

Just off Piazza Pianciani, near the beginning of the elegant Corso Mazzini, a main shopping and café thoroughfare in the upper part of Spoleto, I feel an odd sense of guilt. The Chiesa di San Filippo just opposite me now—I have never been inside. Who knows why. Just haven't, even after seven straight summers here. Is it not inviting, that facade—plain and reserved but by no means ugly? And what do I mean when I say a place is "inviting"? According to what principles?

The small, oblong piazza in front of it—if I can call it a piazza. Maybe it's that bleakness I unfairly associate with the church. On the east side of the street lies Piazza Pianciani: spacious, symmetrical, almost leading the eye to those twin staircases, which in turn lead inexorably to the frescoed portico above. On the west side, a newsstand and sad pizzeria, both usually devoid of people. An overeager yet resigned (how can that be?) starch-shirted employee often lingers in the piazza, distributing coupons to nobody. To the south, San Filippo itself—majestic, even severe, against the early-evening sky—and on the north, a monstrously bleak, metal-latticed bank, perhaps the most uniform building in town and quite possibly the ugliest.

Through this piazza and to the side of the bank, an occasional car turns and shoots the narrow gap between the bank and pizzeria, the stucco walls scarred by vehicles that do not quite square their passage. The dents and chips, shards of glass. Cars and buildings deformed, ugly, used. The piazza itself and just about anyone I see in it: also ugly, used.

"You've never been inside?" a few students ask me. "Not once?"

They are hungry for every open church door, every cool interior. Every threshold must be crossed. Just on the other side of the bank building lies one of the most pleasant walking routes through Spoleto. It once formed the old Roman *decumanus,* the town's principle east-west thoroughfare. And off of it, a complex of medieval structures, the Chiesa di Santi Giovanni e Paolo at its center, along with some old stone facades visible even from the small alley connecting that quarter to the more modern pedestrian passageway. (Spoleto—and much of Italy really—is constructed of guarded glimpses, alleys and intimations.) They should go *there,* I tell them. They can walk straight out of the miraculous survival of a twelfth-century church and right into the face

of a brutalist, 1960s bank building. True what Wittgenstein said about language: it's like an ancient city, with the new astride, even cleaving to, the magnificently old. A city like Spoleto allowed him that notion. The city spawned the analogy.

"Let's go check it out," one student tells another.

Being, existing in this place, understandably requires for these students the disposition of explorers. They are still new not just to Spoleto but to travel writ large, to the forms it assumes. They are awash in their own narratives of discovery. Everything is beautiful because everything seems new.

This is just how beauty operates.

<p style="text-align:center">✈</p>

The students love their Italian lessons, with some, now at the end of three weeks, having made impressive gains. We walk together through the city, and folks say hi to some of them, know their names, ask how they're doing.

"Ciao, come state?" And they answer, all in Italian, "Bene, grazie!"

"Who's that?" I ask one of the students.

"That's Paolo," he replies, "a friend of Massimo's. I met him last night."

They carry on fruitful, if limited, conversations, gobbling up all the language they can. Many have found friends willing to let them stumble through their rudimentary Italian. It's one of the more beautiful sights for me, these cross-cultural friendships built of not much more than maybe a hundred words and lots of patience.

Students are fascinated, too, by the peculiarities of Italian grammar. The letter *s*, for example: how, as a prefix, it instantly reverses participles, nouns, and verbs, turns them on themselves—*fatto*, done; *sfatto*, undone, overdone, trashed; *fiducia*, faith, confidence; *sfiducia*, skepticism, doubt; *mettere*, to put; *smettere*, to stop (literally, to *un*put). Students point to examples all over town. Yes, sort of like the English prefixes *un* and *dis* and *de* (themselves descended from Latin), but those—at least in the minds of the students—seem stolid, overly technical, sanitized, distant. The *s*, used this way to reverse, negate, distort, accentuate, or deform, is sexy in its simplicity, its suppleness, its snake and hiss. One word for "deformed," in Italian, is *sformato*.

And yet *sformato* also conjures for them the tasty, little, quiche-like tarts they have learned to love: a nearby trattoria serves a *carciofo* (artichoke) *sformato* on an aged pecorino cream, with artichoke leaves fried crisp and stacked on top. *Sformato:* deformed but also beautiful, delicious. In the windows of certain trinket shops in town, too, a pasta variety called *maltagliati* (miscut, poorly cut), the odds and ends left over, flotsam and jetsam of shapes now sold in ribboned bags for far more than they're worth. The almond cookies called *brutti ma buoni* (ugly but good). The cult of loving the unlovable, of form from deformity, and the prices paid for it.

So much of Italian cuisine, of beauty in food, is wrapped up in these tiny narratives of privation and rusticity. The students are buying them, packing them away for home, the foodstuffs and their stories. "I can't wait to show this to my family," one says, holding up her bag of mistakes.

Sitting outside a café in the center of Spoleto, I'm surrounded on all sides by the various and beautiful forms history assumes in masonry and need: an uneven stone jutting from a wall; trash trucks lumbering by; add-ons to noble palaces; a dog tethered to a bench, whining while his owner shops for cheese; the unfortunate, serendipitous widenings and constrictions of alleys and their worn cobbles; this bar selling fresh-squeezed ginger and apple juice. Delicious, all of it.

Only time and forgetfulness can build such a city, and there are hundreds like Spoleto in Italy alone. In this bar, in the Piazza Torre dell'Olio—so named because the inhabitants of Spoleto supposedly defended their town against Hannibal by pouring hot oil on his troops (a tale about which I have my doubts)—history is deformed, contorted, stretched like taffy back on itself.

In Italian, *storia* can mean both history in the grander sense or just a simple story we tell our friends. Sometimes there's really not much difference.

✈

Why doesn't the city, I often wonder, just tear that bank building down, at least modify its garish facade? It looks more like a prison than a bank, much less any sort of structure that should exist in Spoleto, a town

that sports an actual Buckminster Fuller geodesic dome, a massive Alexander Calder sculpture in front of the small provincial train station (taxis used to park beneath it), Baryshnikov in the summer, Fellini looming in its past, and wide-eyed paparazzi when celebrities descend on the main square in late June for the Festival of Two Worlds. Five years ago, as I sat outside, Willem Dafoe walked by. He seemed much smaller in person.

Why don't they tear it down? Because it's there, it's done. *Cosa fatta, capo ha,* Italians say. Done deal. Better, in some way, to live with the mistake, if we still call it that after two hundred, five hundred, a thousand years. Richard Hugo advised writers never to erase words in their journals but, rather, to cross them out violently. No clean slate. Instead, markings of a path, vestiges of us, even—especially—at our worst. Bland bank buildings cast in the cold, unrelenting dismalness of midcentury steel, cars scraping along the pizzeria's wall, gouging, wearing away, bit by bit, the history or maybe wearing through. Revelation is simply the act of taking off the veil, discovering what was always there before.

꙳

Today we're touring the fortress at the top of town. Brilliant sunlight, a bit of breeze agitating the olive groves. The hillsides resemble piles and piles of money. Four weeks in, all but nearing the end, and a few students call my attention to a bit of graffiti on the side of the medieval aqueduct. They have often acted perplexed, even disturbed, by what they see as pointless vandalism. Mostly I agree, but today I think otherwise. What might render graffiti back in the States—on a subway car or highway overpass—different from graffiti on this medieval structure? What might link them?

This town: I keep talking about its relentless pursuit of stability, of keeping things the way they are, the way they have always been, but I know that's a lie. Spoleto's various and concentric systems of walls—Umbrian, Roman, medieval, modern—illustrate this principle: the town is constantly in flux. We just don't register change over such long periods of time. We ourselves change much more drastically, much more quickly.

Teenagers, at least those I imagine as the perpetrators of this graffiti, must have difficulty dealing with that change. All the apparent timelessness—the effect must be rather belittling. *I will live my tiny, unimportant life,* these frustrated teens must think, *and disappear, and this town will never even register my passing.*

Earthquakes leave their marks. Armies too. And regionally funded projects like the people-mover system—more than a decade in the making, which now transports people up the hill through a series of underground conveyor belts—they all change and transform this town. What could one insignificant, insecure teenager hope to leave behind? Thought about this way, the graffiti becomes more meaningful to me, more tragic, more desperate. *I was here,* it says. *I mattered.*

Graffiti, from *graffiare,* "to scrape," "to scratch." Yet such different words in English. You scrape a car fender and pay out the nose. You trip over a step and scrape a knee. A scratch, too, inflicts its pain but not usually on the human body, unless by another human body. *Why did you scratch me?* I dropped my glasses last week and scratched the lens (who would say, "I scraped my glasses"?), and every time I look through them now my eyes go right to it, that little nick in the world, that tiny imperfection amplified. Annoying, sure, but not painful. "It's just a scratch," we say, "nothing important." Scratch an itch, and it feels good.

Scratch or scrape: which one do we choose for *graffiare,* for the graffiti on the side of the medieval aqueduct? These anxious declarations, these names in cheap ink or spray paint—Alberto, Marco, Matteo—are they the senseless vandalism of reprobates or just the scratch of an itch that feels good?

✈

Late Sunday afternoon of our final week, I walk around the Giro dei condotti, the trail that once linked all the various natural springs to the massive aqueduct serving Spoleto. Now a flat path clinging to the side of Monteluco, the Giro offers wonderful views of the fortress, the aqueduct, and the entire Spoleto Valley. Near the end, I pass a slender, sharply dressed man peering over a wall into the garden of the house below. We greet each other.

"Che brutta vita qua, vero?" I joke. (Would suck to live here, no?)

But he explains that he was once the owner of the house. The dramatic location perched off this tiny pathway, terraced with olive groves, vines, all manner of fruit trees and flower beds—the place is stunning, or was. The new owners have really let it go, he tells me. A shame, I say, a place like this, with such a spectacular view. It deserves better.

He tells me of a famous British painter who stood precisely there and painted his own version of the aqueduct through mist and nostalgia. Turner was his name, he says. At first I don't believe him. *The* Turner? J.M.W.? The one who painted those violently romantic scenes of erupting volcanoes, shipwrecks, all the high drama of the sublime? Yes, he assures me, *that* Turner.

And he's right: later I find that painting of Spoleto, the view that was right in front of me, on the Tate Gallery site—gauzy, washed in ghostly whites and tinged yellow where a blotch of sun floats in ether. Turner stood in that same place and painted. Rather, he felt it earned his paint.

The Tate site defines Spoleto as "a picturesque Umbrian town."

Teulada / Not Taking Pictures

On the south coast of Sardinia, outside the small port of Teulada, winds thrash the nearby palms, their massive leaves littering the yard behind our rental house. Below, maritime pines and bougainvillea, cactus and bamboo, cascade down a network of decks and terraces we can navigate using a narrow stairwell that bisects the property and descends to the sea—blue and emerald waters ideal for swimming and snorkeling. But I prefer to sit on the uppermost deck, a small tiled slab with thatched roof, accessible from our kitchen door. From there, about fifty feet above the water, the view—south across the turquoise Mediterranean to Africa—seems almost unreal, picture perfect.

Earlier, hungry for lunch, we stopped at a small trattoria in town. First day on the island, and the six of us—three couples sharing the week—had little time to research or think. The menu didn't look promising either: a mass-produced affair with corporate sheen; clean, white pages with a glossy font more fitting for energy drinks. The choices seemed equally uninspired: nationalized pasta mainstays such as pesto and arrabbiata. When I asked about the possibility of fresh seafood, I wasn't expecting much. The owner, however, said that, yes, they did have a few things, some caught just that morning. It was, he said regretfully, not enough to feed all of us. If we liked, he could offer some tastings, a few antipasti, something to nibble on.

We agreed, and within minutes the food began to appear: fresh salads of shrimp, octopus, and clams; shark and black olives in a saffron oil;

lobster with thinly sliced onions and tomatoes; smoked tuna cut thin like prosciutto; bottarga with cherry tomatoes; amberjack in a sweet and sour sauce. We had more food than we could eat, and this was, according to the owner, "just a taste." Soon after, fresh sea snails appeared, still in their shells, heaps of them in a large white bowl, vegetation still clinging to them. Mussels as large as the palms of my hands, mounded in a terrine of tomatoes and garlic, wedges of hearty grilled bread lining it all. What threatened to be a mediocre meal in a small Sardinian town turned out as a most unexpectedly odd and delicious feast. Before we dug in, my friend Dionne fished her phone from her purse.

"Wait," she said. "No one will ever believe this."

Photos, we often think, offer proof, the unadulterated facts. Language? It's either too impoverished or just too slow to reconstitute experience. Since we effortlessly manufacture it, language is also easily wrenched and fudged. How quickly we slip into hyperbole. Just the other day, I was talking to friends about Palermo, telling them about the week Gwen and I spent there many years ago. Gwen looked at me and shook her head.

"We were there for *one night*," she said.

Words trick us. They sound lovely coming off the tongue. Images, photos, *pictures*: they don't lie, even in the digital age. We pull over on deserted roads, in front of National Park entrance signs, take pictures of ourselves with our arms around massive trees, on Broadway under a theater marquee, with the circus clowns, on the outermost point of some forbidden peak. *I was here,* the pictures say.

And yet, here I am, trying to capture experience without the aid of a camera. Rather, I am trying to capture the experience of *not* using a camera.

✈

I stopped taking pictures a long time ago, and I remember exactly where and why. I was in an apartment just off Piazza Maggiore in Bologna, rifling through my backpack, between the couch cushions, in the side table drawers. November 1994, and I had just returned from a weekend trip in Umbria. I shot six rolls of film. (It still came in rolls then, which

sounds absolutely prehistoric now.) Six rolls: far too many for a three-day trip, particularly for a terrible photographer like me. All my sun-bleached landscapes, my off-centered and poorly recorded monuments: they made my anxiety at the time even more pathetic.

Though I later found the rolls, the photos were, as I had thought, categorically bad, not worth saving. I can't even remember one shot. What I remember perfectly, however, was rummaging through my apartment in despair.

No more, I said to myself. *I am done taking pictures.*

Part of that anxiety must have come from the fact that I liked to look at photos of places seen, to relive those experiences. Rather, I liked the *idea* of reliving, since I rarely lugged the photo albums out and looked. A much larger part of my dread that day, then, must have been egotistical. I was twenty-four and liked to think of myself as worldly. I had backpacked through Europe with my friend Vince the year before and was hooked. I looked into language school in Italy, weaseled some financial help, and took four months to live in Bologna. Small dramas—at least they seem small now—ensued. My girlfriend of three years gave me an ultimatum: if I went to Italy, we were done. No more wandering. My frantic search for those photos—bad and unmemorable—must have also had to do with a sense of self on display.

I was here, those photos would say (most meaningfully to her and to my less adventurous friends and family back home). *I was here, and you weren't.*

✈

The Church of Saint Ignatius in Rome houses a most impressive trompe l'oeil fresco. The entire ceiling of the nave, viewed from the correct vantage point (a small disk in the floor marks the spot), comes unerringly into focus. It's as if that ceiling were not there at all. Andrea del Pozzo's masterwork allows us to stare not at brick and mortar, plaster and gesso, but at the heavens, the actual pillars of the church transforming effortlessly into paint and a dazzling series of iconographic images representing each of the four continents. Saint Ignatius himself rises on clouds with the help of a gaggle of cherubs. Jesus, at the center of it

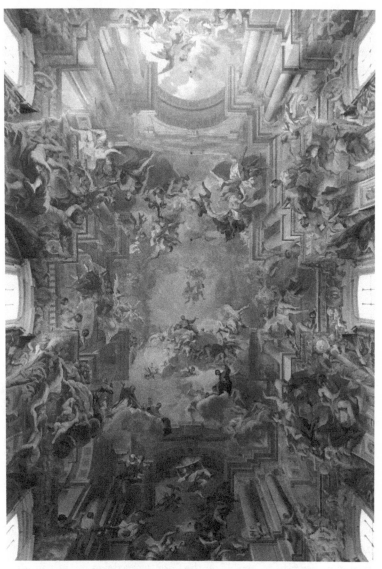

The Apotheosis of Saint Ignatius, 1685–94, by Andrea del Pozzo.
Ceiling of the nave in the Church of Saint Ignatius, Rome. Photo
courtesy Julianna Olson.

all, is barely visible in the haze of what appears vast distance. Even the dome in the transept is a ruse. Though I swear I see sunlight angling through its windows every time and dust sifting through the void, the ceiling is flat. No dome at all, just the illusion of a dome. A picture.

I was in Perugia when I first came across that church in a book. Gwen and I were living only a short train ride away for a year. I studied at the university, Gwen took language classes, and we had our weekends free. The book, a fancy Fodor's guide with a faux leather cover and snappy onionskin overlays, is the only text I know that reproduces Saint Ignatius's massive ceiling with more than adequate fidelity. More so, the editors chose to superimpose a grid demonstrating how del Pozzo employed perspective for those impressive effects. In other words, the image supplied the mechanism through which to view the actual painting, and I'd be lying if I said I didn't recall those pages—vectors radiating out from that focal disk—when I first entered the church and looked to the ceiling. I still default to it every time I enter.

From the moment the camera obscura gave us its version of verisimilitude, we have been telling these sorts of visual fibs. So, why think images are any more faithful? Why not just write ourselves into our surroundings? On one hand, the answer is easy. Writing—at least writing well, writing more than hyperbole and cliché—takes time, patience. Photographs have become common and quick, the machinery easy enough for anyone. I watch tourists stream into Saint Ignatius now, pointing their cameras immediately at the ceiling. They peer through their lenses, mediate the wonder, as if the church could blind the naked eye. Others, stunned by the cool, dark interior, sweaty and worn from the broiling cobbles of the capital of the world, don't even notice the ceiling and so start pointing and shooting even the most meager of secondary monuments in the church's arsenal: a forgettable painting of Madonna and Child, some satisfactorily sculpted crucifix, the tomb of a patrician, his face, in marble on the floor, worn down by the countless feet of gawkers, heads wrenched back to take in the heights.

They may not notice the ceiling right away, but they always find it. I watch them watching history, absorbing that fanatical work over three hundred years old, and I have to say there's some joy in it. To

experience that church for the first time only happens once. Through those tourists, however—more precisely, through their cameras—I almost see the ceiling for the first time. Rather, I almost see it for the first time *again*.

But then, is watching people watching the church any more profound? Am I just taking another kind of picture, acting the parasite, living through the lens of some German high school student or that lone Brazilian couple in bright-yellow jerseys, maybe the older American man in khakis and white sneakers? Just because I don't take photos doesn't mean I'm any more knowledgeable, any less a spectator. *Not photographing* does not necessarily mean *knowing*.

And yet I used to take a perverse pleasure in not taking pictures. There was something lowly to me in the camera and its work, too easy, too superficial, and too—in a word—*touristy*. Then again, maybe my qualms with the camera-clad had little to do with their *being touristy* and much more to do with their *not being touristy enough*. I was critical of their inability to penetrate deeply into the culture at hand, their contentedness to remain always on the surface, perhaps dazzled by their own reflection in the camera lens. But do I see any more clearly with my own eyes, or is any perceived superiority just as self-serving as the picture in the forgotten album, just as much of an illusion as the frescoes in the Church of Saint Ignatius?

A few days ago, Dionne took a photo of herself seated beside Gwen on a train and posted it on social media. Within hours, Gwen's sister commented on how refreshing it was to see the photo, since neither Gwen nor I hardly take any. *Refreshing*. Part of taking photos, then, resides in the pleasure that others will take in seeing them, even if that pleasure is one of assurance. *I am here*, the pictures say, *and I will always be here*.

While that's not true, the relentless present tense of photography always suggests otherwise. When Gwen's sister sees us in that photo, we are momentarily transported to her, crossing space, yes, but, more important, also time. *Refreshed*. When we see relatives, long dead, in photos, we inhabit that space again with them. *How can it be*, we think, *that they are no longer here?*

Or what about this: when I enter Saint Ignatius and look up, I do so with my mother's eyes, because I took her there before she died and watched her watching it. I saw that ceiling through her, and I am doomed (or blessed) to repeat it. The image of my mother is refreshed every time I step into that church.

I am here, I think, *and so is she.*

✈

Chiapas, Mexico, 1995, and I am working at a small English-language school for the summer through a teacher exchange program. At the entrance to the church of San Juan Chamula, a Tzotzil woman offers me some fiery liquor poured from a goat bladder. Nearby, a tourist takes her camera out to capture it all, and I hear someone hurriedly tell her to put it away.

"They don't like their picture taken," he says. "It steals the soul."

I've since heard countless versions of this, and I have to admit that the skeptic in me sees economics at play. Some money, in other words, can usually offset the loss of soul. *If you want to take that photo,* I almost hear, *you have to pay for it.* It's a way to limit access, curb the ever-present shutter clicks, undemocratize the camera. We might be free to take as many photos as we please, but we can still be shamed into thinking otherwise.

On the other hand, I can't help but think some strange truth lies in those superstitions. Walker Percy asks a wonderful question in "The Death of the Creature." If we find ourselves at the Grand Canyon with a thousand other tourists, are we only seeing a thousandth of the canyon? Does the presence of other people steal from our experience? In some sense, an absurd proposition. The canyon does not change, regardless of how many tourists perch on its rim and peer in. In another sense, however, it does, at least our appreciation of it.

We love to have monuments to ourselves, to be alone and in awe. How many times we tell our stories, fresh from travel—*we were the only ones there, just us with that Michelangelo, for a moment.* It might even be difficult to feel awe in the presence of hundreds of other chatty, sweaty, picture takers. The experience seems lessened by the fact that we do not

experience it alone. We were *robbed*, we say, as if we somehow owned what we looked at, as if what we looked at owed us the privilege of intimacy. Those cameras—and the people peering through them—are hoarding all the loot.

And yet a paradox remains: we need the crowds (or at least knowledge of them) to assure us of the thing's worth. Millions of people come to see this monument or fountain or crumbling church. Consequently, its worth, like a public offering of stocks, seems contingent on the premise that we will continue to believe in its *being worthy*, that people will keep coming to see it.

Taking photos must also be in some way related to this paradox of crowd and solitude. When we snap that picture, even among the myriad tourists in the center of Saint Ignatius, we preserve some bit of our experience just for ourselves, maybe to the detriment of others, maybe—in the case of the Tzotzil and that goat bladder—to the detriment of what (or whom) we're shooting. We are cordoning off all other spectators. We even wait patiently to take pictures that make it seem as if we were alone.

This is my church, the picture says, *not yours.*

My friend Marella, from Treviso, has lived in the States for twenty-five years but travels back to Italy often to see family. Once I asked her to bring me some olive oil. When she gave it to me, I asked what she had brought for herself.

"Nothing," she said. "I used to do that but then realized it's even more depressing when I run out."

Bringing back a part of home simply reminded her of what she was missing. Cold turkey, she thought: the best operating procedure. Leave Italy where it is.

Is taking pictures sort of like trying to capture happiness? Are we engaging in a kind of masochistic act, deriving something close to pleasure from the pain of recalling how content we were on vacation in the Alps, near a tranquil Lombard lake, in the bustling center of Rome? Are we saving up these pleasant souvenirs for our workspaces and desks, our refrigerators and mirror corners? Do they really just say, *I know what happiness is, and it looks like this?*

Such reasoning seems sad to me, as if we knew our daily lives would return to their dull and monotonous routines and so have shored them up with images of bounty, of excitement, of past experiences that will forever remain out of reach, even on the nightstand next to us as we turn off the lights and fall asleep.

＋

Point, aim, shoot, take. The language of photography, at least in English, is rooted in transgression. The idioms correlate most compellingly to hunting. We point our machines at what we want to capture. We take aim and shoot. We treat what's in our view as prey. Crosshairs are still superimposed on the lenses of some cameras.

＋

Today we toured Nora, an archaeological site on Sardinia's southern coast. The complex resembles a giant, architectural palimpsest: Roman colony atop a Carthaginian city, in turn sitting on Phoenician origins. Most of the dwellings and infrastructure are destroyed, sacked over centuries and eroded by the encroaching sea. We needed a great deal of imagination to conjure the broad Roman thoroughfares, the villa with its ample atrium once carrying cool air to its rooms. The most evocative elements were the villa's simple, if elegant, floor mosaics, thousands of tiles arranged in strikingly geometric patterns.

"You might discern," our guide added, "representations of sea waves in these mosaics."

The image of the sea carried itself out of the current, into the very homes of the rich and privileged. Rather, the rich and privileged paid for it to be so. Wealth—at least in the West—has often been tied to the ability to will into the world the images populating one's mind.

When my mother died, I knew what I had to do. If I couldn't will something of value to say, if I couldn't speak at her service in front of friends and family, then what good was I? I am paid to write and to teach others how. If I couldn't deliver on this occasion, I would consider it a complete failure. What I said, in hindsight, was mediocre. Even the

stoniest of writers would have difficulty, I imagine, with that task. Still, I felt right when I sat and tried to scribble a few words that were more than a string of clichés—what one usually hears at such rituals.

At the same time, I remember being acutely aware of the synthetic nature of what I was saying, where I reached for a metaphor, where I turned a question over in my mind, trying to answer it eloquently, pithily. I was conscious, in other words, of the eulogy *as eulogy, as memorial*, not just as a group of words about my mother. The genre preceded the information; form came before content. I actually remember the act of writing more than what the writing came to say. Still, I lived up to some vague promise, some obscure oath, and felt I had performed a solemn duty entrusted only to me.

The act of taking pictures, for some, might just be similar. The content of the pictures themselves remains of secondary importance. Some ineffable satisfaction derives instead from the center, the focus, the capture, the shot.

New technology often begins by mimicking older, familiar forms. The first printed books resembled manuscripts. The first cars—"horseless carriages," we called them—came with slots for riding whips. Likewise, some digital cameras still feature the sounds of a mechanical shutter, the automatic film advance, even the pop of an old gas flash. No matter how advanced the technology, we seek the comfort and feel of the old, maybe even the heft of the camera in our hands, the safety of the weight we know.

New cameras could be much smaller, I hear. The technology is ready. The human hand is not. We need cameras to be a particular size, a comfortable dimension, a soothing presence.

It's not the pictures we take; it's the taking of pictures.

✈

A friend of mine met a performance artist at a colony in New England. Fresh from Europe, she had received grant money for a project: to try and insert herself in as many vacation photos as possible. We've all had those slightly awkward moments at touristy destinations: someone

trying desperately to take a picture of a friend or loved one with the monument in the background, while hordes of people wait awkwardly on either side.

He's still focusing, we might imagine. *There's time to walk straight through.*

A great idea, I remember thinking. She could tour the capitals of Europe, ducking in and out of hundreds of photos, a celebrity if only because she would appear in the scrapbooks and albums of people from all over the world. And yet part of the project was disconcerting: she would have absolutely no proof. *She could just approach the people afterward,* I reasoned, *describe her project, ask for a copy.* The proof would be there, for sure, in the homes of all those tourists in whose photos she appeared. They wouldn't know who she was, however, and she wouldn't have the evidence otherwise. The project was ephemeral. It existed only in the act. All that work had absolutely no tangible result other than her theorizing after it happened.

In some ways, my resistance to photos—to taking pictures—is similar. Maybe, at least for me, experience versus photographic evidence really is a zero-sum game. Maybe it's akin to Percy's argument about the impoverishment of experience when in proximity to others, that a photo's very existence testifies to the ways in which we unwittingly mitigate the potency of the things we see. Maybe the photograph simply dilutes the experience, disseminates it too broadly, renders it a mere commodity.

When I take friends and family to Rome, Saint Ignatius and other lesser-known sites seem always to offer more of an impression, simply because they are less easily recognizable, more surprising. The immediate power of our seeing the Colosseum, because of countless guidebooks, films, documentaries—in short, through pictures—has eroded. As a result of our constantly being bombarded with images, we inevitably compare the massive amphitheater to those representations we have seen. As Percy rightly points out, we might even hear someone near us (or even hear ourselves) say, "It looks just like the pictures I've seen" or "It's even better than the pictures I've seen" or, perhaps most distressingly, "I think the pictures I've seen are better." Regardless, we

are—whether consciously or not—judging the real by the merits of the facsimile, the actual by the copy.

In the case of Saint Ignatius, the first experience does not often come pre-supplied with particular emotions. Most of us do not know what to expect, so we are not prepared or even inclined to feel anything specific. I could say that the interaction is more honest, more sincere, but I am not sure that's the case. Such language seems to imply, then, that our experience at other more well-known sites, such as the Colosseum, is somehow dishonest or insincere, as if we had any say in how we have been inundated with images, with pictures. We don't.

By *not* taking pictures, then, we might even be protesting the proliferation of images that renders seeing the world difficult. Small rebellion, I know. Still, a refusal to take pictures is, in some way, a defense of uniqueness, of strangeness. "This thing is here," we might say, "precisely in relation to how few likenesses, how few pictures of it, exist."

✈

In Maurilia, another one of Calvino's "invisible cities," visitors peruse turnstiles that feature postcards of the town as it used to be, in earlier times. Where now stand the trappings of the modern era, vestiges of Maurilia's past appear: "the same identical square with a hen in the place of the bus station, a bandstand in the place of the overpass, two young ladies with white parasols in the place of the munitions factory."

More than just admiring these older incarnations of the city, in fact, visitors to Maurilia—if not wanting to attract the scorn of its inhabitants—must prefer them to the modern versions all around, must pine after what Calvino calls "a certain lost grace."

Such appraisals, Calvino notes, are strange, given the fact that during the era in which those old postcard photos were taken, "one saw absolutely nothing graceful." Time, in other words—the distance between the photo and the present reality—provides ground enough for some synthetic nostalgia to take root and flourish.

For a while after I had given up taking pictures, I bought postcards, which were almost invariably better than anything I could produce. And if preserving an image were our primary aim, then buying a profes-

sionally executed photograph seems the best possible method. Second, doing so feeds the local businesses, necessitates participation. We *buy* postcards, a verb that implies both a subject and object (who's buying the thing, and what thing is it?) as well as an indirect object (who are we buying it *from?*) and even a price (for how much?). A simple verb, yes, but one that contains an entire set of relationships, all of which require social interaction. We *buy* postcards, but we *take* pictures.

Since then, however, I've even stopped buying postcards. I rarely feel any connection to the professionally shot image: some free-floating beauty devoid of any personal significance. In fact, such images might even be more symptomatic of the ways in which we commodify experience. And then I hear myself saying those baggy abstractions: *connection, significance, experience.* How do we feel those emotional complexes in relation to an image? For me, in any case, it's some small detail in the thing itself—a random bit of mosaic in the ruins of an entire city, the squeal of a baby girl in Santa Maria Novella in Florence and her mother's hurried arms to quiet her, the broken finger on one of Bernini's massive figures in the Fountain of Four Rivers, in the center of Piazza Navona, in the heart of Rome. I doubt those odds and ends—hopelessly subjective, for sure— find their way onto many postcards. In fact, they shouldn't. If they did, they might cease to be small details. And I would most likely cease to care.

Still, it's disconcerting to think of travel as some constant trial of evasions, a ceaseless quest to stay clear of the preplanned, the pre-recorded, the images of the many. First, I don't think my tastes are that unique. To deride certain sites simply because they are popular is misguided. Red wine is popular, too, and I continue to drink it. The Pantheon, for all its popularity, merits the praise. When I am there, in front of that massive structure, I feel—however wrongly—that it's partly mine, as if I'm visiting part of my hometown, at least a place in which many versions of myself have chosen to remain. It's as if we could claim home through our refusal to document it. Home is too central to need such assurances. Home, for me, is wherever the pictures are *not*.

Home is the absence of likenesses of home.

Years ago—I can't remember precisely when or how—Gwen and I

fell in love with old photographs of Rome. We wanted to find images of famous sites—the Pantheon, the Colosseum, Castel Sant'Angelo—that were obviously early twentieth century. One day—we were leaving the very next morning—we challenged ourselves: find one of these old photographs, poster size, of the Pantheon. We must have devoted three or four hours to the search: going in one tourist store to ask, following the directions of the store owner, who somehow always seemed to have a hunch about where we might find such a thing and who somehow was always wrong.

Almost always. We found the image, the Pantheon at the turn of the twentieth century: women in hooped dresses, men in hats, a horse-drawn carriage tethered to a massive column. We framed it, put it above our bed, and I look at it every night before I sleep. I could say that it's all about the content. The Pantheon, for me, has always been a wildly affecting site. It stuns me each and every time I walk around the corner and catch its full enormity, which dwarves all the shops and buildings around. It's as if someone had shoehorned it into that piazza, which has grown up around the temple, millennia of accumulation, detritus, history, and neglect. What surrounds the Pantheon, then, seems pulled into its vortex. The gravity still works, even from across the Atlantic, in our home near Atlanta.

On the other hand, what I see when I look at that image of the Pantheon is *not* the Pantheon. I see, instead, the myriad shops that Gwen and I entered, the locals we spoke to, the day we spent scavenging. I don't see the Pantheon at all. I see the two of us walking around Rome. I can even remember the weather—muggy, hot—but mostly just the thrill we had with our own challenge, however small and odd, asking our question to perplexed but not wholly unamused shopkeepers.

"It is pointless," Calvino continues, asking which is the most authentic version of Maurilia, the old or the new. "There is no connection between them," he continues, "just as the old postcards do not depict Maurilia as it was, but a different city which, by chance, was called Maurilia, like this one."

✈

Over eight years have passed since my mother died. A postoperative infection from which she never recovered. With regards to photos, *pictures*, especially of the family—my mother and I could not have been more different. Several times over the course of my childhood, we went for the staged family photo, sometimes even with our extended family—cousins crowded around grandparents, our parents dressed in clothes we never saw otherwise. I hated those events, as any kid would. I remember my mother primping me, commanding me to behave, not to fight with my cousin. Those photos clutter the walls of my parents' house, embarrassing me when friends come to visit my father.

He's alone in a large house filled with my mother's quilts, photo albums, scrapbooks. The weight, I'm sure, can be overwhelming. In fact, he's begun to clear away, create order, rummage through stacks and stacks of uncatalogued photos yellowing at their edges, smeared dates on their backs. I visited not too long ago and came across one of my mother as a kid. Oddly staged, she's pulling on a string tied to a loose tooth, snarling in what appears to be mock mischief. On top of that, whoever took the photo also colored it artificially, reminding me of those black-and-white films with postproduction color.

The photo is about as synthetic as possible. I fell in love with it instantly.

Maybe the same affection I have for that Pantheon image is there in the portrait of my mother: the recognizable form transported through time. Certainly, the temporal disparities of the two signify very differently: the Pantheon is still there; my mother is not. The logic appears obvious: both photos illustrate the passage of time, though with strikingly different effects. One emphasizes the everlastingness, one the ephemerality. *Ars longa, vita brevis.*

Or maybe it's the opposite: the Pantheon has been a center of religious and social life, yes, for two thousand years. What happens, though, to that image, that poster on our wall, when Gwen and I move out, when we're gone? Where will it end up? And how old is it, really—not the Pantheon but that representation of it? On the other hand, the campy photo of my mother: that will remain. It is already a kind of family relic, older than my poster of the Pantheon. The date

on the back says 1954. My mother was nine years old. Photos like that are often as indelible as the monuments we travel halfway around the world to behold. They are nearly religious, glowing from inside, simply because they've made it. They've survived.

Hanging that photo in our hallway a few years ago, I realized how barren our walls were. I have tried to change that fact slowly, have begun to reproduce and enlarge old, candid family photos discovered in the attic of my parents' house. Gwen, always the organizer and archivist, helps me sort and date them as accurately as we can. We have even started to digitize some, which is probably as close as we'll come to scrapbooking.

This past May, for my father's birthday, I framed an enlarged copy of a photo we found of him. We argue about the precise spot and age of the shot, but he's in the Southern California mountains somewhere, huddling around a pile of backpacks, taking five from a long hike. He looks midtwenties, is peering straight into the camera with a smirk. Gwen says the resemblance to me now is uncanny—odd how time reverses in photos, how father resembles son. I made myself a copy, too, which hangs next to the portrait of my mother.

The trouble with taking pictures is gravitational. Such airy, ephemeral things at times, and yet they possess enormous weight. When we take certain photos down to clean or paint, we treat them like icons, artifacts pulled from the depths of the Mediterranean, like the Roman amphorae displayed right next to me here, in this rented house on Sardinia's coast. Our hosts told us that the vases are Roman, *real* Roman, recovered off the coast of Africa, over two thousand years old. We're worried that we'll accidentally knock one off its iron stand or that the wind will blow (as it does ceaselessly here) and topple them. History, though, is fairly recalcitrant. It's heavier than we think.

Maybe my reticence toward photography, then, has to do with what I think I can handle. My friend's house is covered in family photos: of him and his wife in San Francisco, in New York; his wife as a toddler; his three-year-old twins in their choicest poses; his parents vacationing on some furiously white beach in Florida; grandparents in those oddly somber photos. (Did anyone smile in photos before 1950?) Maybe the

weight of all the pictures is what I'm scared of, the predilection some have to live more in the past, surrounded by images of the already, the happened, the happy. Or maybe it's not fear so much as avarice. *These are my people, my places,* I hear myself say, *and only I may look.*

Mostly, I have had my way. Gwen is no better, really. We live in a house that—until a few years ago—had exactly zero photos of family, of friends, of us. Now, aside from the two photos of my mother and father, my sister sends me photos of her kids, and my brother, too, some portraits of his young daughter. These crowd a pair of bookshelves in our living room.

The shelves are built into the wall. They have been there since the house's construction. They are sturdy. They can handle the weight.

Postignano / On Ruins

"I have a place I want to show you," Luana told me.

Four years ago, and I was still focused on Spoleto as potential site for a would-be arts and literature conference. Running my university's Italy program in that Umbrian town each summer had inspired me to consider an adult analog to study abroad, with great food and wine to fuel it all. A close friend agreed to run it with me if I could find the ideal location.

I had no luck, however, with hotels around Spoleto—they were either too expensive for what they offered, too remote from the center, or a little of both. A local property manager and (by then) trusted friend, Luana helped me search but was also stymied by the lack of possibilities, particularly during summer.

"This other place," she said, cinching the corners of her mouth, almost in a wince, "it's very remote, and I just started working with them."

She showed me a map and pointed out Postignano, tucked in the rough Nera Valley to the east, through a four-kilometer tunnel to the most remote part of Umbria, already one of Italy's least populous regions.

"It's probably crazy," she added, "but let's go out for lunch this week."

I asked my colleague Maggie, teaching with me in the university program in Spoleto that year, to accompany us, told her I'd appreciate her opinion. Luana drove us both carefully through the snaking valley floor, chain-link avalanche fences lining the cliffside, the dark Nera River on our right. I heard Maggie stifle a gasp each time a tiny

hilltop village appeared and quickly vanished behind the front range we flanked.

"Help me with the signs," Luana said, as we took a curve wide around a trio of brightly dressed cyclists. "I always miss the turn for Postignano."

But like Maggie, I found it difficult to concentrate on such a pedestrian affair as signage, my eyes pulled toward the peaks, anticipating the next glimpse of some rugged, medieval town.

At Borgo Cerreto, we turned from the valley floor and started our ascent through farmland and isolated country villas. Poppies stained the slopes as the streets grew appreciably less maintained, salt from winter treatments cracking, desiccating the asphalt. Signs of habitation, in fact, quickly gave way to wilderness. We were just west of the Sibillini National Park, a massive expanse of Umbria, altitudinous and myth strafed, so named because of the way the terrain easily recalled for former settlers a haunt for the Sybils, augurs of the future, in touch with the gods of the underworld, the chthonic deities. What is uncultivated and wild frightens us, at least it used to.

Luana's white SUV, however, easily glided through the narrow passages between overgrown gorse and broom. "Around the next corner," she said, "I remember now. You'll have a view of Postignano."

Strange, at six years' distance, trying to recover my first sight of the hamlet—how shocked I was by its remove and verticality. The *borgo* seemed to float off the green hillside, as Christ does in those early Crucifixions, triumphantly, far from the hunched-over, slackened, human form he assumed later.

"There it is," Luana said.

I turned around to see Maggie, mouth open, saying silently, "Wow."

Met at the street level by Michele, the manager of the hamlet, we followed him up the steep, stone staircases and pathways, as he chatted about Postignano's myriad features, jingling a massive key ring in his hand. Maggie, panting a bit, careful of her footing, kept the camera to her eye, taking various shots, framing each one carefully while trying to stay at least in earshot of frenetic Michele, who was deep into the presentation of a place he clearly adored.

Postignano, he explained, began essentially as a strategic military

outpost around the turn of the first millennium. Fought over by Spoleto and Norcia (once the principal powers in the area), the *borgo*'s architecture conforms to a characteristic triangular shape, which military fortifications in this valley, and indeed in Umbria in general, tend to follow. At the top point of the triangle (the highest elevation) stands a surveillance tower, giving the best vantage of the valley. Though the tower is still there (one of the few remnants of the hamlet's bellicose past), it's quite difficult to see once inside the tight alleyways, which snake around the sheer stone walls.

In fact, much of Postignano's past was difficult for us to see, the *borgo* having been resurrected only in the last twenty-five years. American architect Norman Carver even featured Postignano—the ruins of it, anyway, nearly reclaimed by the hillside's pale ochers, grays, and browns—on the cover of his 1979 book, *Italian Hilltowns,* his homage to the artful ways in which places like Postignano can (and do) die. Michele pointed to a few of the photos hanging in a gallery of sorts, just off the main walkway: severe shots, almost as if cut into the paper, of crumbling stone architecture and dour folks in strangely formal wear.

At a certain point, fearful I would lose her, I turned back to wait for Maggie, who came slowly around the corner of a walkway lined with lavender and rosemary, an old wagon wheel artfully hanging on the wall. Unaware of my concern, she lowered her camera, as if looking, really looking, at this peculiar place—half-tiny town, half-movie set— for the first time: stone staircases rising Escheresque at odd angles; alleyways meandering out of view; roses climbing steep, roughly hewn walls and parapets; a terrace featuring the stone weight from a defunct oil press as a table; all commanding a view of the desperately green Nera Valley, where we could see just a few houses, a few reminders of the human.

Michele had moved on, inventorying the amenities, the painstaking renovation, the love and audacity given to Postignano. I tapped Maggie's shoulder.

"Well, what do you think?"

I waited for her to make eye contact with me, but she kept scanning slowly around, almost right through me.

"Holy shit," she said.

I signed a contract that day.

<p style="text-align: center">⤙</p>

"Two vast and trunkless legs of stone" is how Percy Shelley begins his description of the crumbled colossus in his 1818 poem "Ozymandias." By then well known, Shelley could just as easily have focused on a recent work of art, a living monarch or potentate. Instead, he chose the Egyptian pharaoh Ramses II (Ozymandias in Greek), the ruins of a statue devoted to him, anyway, shattered and inexplicable. Shelley is keen, first, to highlight the sculptor himself (just like a poet, always focused on the making) and how he formed out of rock the ruler's "sneer of cold command." Ultimately, though, the elements themselves, and not the sculptor, impress much more upon the stone: rain, heat, snow, the unforgiving stamp of every abuse on all those chunks of history, as Shelley put it, those "lifeless things."

And yet Shelley *gave* them life, the remnants of a colossal Ozymandias at least, featured them in a sonnet, arguably the most beautiful of the beautiful, a form that renders form itself more stunning, even—especially—when its subject is the grisly, half-erased visage of a tyrant king of Egypt. Who's to blame Shelley, anyway? Who doesn't love ruins, those shards just barely discernible, inviting us to complete the gaps, reconstruct a past in our minds? They give fragmented form to formless history, unfathomably distant and inchoate, recording all the marks of time passing.

But are ruins, then, simple ledgers? Not all rubble surely turns to ruin. A deserted Esso gas station on the outskirts of El Paso may qualify as old-timey and anathema to the sparkling newness of America, but it is not a ruin. It is merely not new. Ruins, then, rely on the new to define them. Without the new, how can ruins be?

Turns out ruins are dependent and insecure, less formidable than our reverence warrants. They are more temporal, in fact, than they let on, with their sphinxlike inscrutability. They occupy a place not so much in space as in time.

We love the ruin, at least respect it. We invite mystery into those Italian men hunched on the bench in the Norman Carver photos, into the crumbling stone walls of a ruined Postignano behind them, into a pharaoh's countenance, too, which, Shelley claims, "its sculptor well those passions read."

But such mystery is easy to freight in hindsight. How quickly we tend to revel, to muse and wonder. It's what the ruin does to us, why we like it. The schism that appears between its hoary facade—blocks of marble riddled with fissures, grooved and discolored—and the poppies jutting from its flanks, maybe a modern convenience in the background (a gas station, it could be), reminds us of the inevitable, indomitable, yet quotidian nature of the passage of years, centuries, millennia.

Why, then, is that reminder pleasant? Is it? Or are we tricked by the ruin, duped, believing we honor it when, in fact, we're forced to witness, to come to terms with, the ultimate ruin of everything, including us?

✈

During the first year of our conference in Postignano, a classical guitarist played in the church as part of the *borgo's* summer concert series. Odd instruments, anachronistic but accurate: baroque Spanish guitars and a fabulously extravagant, long-necked *tiorba*, which the musician pulled out after a few songs.

"That thing is so beautiful," a colleague whispered to me, "he doesn't even have to *play* it."

And yet he did, the sound of which still haunts me. Lute-like but with a much greater range (its neck, like a guitar's, terminating halfway, with a bass neck extending beyond), the *tiorba*, or theorbo, managed a sound both antique and strangely contemporary. I swear I heard the ghost of the banjo in—what *was* it?—the tenseness of the strings, the slightly metallic overtones.

Once he started playing, that familiar sound filled the tiny deconsecrated church, where we all sat on transparent plastic chairs, few of us—perhaps none of us—equipped to appreciate either the historicity of the instruments or the accuracy of the performance. I looked around

the room at the retiree writers and theater professors from Alabama, the poets and yoga enthusiasts, and almost to a person they sat completely still, in awe of the thing and of the musician playing it.

They, *we*, were listening not so much to music but to history. We heard the distance of four hundred years.

Though various performers come to our hamlet each summer, nobody has managed that startling, transfixingly odd blend of the old and new. No other music has transported us through time. But that's not exactly fair. Maybe we're only given that one opportunity. Maybe we're now expecting the rush of the past whizzing by us, the sound of it in our ears, the look of it in the graceful hands of the guitarist with his mop of black hair and understated, tightly fitting, dark suit. And because we're expecting it, it does not come. Or it comes and we are too ignorant, too blind, or just too close to see it.

Ruins seldom strike us more than once. We are either moved (almost transported through time) or we are not. They have just one chance.

That's not quite right either. It is *we* who have just one chance.

✈

I come from the new. I was born in it. An impossible new, pushed—squeezed, really—into the brightly lit corner of the Golden State, Southern California, Upland, San Antonio Heights. Every time I say those words, I think of the blinding aisles of chain stores birthing into the world, glass cathedrals of empire rising like monoliths out of the desert, cars in various shades of lovely, sparkling metal. As a kid, I thought I lived in the center of the universe, a place—an attitude, finally—everyone envied, and I called it home.

And then there's the other Southern California, the one I grew to distrust, even at times despise, with its endless snakes of strip malls and excess, the eruption of traffic along arteries feeding the Los Angeles basin. If California were a color—at least during the years I wanted badly out—it would be dirty neon, worn yet falsely cheery, something invented in a laboratory with harsh chemicals, then promptly improved upon and shelved.

Yet my rejection of this gleam is its own cliché. I quickly find myself

in a hall of mirrors in which the real recedes behind infinite regressions of copies, fabrications, *ideas* of California rather than California itself. All I need to do is simply concentrate on the feel of my feet on the dew-wet concrete of our swimming pool's perimeter, salt stains like storm demarcations welling out on a weather map, and breathe in the oleander. If I do, I am transported back to my childhood, staring toward the mountains behind my house—the San Gabriels, they're called, the tallest of which, Mount Baldy (its folksy name out of place in a place so furiously unfolksy), rising over ten thousand feet. My father boasted of having climbed it multiple times, and I, upon climbing it myself at the age of ten, felt somehow inducted, part of the very pine-covered slopes stretched below the eerie barrenness of its summit. That, at least, still feels real.

Odd how Baldy continues to inform most any mountain experience for me, especially since I could not even see its summit from my backyard. We pay so little attention to *how* we pay attention, sometimes *what* we pay attention to. We fail to see that which is closest to us, that which we call home. I had to travel some distance south (ten miles or so) before Baldy rose behind the front peaks—Cucamonga, Ontario, a few others—to reassert its dominion. And I had to travel twenty-five years, to this moment, to write about that peculiar distance: seeing home clearly by moving away.

It was not Mount Baldy, anyway, that I remember beholding in my childhood, my right hand level over my eyes. It was not the mansions painted unreal white, dotting the hills, their tall windows dazzling the light. Not the light itself either: synthetic, crayon-colored light, which darkened to crimson on the frayed edges of clouds. But the scent of oleander, musk-like, almost human, mixed with smoke, always smoke: the sickening smell of damage and destruction. Wildfires: they erupted each year, frighteningly regular yet capricious and improvisational, flaring up in a tight canyon or carpeting the entire front side of our range. It didn't matter the size. Half the time I couldn't see anything but smoke, sometimes not even that, the burn mixing with air until I wheezed.

Yet to a kid, scanning the hills with his father—who uncoiled the garden hose, had me hoist it up to him on the roof to soak the shingles

(ash and embers, like locusts, descended on our yard, dusted the pool)—
the fires terrified. To this day, the smell of them nauseates me, as much
from whiplash as from fear, for I am suddenly a child again.

<center>✈</center>

What is it precisely that Shelley's speaker sees in the desert, reads in the
inscription on the base of the toppled colossus of Ozymandias: "Look
on my Works, ye Mighty, and despair"? And when exactly did that
commanding threat—the tyrant's power on display, once ludicrously
imposing—turn to its opposite, a warning that everything mighty will
(and must) dwindle and fade? Which does Postignano represent? Which
did Norman Carver intend in his eerie photos, almost specimens them-
selves? And why are we continually drawn back into the fires?

Two summers ago, the air at Postignano grew cumbersome and
weighty, dry as flint. Unaccustomed to heat waves, the entire village
(the valley itself) had no defenses. The usually green mountainsides
withered, yellowing like old photographs at the edges. We sweated in
the big communal rooms, closed the shutters for morning lectures, hid
with chilled white wine in shadows almost burned into the stone. As
hosts, we felt responsible for the weather. Absurd, yes, but my codirec-
tor and I became acutely aware of how insulated Americans often are,
habituated to our own infinite present tense: the same temperature no
matter the time of day or even year, cars and homes heated and cooled
to our whims, air-conditioned offices and dreams. In Italy, the elements
intrude more often, become antagonists in the dramas we set in motion.

One afternoon, I'd had enough and drove to a local appliance store,
bought ten huge fans on wobbly, plastic bases. Returning to the ham-
let, proud of my spoils, I saw Michele and his wife, Maria, unloading a
carload of fans themselves, each of us desperately outdoing the other
in the complicated arena of playing host: they to us, we to our confer-
ence attendees.

Some fires, we know, renew. They tell a different story. Take Postignano.
Partially destroyed by a massive mudslide in the 1960s, then subse-
quently abandoned, the hamlet was going about its business of quietly
allowing the mountains to scar over it. Even today, there are no year-

round residents, the last citizens having long ago moved into drabber, more pragmatic housing far below the hamlet, almost out of view. No actual residents, no, but at least three exhibition spaces, one of which features the Norman Carver photos, attesting to the state of things after the very earth gave way.

Two years ago, I spent a quiet hour peering into them: gravelly, hay-strewn alleys where we now walk on artfully distressed stone; old men in dirty clothes stooped over a bench where a riot of geraniums now sprouts from an antique planter. In another, some sort of religious procession under way, men in white robes carrying lanterns, staffs, and a linen-draped crucifix out of the one church in town, the silhouette of a chicken in the fore.

I felt strange examining them, one after another. Right outside, our conference attendees were enjoying their own rituals: cold prosecco and Campari, talk of frescoes and sonnets, laughter on the terrace. Each year we mill about in a fully intact medieval hamlet, painstakingly restored in the 1990s by two architects who bought the entire village, purchased a complete history, which, even in Italy—a country of ruins and rubble, of entire civilizations submerged and buried (Etruscan, Oscan, Umbrian, Samnite)—even then, seems odd, even slightly illegal, as if the two men were altering a history beyond recognition, distorting and doctoring it. The photos attest.

And then what is *not* present in those photos: the elegant stone footbridge now connecting the Campello apartment (my personal favorite) to the tiny square in front of the church, indoor plumbing and ambient heating, internet cables, even a swimming pool, glimpses of which we catch through slits between the towering structures and which we may access (along with the sauna and massage room) by means of myriad stone staircases chiseled into the hamlet's walls or by an elevator built into the bowels of the hill.

Luana laments these modern touches as well as the few pastel stucco facades (originally all raw and local stone, humble and indigenous). We don't mind. We can handle the flair, the modern conveniences, the sprucing up. True, Postignano is not quite Italy, if what we desire from Italy is still snagged, unfairly perhaps, in a near invisible web of roman-

ticism, in our yearning for more and more artful ruins. No, Postignano just somehow seems truthful about its machinery, shows its hand—the dealing of the new in the cloak of the old.

That scorching night two summers ago, after we lugged up the merchandise—Michele and Maria with theirs, I with mine—all twenty of those fans made their way into various apartments, delivered almost like Christmas gifts to the participants and staff. That night—the hottest I had experienced in Italy, at least in dark and moody Umbria—we fell asleep, all of us, to the calmingly mechanized, whirring spiritus of the modern era.

The breath of God comes in many diameters, and it oscillates.

✈

The mountains of Umbria are mostly carpeted in thick vegetation, with only their bulbous summits breaking through. I wouldn't call them craggy or forbidding. Though the high plain near Postignano harbors a nearly lunar stillness, it strikes me as more unsettling than frightening, more alien than sublime. And the relentless cultivation of olives and grapes means the lower hills are often quilted, patterned in gray-green and emerald. Indeed the fact that we find the natural environment of Umbria pleasant and picturesque suggests something about our complicated relationship with nature itself, that we like it most when it's shaped and sculpted by our own work and for the purposes of sustaining us. "Look on my Works, ye Mighty."

The mountains of my childhood, on the other hand, were towering and ominous. People died each year in skiing accidents, avalanches, or they simply got lost a few miles from my house and froze. Yet Umbria, at least since I've known it and however imperfect the reasoning, reminds me of my home in California: the sloped terrain, the rocky soil, the rich loamy scent under the cover of the holly oaks. No wonder Italian immigrants settled in California for serious wine and olive production: the similarities at times seem uncanny.

All that beauty, though, has a catch. One must live in constant fear of the very earth liquefying underneath. Norcia, some ten miles from Postignano, was ruined by the 2016 Umbria quake. Even Spoleto,

twenty miles away, incurred serious structural damage. I remember writing to my friends in Postignano, asking if they were okay.

"We live in a fortress," Michele said, which is, in a way, true. The only casualties: two bottles of wine.

Once, after a particularly frightening quake in the middle of the night, I ran to my parents' bedroom. I must have been a young teenager by then. Outside their patio door—open, letting the cool night enter— I could see the pool and, in it, large waves rushing from one end to the other, as if manufactured. Once, during band practice in a friend's garage, I lost hold of my side of a guitar amp. It dropped no more than a few inches but seemed to rattle the thin, metal garage doors rolled above our heads. When the rattling didn't stop, and in fact grew deafening, I noticed the street outside rolling itself—there's no other way to say it—the asphalt undulating. Or the big Northridge quake that collapsed entire sections of highway: even in my room sixty miles away, early morning, my bed shook into the center, with me, petrified, sitting up but frozen in panic.

Earthquake, as a word, is not as accurate as I'd like. Before I felt one, I imagined them as agitations. The term promised that. I thought of the earth shaking underneath me, like the electrified fields of magnetic children's games. Quaking is just shaking, herky-jerky. But earthquakes do not quake or shake, at least not the ones I have known. They slide, back and forth, sometimes in haunting slowness, sometimes, as in a drunken dance, violently favoring one side: one step to the right, two quick steps to the left. The terror of an earthquake begins with the sense of suddenly being adrift on water, pitched back and forth, not knowing how long the waves will last, if the entire craft will finally tear apart, if the sea will suddenly split and swallow you whole.

✈

"Imagine the cost of the most expensive renovation project possible," Matteo said to me the first year in Postignano, "and then double it."

He and his partner, Gennaro, spent a great deal of their lives and wealth coaxing the hamlet back from the past, a project that has consumed them both for the last twenty-five years. Part investment, for

sure—though the game is quite long, with substantive operating costs on top of ongoing renovations—still it's difficult to imagine anything other than obsession and love driving the enormity of their restoration. Each year we return, in fact, some novelties: a few summers ago, an enclosed patio area off the entrance to the restaurant; the previous year, a stunningly terraced rose garden with an elegant tent structure overhead, chaise longues scattered about. New apartments open up, too, and become available for us to rent, masterfully appointed spaces with that curious mix of antique and new—plexiglass-enclosed shower stalls, original wooden beams exposed above—each dwelling named for a nearby town: Gubbio, Montefalco, Bevagna.

I cringed a few years ago as I showed some folks into the Norcia apartment, knowing, at that very moment, that crews were busy finishing what the 2016 earthquake had started: the complete demolition of Saint Benedict's Basilica in the central piazza of the town, piles of fourteenth-century stones behind bright orange construction fence. When we talk now of Saint Benedict's Basilica in Norcia, we must relegate it to the past. Whatever rises from those ruins may be a basilica. It will not be *that* basilica.

All the tiny touches in Postignano, too, the nearly invisible improvements, the subtle ways in which the new invades the old, subsumes it. How long, really, before every single surface in the hamlet—every stone landing and desiccated beam, each artfully rusted hinge and door handle—how long before it's all wiped clean of its ruinous past? Will it be the same hamlet? Will we—can we—even use the word *past*, a word that unfairly transports us, if just lexically, in time? Will we have traveled backward or, strangely, not traveled at all? Will we remain the same while all around us the hamlet converts, assimilates, to the now? "Look on my Works."

Then again, Postignano does merit looking. In that deconsecrated church, for instance, during the early renovation processes in 1997, as Matteo and Gennaro sent in crews to clean the walls, they found sixteenth-century frescoes: Saint Lawrence, for whom the church was later named, burned alive on a gridiron. Local work, attributed to a circle of painters from the Marche region to the east. Later that year,

Frescoes in the Church of Saint Lawrence, Postignano.
Photo courtesy Gaetano "Nino" Di Bonito.

an earthquake caused part of the interior wall of the apse to cave in, revealing even older frescoes, this time from the fifteenth century: a Crucifixion scene with Mary and John, the Archangel Michael to the side.

"Incredible," Maggie said, shaking her head, the first time we entered the church and Michele spoke of that odd occurrence. "The place has backup frescoes."

Layers behind layers. Maybe Matteo and Gennaro are just adding more, contributing to the history. But is that accurate? Are they adding to or somehow preserving, as in amber, this moment of contact, early in the twenty-first century? Difficult to separate restoration from preservation from the very act of creation: the cleaning of the frescoes to the discovery of the older ones to the odd double vision I experience walking into that church now, seeing both periods simultaneously, along with the memories of that Spanish guitar concert. In Postignano, most any meditation is difficult, complicated. The briars and foxtails of the past just adhere, no matter how much you swat them from your pant legs.

And all the while, in a back room, off the right side of the apse, under the jigsawed glare of saints from various centuries, preserved in stacked trays like those I've seen in industrial bakeries, a thousand fragments of the previous wall's frescoes—bits of Christ and the cross, elaborate dress and the grimace of a martyr's face—lie in wait. We drink bottles and bottles of wine—the entire crew of us, usually around thirty people—deep into the night. We hardly even think of those fragments at all.

<div align="center">✈</div>

"Two vast and trunkless legs of stone": our first glimpse of the gargantuan statue in Shelley's poem. Even that description, however, is hearsay twice removed, for it's not Shelley as poet or even his narrator who relays the sight directly. Rather, the narrator recounts how he himself "met a traveler from an antique land" and how this *other* speaker, this mysterious anachronism, recounts his own confrontation with the ruin. Something about Shelley's use of *antique* there too—not *distant* but *antique* —as if the traveler and the land he came from were somehow as hoary, as encrusted with history, every bit as ruined and of the past as the monumental fragments.

Easy, I know, to imbue Italy with fictitious authenticity, to load it with our desire for some mossy nostalgia (whatever we imagine as better than our present), to museumize it, drape red cords and tack up signage. More problematic still to load all that desire, that mixed bag of absences and my own faults, onto the people still living in Italy, some near Postignano even: Michele and Maria, Gennaro and Matteo too, but—much more so—Amarisa, whom I barely see each summer, even if her work is notable. When I return from lunch, from whichever lecture we've held in the morning, my apartment is remade, towels folded back on their racks, any flotsam I've left in a rush neatly placed on the drawers. Amarisa's family, I have learned, lived in Postignano before the mudslide of the 1960s dispersed them, a mini diaspora in the mountains of the Nera Valley.

How authentic, I can hear myself say (and I wince): *the housekeeper is actually from this village's past,* as if she shepherded goats down from the hills instead of driving a Fiat here every day for this, for us.

"Guardalo!" Maria said to me, as I was turning pages in the Norman Carver book the first or second year. She landed her finger on a fetchingly dressed boy of about twelve, hands in pockets, white turtleneck, in the middle of a dour group of men in plain black suits, under the arch leading to the chapel.

"Guardalo!" (Look!) "È il fratello di Amarisa." (That's Amarisa's brother.)

And how easily I can find in Amarisa's smile now, when I spot her, that same impish grin as well as my own yearned-for continuity with the past. And yet a past bereft, in some ways, of the very continuity I crave. Just like Shelley's narrator, I am always at a distance from Postignano, even—perhaps especially—when I am in the *borgo*, among its incessant present tense, its immaculate, hotel-like orderliness and logic, its dolled-up rustic charms. Amarisa, though, must still find glimpses of that fracture in time, that other Postignano, her village, the one nearly destroyed and—by sheer luck and happenstance—revived. Yet revived as more of an installation, exhibited, on show, the pretty little hamlet everyone is talking about. "Look on my Works, ye Mighty."

How easy it is to believe in fate, that Postignano—how do I say— *warranted* its own resurrection, that it *deserved* it. What about that toppled colossus? And why has the traveler from an antique land carried his burden forward, passed it on to the narrator, to the poet Shelley—himself a ruin, whose own remains lie in a Roman grave east of the Tiber, near the magisterial shell of the Baths of Caracalla?

It does make for a decent poem, however, that gnawing mystery, that meditation on the ruin (given time) of everything. And I suppose time is what many of us are after, as we sift through the rubble of Italy, supplying our own meanings to the bits and pieces of overthrown empires and wealthy city-states, ravaged republics, even the countless shards of colored gesso, placed in felt-lined trays in that Postignano church. The ruins give form to time but also disrupt it. We are suddenly *out* of time, antique ourselves.

Plus, that poem, the cryptic paean to the likeness of a tyrannical king: Shelley wrote it to commemorate the actual ruins of a statue to Ramses II, found in Egypt the previous year. The ruins are real, even if Shelley's treatment of them plays with fact.

And Amarisa's brother?

"Ma scherzi?" Maria questioned me (Are you kidding?), when I asked if he was still alive.

"Of course he is. He's our mechanic. He fixes *everything*."

✈

One summer, we chartered a bus and took everyone in our group at Postignano to the high plain near Castelluccio—the remnants of a prehistoric alpine lake, now a vast, treeless basin. Not forty miles from Postignano, but the road twisted and turned, switchbacking up the Sibillini Mountains. By the time we arrived in the thin, cloudless air of Castelluccio, it was all folks could do to keep from vomiting. We spent an hour or so, dazed and pacing, and tried to regroup.

That fall, the earthquake centered near Norcia took at least a quarter of the entire village of Castelluccio, reducing it to those ubiquitous piles of cement and stone we see on the news, streets with gaping fissures in them. The next year, the road to the high plain remained closed. Now, though crews have cleared the road, welcoming back the day-trippers and hikers, I fear what I'll see. In *The Aeneid*, the Sybil leads Aeneas into the underworld, shows him the way down. Not much has changed, I suppose. Portals remain or are created from time to time. The road is open again.

And yet everything *has* changed. Castelluccio—*cute little castle,* that curious use of the diminutive adding to the fairy-tale quality of the entire place—is a wreck, a ruin. I know. I've seen the photos, heard the stories. Luana—never a lover of the modern touches in Spoleto, in Postignano, in any place in Italy—hopes Castelluccio rises again but with a distinctly historical flair. Sad, she said, the destruction.

"But maybe"—she shook her head slowly, squinting a bit as if peering into the future—"maybe they take the opportunity to make smart choices in construction, rebuild it out of stone."

Maybe, in other words, they make it newly old, presently historic, an original copy, out of time.

✈

"What's the significance of the name Postignano?" I remember asking Matteo that first year. We were in one of the exhibit rooms, appraising some nails from the town's medieval construction period, found during their ongoing restoration. Roughly fabricated and oversized, they were coal black with bent tips and tortoiseshell heads. Matteo smiled. As with many of these sorts of etymological questions in Italy, theories vary, most remaining provisional and contested. Some names stay half in the shade the very name Umbria retains and to which a few English words stubbornly cling: *umbrella, umbrage, adumbrate.*

"My theory," Matteo continued, "is that some sort of village or castle existed here before this one and that it burned down, was destroyed, and that the name *Postignano*"—he smiled and tapped me lightly on the chest with a pointed finger—"is a corruption of the Latin *post ignum.*"

Post ignum. In Italian, "dopo l'incendio." In English, "after the fire."

Rome / The Maintenance of Ghosts

In the Villa Farnesina, across the Tiber in Rome, Gwen and I admire the gold-capitaled columns of the so-called Room of Perspectives, lavishly frescoed, high-ceilinged, all Renaissance and ruse. The trompe l'oeil walls resemble those of some ostentatious loggia: an immense, covered balcony offering views onto a tumble of tiled roofs and Romanesque belfries, the gray-blue hills of imagined countryside beyond, all of it just visible around the massive, marble (or, rather, painted to look massive and marble) columns. Just across the Tiber, mind you, in Rome's historic center, constantly inhabited for nearly three thousand years. Already by the sixteenth century—when Agostino Chigi commissioned this room and its wonders—those uniformly pleasant terra-cotta rooftops and pastoral landscape, all of it painted on the walls of the second-floor Room of Perspectives, in the Villa Farnesina: just a dream, pure nostalgia.

The room might even improve on what it imitates, nostalgia sculpting out of the real a better, more harmonious version of the real. Chigi and his painter, Baldassare Peruzzi, possessed the power not only to claim imaginatively the land around them but also to render it more beautiful than those crowded streets of Trastevere surely were nearly five hundred years ago. In most ways, this particular privilege—surrounding oneself with beauty—is the same just about anywhere. No

different, say, than in the papal apartments in Castel Sant'Angelo: richly colored frescoes, odd and at times disturbing grotesques adorning the spandrels, the detail and pomp, the overwhelmingness of it all.

On the other hand, Peruzzi's Room of Perspectives seems radically different. Here the painter transforms the land around the villa, renders it imaginary and idealized, a place not of this place. Easy enough for someone of Chigi's stature—a Sienese banker of fabulous wealth—to possess a country villa with precisely that kind of loggia, affording views of an ideal (but real) landscape somewhere in majestic, central Tuscany. Something else entirely to move the country villa to the city. Or better yet, to transform the city into a country villa.

✈

Before I was born, my father built a ghost. Nothing more than a bedsheet with electrical tape eyes, a plunger as its base, an overturned plastic bowl for its head. Rigged to a garage door spring, the ghost would pop up from its black coffin (which he also made) when trick-or-treaters tripped the light sensor on their way to our front door. My father loved his ghost, loved the scare it consistently gave the neighborhood kids. Mostly, I think, he loved the working mechanisms, the surprise a well-made thing delivers, with maybe just a hint of sadism.

I, however, loved the soundtrack. From some dated Disney haunted-house vinyl compilation, my father looped a diabolical scream to play out of an old speaker. What I remember most was not the way the scream turned from a distinctly female, high-pitched screech all the way down to an Orson Welles–inspired baritone rattle. (One small segment reminded me of my uncle's laugh: a rapid-fire, guttural chortle.) Instead, I remember the fact that his recording retained a striking imperfection. It skipped, just a few times, but those skips, those jumps of the needle on a vinyl disc, remained on his tape loop. The anticipation for me, even as a kid, involved waiting for those scars. It made the whole thing spookier. The haunting was the foreknowledge, the spark of recognition. I heard what I wanted to hear.

Though the record itself is long gone, my sister and I much later got

on a kick to find the original recording and did, rummaging free files on the internet. Yet when I heard the entire track again, uncut, unblemished, it simply didn't sound right. Without the inexplicable joy at that sudden jag of the needle, the recording sounded flat, computerlike, inhuman. There was no mess, no snag, no spirit, no ghost.

Plenty of ghosts in Rome, no doubt, if ghosts are what we call these impressions and anticipations, these tiny imperfections, snags in the system. Seems to me we see them only when we want to. Renting a tiny apartment for this week in Rome, in Largo dei Librari—a tiny piazza near Campo de' Fiori—I remember one ghost in particular. Twenty-five years ago, the woman who would become my wife traveled to Italy for the first of many times to meet me, and we walked this street outside. We entered a bar for a predinner Campari. Not knowing Rome well, I asked the bartender for a restaurant recommendation. No big internet presence yet, which meant no Yelp, no overly excited food bloggers. He gave us a tip, was happy to, and we followed the suggestion, enjoying a fantastic meal with an Australian couple we had just met, whose names, too, I still remember: Philippa and Kane.

The restaurant, however, is gone. Rather, I can't find it anymore, can't even remember the name. (The bartender, when giving me directions to the place, simply gestured in a direction, gave me a few rights and lefts to follow, told me to enter and ask for Mario.) Every time I walk this street, I think of that meal—darkly flavored Pugliese food from the heel of the boot: anchovy-rich orecchiette, "little ears," and exquisitely bitter greens (chicory, maybe, or broccoli rabe tops). I remember the taste of the pasta—the crunch of bread crumbs thrown on top (a poor man's cheese)—but not the name of the restaurant, where it was, where it might still remain. I could walk past it today and not even know.

Late at night, Gwen and I hear but do not see a gaggle of teenagers. They amass outside a frozen yogurt shop, which doubles as a cheap bar right beneath our apartment. They spill out into the piazza singing in unison and drunkenness. Awakened by them, I can scarcely distinguish their churlishness from that of the ubiquitous gulls.

✈

Today, in the National Etruscan Museum in the Villa Giulia, which we found by accident, we come across a tiny figurine of the Haruspex, a religious diviner in Etruscan culture. *Haruspicy:* the act of divination by reading entrails, a vaunted skill among the Etruscans and one lauded by the Romans too. The history itself fascinates, as does the language describing it. I learn also of *extispicy,* the Latin translation of *haruspicy* (of Greek origin), and, my personal favorite, *hepatoscopy,* which specifies the particular innard under inspection (in this case, the liver). Innards, under, hidden, obscure, but also waiting to be brought to light, by blade, garage door spring, or word. My dictionary tells me that *hepatoscopy* is both "uncountable" and "rare."

But the Etruscan figurine himself unsettles even more than the grisly business he signifies. Standing about one foot tall, this iteration wears a characteristically pointed hat (I learn all this from the placard) and holds a small vase of some sort, probably used in his religious rites. Expressive, almost mischievous, his face belies the seriousness of his profession and the gravitas the culture grants him. He looks more like a horror figure, a sadist with a grudge, someone who has learned not to depersonalize the act of cutting out the viscera but, rather, to enjoy it.

More than the haunting gaze of the person with the knife and the mandate to use it, however, is his gaunt body, attenuated, Giacomettian. He captivates primarily out of difference: he simply doesn't look like the other more anatomically correct votives, even those in the same museum, in the same glass case. But what accounts for that difference, that freakish height and thinness? Does the representation correlate to some inherent trait in his manner, tied to the bloody business of sorting out entrails to see into the future? Why else render these grotesque characters in such a wildly expressive and figurative manner? Did the artists fear capturing the ghoulish men's likeness too realistically?

The cultural importance of these diviners might well have demanded such manipulation, granting them power through uncanny, unreal bodies. The profession may have even called for a brand of artistic asceticism, represented here by fabulous thinness. But did fear or reverence drive the artists to sculpt in this particular fashion? And what's the difference between fear and reverence, anyway?

Gwen loves ghosts. She's a sucker for the scary movie, true tales of haunted houses, mirrors with hands, the spooky stuff. She loves cryptids too: Bigfoot, the Loch Ness Monster, and all the local variations. She keeps somewhat abreast of the latest Skunk Ape half-science and giant squid sightings, and I have to admit: I find it all endearing, if maybe quaint (or *because* it's quaint), and my doing so just eggs her on. I joke that the lapsed Catholic in her still craves some sense of slippage between this world and the next. Take God out of the mix, and sometimes the void that remains becomes its own dynamic body, its own dark matter, rarity, or ghost. All that Sunday school has to amount to something.

Or maybe we all possess, if not the most exquisitely attuned senses, arguably the most anxiety-producing ones. Coming out of the jungle canopy must have demanded an overdeveloped sensitivity to the stray branch breaking or thrash of leaves on ground. (What was that sound? a snake, a hungry cat?) I remember a few nights camping on Cumberland Island, off the coast of Georgia. No big predators to worry about, no bears or wildcats or anything. Still, each night the constant rustling of the papery saw palmetto leaves persisted, soft but unnerving. What caused the ghostly commotion? armadillos, lots of them, harmless, just rummaging around in a cluttered campsite. Each little rustle, however, meant I never slept.

If most of us do not much worry about actual threats in the night anymore, we still possess that innate edginess, that jerk of the head toward the slightest sound. Maybe, just maybe, all of Gwen's ghosts are simply that: vestiges of those potential dangers and their audible manifestations, almost conjured from the invisible realm. You can take the threat away, but the body still seeks its telltale signs. Stare hard enough at a bath towel draped over a shower door in the near dark, and it too trembles. The more we try to look away, the more our brains fill in the gaps. The more we look, the more we see.

Heartaches, too, are ghosts of sorts. Our dead cat Starsky, if only momentarily, returns at night, manifest in every pile of clothes on the floor of our room in half-light.

Some of us train to keep the body in shape. Some of us train to see ghosts. Some of us have no choice.

✈

Geography is memory. I know Rome not as an obsessed lover but as a sober spouse. I don't simply tolerate its shortcomings; I don't ignore its wonders. I adore its failures, marvel at its everydayness, its ho-hum, its black warped cobbles and the light spilling on them late in the afternoon. "There are no paradises," wrote Borges, "other than lost paradises." But then, what about Rome, lost and rediscovered, reimagined continually? Rome is the only city preserved in a verb, *to roam*, which once literally meant the act of pilgrimage to this glorious metropolis. And for me, here, watching it all, that slow, limitless descent into history: I am the closest to paradise I can come.

Paradises, too, possess their own geographies, origins we have mostly forgotten. From the Avestan *pairi* (around) and *diz* (to build a wall), *paradise*, then—first and foremost, in its deepest etymological valence—concerns keeping certain people in and others out.

I am also always an outcast in Italy, especially in Rome. I walk this morning to a pastry shop off the Campo. (I know Rome the way a hiker knows the trail to a favorite peak.) Around me rises massive, almost incomprehensible grandeur, about which I know very little. (Rome, like so many canyons of the American West, seems nearly geological in time.) I remember my path down to the periphery, the marginalia, the easily overlooked: the cheap clothing shop with its white linen dresses rounding the entrance, 5 *euro* pasted on every last one of them, the blast of cold air and not completely incongruous scent of waffle cones and Vespa fumes by the gelato shop, a strangely—because sharply— dressed beggar with a few coins in an overturned hat.

"Vi prego," says the handwritten card. I beg you.

Overturned and unnoticed, stray coins and handwritten messages. Mostly, Rome remains ignorant, overlooks us both.

With my gaudy running cap, however, and groggy from sleep, I am not so easily overlooked this morning. Italian men, in their characteristically quilted jackets and hands locked behind their backs as if in

renunciation, stare briefly at the uncouth guy in the uncouth gear. (*Un-couth:* "unknown, rare, not usually done.") Women decked out in scarves and disdain give me the once-over. Though I speak the language, navigate the culture well, in Italy I always feel outside, semi-indecent, like a ghost, not wholly invisible but almost. Invisible save for the annoyance I cause with my near invisibility. I am of this world and not.

And yet Rome, all of Italy, really, is a ghost *in me*. Walking today, I return to every Italian city I have ever known. Vestiges of Bologna, city of my first encounters with Italy, brought back to me with the particular smell here on these Roman streets: hint of cigarette smoke, fetid vegetable remains in the open-air market, diesel fumes, freshly baked bread. Or the dark, ponderous stones and constricted alleys in this district of cloth cutters and key makers: it could all be Perugia, where Gwen and I spent a year in an apartment on Via del Balcone (with no balcony). Or Spoleto, where I stay each summer now, with its sunny thoroughfares and the clipped charisma of its dialect like many others of the South, the lopping off of word endings, another sort of violence. I hear it here, am transported there, one city as ghost of another, layered, superimposed.

✈

Last summer, I asked my father why he had built the ghost in the first place. We were in Colorado on vacation, on the shores of Lake Purgatory. Squirrels chattered in the pines. Late sixties, he thinks, when he built the thing, the original version popping from a simple toy chest. (The coffin, he informs me, was a later embellishment.) And the soundtrack? Back then, an actual record player inside, whose needle would drop when trick-or-treaters tripped his homemade sensor. All at another house too—one I have no memory of.

"But why?" I asked again. "Why build it in the first place? What *possessed* you?"

He stared out on the lake, shifting back and forth on the rickety camp chair, his elbows planted on his knees. The squirrels yammered on about something, maybe a hawk patrolling the shore.

"I don't remember," he finally said.

And that's the word he used, the one I probably would have too. *Remember.* And I think now of the subtle violence implied in the act of forgetting, a violence visited not on the event but maybe on ourselves, at least in the odd logic of our language. Because if remembering (metaphorically but maybe even physically) sutures the frayed ends of synapses, *re*-members them, relinks us to our pasts, then forgetting means also, by analogy, a severing, a *dis*-membering. And suddenly that ghost is less than a harmless bit of fun.

The squirrels proved prudent. I never saw the hawk but heard its death rasp overhead: that freakish, high-pitched grate, like nails on a chalkboard.

✈

Ghost derives from *gast*: "breath," "good or bad spirit," "angel," "demon." Lots of linguistic branches, roots far deeper than just Old English, means we have been wrestling with these strange creatures a long time, creatures that keep appearing (as in the synonym *apparition*), keep returning (like a *revenant*). And all the ways we've attached ghosts to other matters: a ghostwritten book, a ghost in the machine, giving up the ghost. Musicians often speak of ghost notes: those with rhythmic value (they occupy space, are, in a sense, played) but no discernible volume. The musician executes the note, but no one really hears it.

Or my father's whimsical ghost, which he recently updated. Though he rarely carts it out at Halloween anymore (not many trick-or-treaters, plenty of other things to be afraid of), he spent a few weeks on a mechanism that would auto-load the specter once his duties ended. (We had to attend to the guy each time when I was young, collapse the spring lock, fold him down, secure the latch.) His soundtrack, unskipping and pristine, is now of course digitally delivered, and the inside of the coffin seemed much barer when my father cracked it open during my last visit, presented all his work. The odor inside—stale bedsheets mixed with lacquer and sawdust—haunted me for days.

Or ghost town. I say that and am transported to some tumbleweed-strewn, stagecoach stop west of Santa Fe. Hangman's noose and saloon doors. Or it could be here in Rome, another magnitude of ghost town.

I have no way of knowing for sure, but I bet Rome houses more dead than just about any other city on the globe: the myriad burials in the warped marble floors of darkened churches; a Capuchin crypt just off the fashionable Via Veneto (where Fellini set scenes of *La Dolce Vita*) made entirely of human bone, chandeliers constructed from pelvises, an elaborate sunburst clock on the wall just a series of femurs and tibias, a sign at the end (it *had* to be at the end) that says simply: "WHAT YOU ARE, *WE WERE*. WHAT WE ARE, YOU *WILL BE*."

Keats died in a small, rented room just a ten-minute walk from here. Emperors, too, martyrs and partisans, movie stars and soccer pros, the unacknowledged hordes stacked like cordwood in Christian catacombs down the Appian Way.

Bernini's creepily sculpted tomb of Pope Alexander VII in Saint Peter's, for example, features a winged skeleton holding an hourglass, his face half-concealed by what appears heavy drapery but which is actually marble, which renders even more impressive the skeleton's attempt to shake it off. Try as he might, though, the marble and stone of this city prove almost immovable. Almost.

✈

Athens, fifth century BCE, and Zeuxis challenges his rival Parrhasius to a painting competition, both of them known for tricky trompe l'oeil renderings long before such a term existed. Zeuxis offers a still life of grapes so realistic that birds descend and attempt to peck at them. Pretty impressive, he thinks. When Zeuxis, however, attempts to reveal Parrhasius's work, which rests behind a curtain—at this point smug with the thought of having bested the upstart—when he tries to grasp the curtain, he touches paint instead. The curtain draped over what appears to be the painting *is* the painting. Zeuxis loses.

"I have deceived the birds," the vanquished master declares, "but Parrhasius has deceived *me*."

✈

Something's different this time in Rome. Maybe this unusually calm week to start my chaotic summer in Spoleto with the university pro-

gram, maybe it fools me into ease. Or maybe it's that tenseness Gwen and I feel in the major piazzas, like a held breath before diving into water. After multiple terrorist attacks in Belgium, in France, in Florida, violence and its threat seem more a part of the weather, predictable as storm fronts. Soft targets abound. Carabinieri mill about with assault rifles clipped to their chests, their fingers on thick triggers.

Or maybe it's the bread here, the pleasantly charred but still pliable crust giving way to that spongy core, or the memories of having been here many times before, in this touristy joint tucked between some Roman columns in the Jewish ghetto, all the times we sat here, Gwen and I, ate here, all those evenings now stacked like pages wet with ink, bleeding through, merging, returning again and again: maybe it all seems different because it's *not*. Something's not right, and maybe what's not right is all the rightness, the calm, the absolute sense of feeling at home. This place does not change. We are older, yes, but Rome is not. It measures time in eras. We measure time, unfortunately, all too well. That's the difference.

Or maybe it's that, this time, Gwen has come at the beginning of the Spoleto program, which, every year, stretches farther, like an evening shadow, into summer. Typically, she arrives near the end, before we take a week by ourselves in Sardinia, in Bologna, or in Puglia two years past. Lovely, yes, those midsummer weeks to ourselves but hot, even sweltering. She wilts under it all.

This year, to beat the heat, she flew over with me for this antici-patory week but will leave soon after the Spoleto program starts. We will be apart about the same amount of time (just over a month), but I worry that the distance will feel elongated, tampered with, doctored. If before the chaos of the university students in Spoleto kept my mind occupied and I could look forward to her arrival, now we will say good-bye before the swirl of classes and buses and group meals. If before I weathered it on my own, I at least had the comedic sense that all would finish for the better. This way the machinery reverses, and I'm a little spooked by it all.

Still, Rome feels like our city for a week, and maybe the knowledge that she will soon depart and I will be without her for a month just

sweetens these afternoon museum trips, makes the spritzes that much more botanical and lovely in the tightly roped *vicoli* south of Piazza Navona. Maybe.

Our friends, married for almost twenty years, seemed always on the go together, just the two of them. Caribbean destinations here and there; in rented cabins dotting the mountains north of Atlanta; on calm, cold lakes in the Adirondacks. I envied their closeness, a bond of such unbreakable certainty, it seemed. When they divorced—what felt suddenly—it shocked us all. They had appeared perennially content and loving, possessed what we all thought a secret unity against indifference of all kinds. Those trips: a sort of lie we easily tell ourselves about togetherness.

This trip is strange, I know. But maybe the strangeness is that no strangeness seems to mar the week. We carry on as we do at home, only more so. All the choreographed routines of our lives together (now twenty-five years) continue, unbroken here in Rome, but seem—how to say it?—more fluid, more natural, and yet tighter, in the sense of precision, in the same way the steering of our car feels tighter after a car wash. We know there's no connection, that simply sudsing up the thing cannot render rack and pinion taut. We know—and yet. We know our lives are narratives we either ghostwrite or have ghostwritten. We'd rather take the check and keep out of all the headlines.

✈

"Machines and Gods": this written on the entrance to the Montemartini annex of the Capitoline Museum, in a defunct Testaccio power station. Busts of Augustus and Julius Caesar next to massive steam-powered engines. Headless torsos of goddesses in niches of the black, iron mass. Pressure gauges and pump switches. A series of funerary sculptures from the first century BCE. The arm of a massive statue of Fortune herself, lying effortlessly in the corner of the main exhibition hall, if I can call a power station that. All around, the artifacts of ingenuity and engines, artistic and technological, the sculptured mantel of Juno alongside the black, corrugated stairs that lead into the mysterious chambers of this steel and iron behemoth.

Centrale Montemartini, Rome. Photo courtesy Luca Di Ciaccio.

Smartly, the curators have placed placards not just by the sculptures but also by the workings of the monolith machines themselves. Glass cases in the lower level preserve mostly cultural flotsam from the imperial capital—bits of bronze handles and potsherds, a fabulously ornate bed used in parades. A few cases, however—tucked right in with the rest of the richly detailed Roman art—contain mallets and open-end wrenches, oddly shaped apparatuses, all the tools necessary to tend to the massive, modern machines in the middle of it all.

There's no escaping the fact that, really, the gods and this power station are made of the same stuff. Not the marble or the iron but, rather, the stark imagination, the cognition, materials fussed over by the mind, yes, but also by soiled, callused hands, the oils in them, the creases of palms that touched all these fabulous machines. Gods both, at least their likenesses. We built them, these artifacts of dread and wonder.

"When the King of Siam disliked a courtier," writes Jack Gilbert, "he gave him a beautiful white elephant." Here's how the rest of the short poem goes:

The miracle beast deserved such ritual
that to care for him properly meant ruin.
Yet to care for him improperly was worse.
It appears the gift could not be refused.

Walking around this power station-turned-museum, I have to wonder which machines (the gods or turbines) required more care. Gilbert intends allegiance to another kind of art, but only obsessives and martyrs fret over such complete and utter servitude. I have a feeling what fueled much of the sculptures here had more to do with money than with piety or a sense of duty to Fortune or any other god. Sure, the wealthy patrons who commissioned all this beauty wanted (even needed) the semblance of fortune on their side. They also, however, exercised their power in feigning to relinquish it.

Those who commissioned such works enjoyed immeasurable wealth, the statues make clear, and chose as an embodiment of that power some imagined homage to the willy-nilly, the accidental, the gone-tomorrow-ness of fortune. We don't even have the whole statue, just a disembodied arm lying on the floor. The power station no longer functions either, at least not as a power station.

In Italian, saying "Buona fortuna"—uttering those words—brings bad luck, like saying "Macbeth" in a theater. It's a curse. You say, rather, "In bocca al lupo" (Into the mouth of the wolf). To which one responds, "Crepi il lupo" (May the wolf die.)

✈

Parrhasius's victory over Zeuxis was not so much the ruse of a well-painted curtain, the verisimilitude of the cloth cloaking his canvas. It's whatever Zeuxis imagined in his mind. What did he expect behind that veil? A crowded still life of fish and apples and rabbit? some goddess primly tending to her hair by the shores of a mythic river? a crush of snakes in a golden bowl? some beastly amalgamation of them all?

Whatever that magnificent painting was, it only existed for that moment and only in the imagination of Zeuxis before he placed his hand on the canvas, and it vanished forever, like a ghost.

Perhaps the most famous painting that never existed, and Zeuxis—not Parrhasius—was its creator.

Zeuxis was fortunate to lose that contest.

✈

Rome. Roma. Caput Mundi. The Eternal City. Language upon language. Names for names for this city. Henry James, who loved the place, accused himself of "making a mere Rome of words, talking of a Rome of my own which was no Rome of reality." Gwen and I have spent a good deal of money to be here this week, and a good part of that time I spend sitting on this less-than-comfortable couch, in this tight and self-consciously modern apartment, writing self-consciously about being here. How much being here, though, do I experience if by being here I am not here but just writing about here? What difference, if any, is there? Why, when we walk out in the afternoon heat to grab a bite to eat and then stroll off to a dank church or villa or coffee with friends, why do I feel so much more of the place, having just spent hours holed up in an apartment, writing in English, while Rome whirls around us outside? Who's the ghost here?

Running the Spoleto program each summer, I can finally afford to sit around and not feel as if I'm simply wasting valuable time in Italy. Maybe wasting time, however, is precisely how we become acquainted with a place, how it becomes a kind of home. Loitering, haunting, setting up camp, crashing on the couch just because. I turn a corner now in Rome, in my writing of Rome, and reenter my own past. Piazza Navona late in the evening will always remind me of meeting a friend on vacation in a café there, her telling me how she had bought a leather jacket in a market close by, how the salesman first gave her a jacket obviously a size too large.

"An old trick," she said, tapping the side of her spritz with a finger, her eyebrows raised. "Always flatter first, tell her she needs a smaller size."

All these attenuations, constrictions. Bodies thinner and thinner. Neptune himself in Giacomo della Porta's fountain in Piazza Navona, slightly less than he was in the past, all that water gurgling around him, all the rain and punishing sun, the freak snow that descends ghoulishly

on this piazza from time to time, shrouding him and every other figure in white: all that wearing away, grain by aching grain. Yet in my mind it is always dusk in the piazza, always sixteen years ago, the sun illuminating my friend's candy-colored drink on the café's table, that moment preserved in the amber light of late sun on warm stone.

<center>✈</center>

We visited Trajan's Markets today, a section of the Imperial forums built into the side of the Quirinal, one of the seven original hills of Rome. The shop stalls are still intact, down to the shallow tracks sliced into the marble thresholds for wooden doors to track. Walking around the massive arcades, I found it almost impossible to believe that most of this zone was covered, buried, forgotten, only rediscovered in the 1930s, when Mussolini created the large thoroughfare linking the Colosseum to the Vittoriano in Piazza Venezia. As workers demolished entire blocks of medieval-era tenements, they slowly uncovered this stunning complex below. That demolition allowed for ominous fascist marches from the old empire (represented by the Colosseum) to the new (the Vittoriano). It also carved a road right back to the past. Etymologically, *road* and *raid* are linked, and here in Rome, that troubling history is ever present.

All the rage in Rome, it seems right now, are digitally enhanced reimaginings of monumental sites. Palazzo Valentini, for example, behind Trajan's Column, offers viewers a chance to watch cameras transform the ruins of a Roman villa back into a stunning, brightly colored first-century dwelling. Even a few of the forums now attract folks at night, who sit in bleachers and watch the cameras do their work, the age of Augustus on display. The lengths we go for nostalgia, for ghosts, the technology of it all. Those cameras swiveling and panning on command: I watched them one night, so silent and precise in their work. All this time, and the place is still a market, if no longer selling goods but, rather, memory.

And all memory becomes geography. Or better yet, all memory resolves itself in geography. Our nostalgias are cities, invisible ones, like those Calvino inventoried—some thriving and meticulously tended to;

others neglected, infested with weeds. Some are both simultaneously, like Rome. Just yesterday, we visited the Basilica di San Crisogono in Trastevere, where a baroque facade quickly gives way to a twelfth-century floor plan, under which remains the shell of a fourth-century Paleo-Christian church. If that weren't enough, the multiple basins still visible in *its* foundation suggest that, before all the Christianity and history, the martyrs and euphoria, the place probably housed a dye shop or laundromat. Fitting, that notion of cleansing, making new, continual reuse.

Older still, the words we use to talk about these places. *Memory, geography*. Some of the words at least. *Paradise*. Some paradises, I know, exist in language only. Maybe all of them. Walls here seem always in ruin, and language is its own church upon church upon church. Like the distances we travel between words. *Cleaning:* quotidian, perfunctory; *cleansing:* set apart, ritualistic. Stones both comprise the walls we build and help to conceal them.

Memory and geography: they are not antagonistic; they are not collaborative; they are the same thing.

<p style="text-align:center">✈</p>

This morning, we leave this tiny apartment in Largo dei Librari, the old booksellers' square. In fact, Campo de' Fiori and its surroundings (where we are situated) has served as a marketplace for centuries, to-day with everything from freshly squeezed orange and pomegranate juices to the seasonal *puntarelle*, "chicory stems," which Romans dress with anchovy, garlic, and olive oil, and which we eat any chance we get. Cheeses, truffle oils, silly Roma baseball caps. Coffeepots and kitchen towels; the odd, spiral vegetable slicer with which a man, sitting on an upturned orange crate, churns out helices of squash.

We will follow Via dei Giubbonari to its end to catch our bus, and I'm reminded of the fact that even that name, Giubbonari, refers to this area's market history. The jacket makers resided there, where, for the past few years I have bought light jackets. Still going, still open for business, Roman dealers—many of them the same each year I come—keep at it. The jackets fit me wonderfully.

Giubbotto, giubbetto, giubbino. Giacca, giaccone, giacchetta, giacchino.
I have never been able to remember the differences. One's an overcoat,
another a sport jacket. Myriad ways to protect our bodies, shield our-
selves from weather. I suppose the great variation and particularity of
words for jackets in Italian reflects the culture's rather extreme fear of
catching cold. Last night, an Italian friend and self-confessed Anglo-
phile critiqued his own culture's shocking aversion to cold. He lives near
the Colosseum but works beyond the Vatican, which requires a brief
subway commute. Around the Colosseum, he said, tourists—many of
them Americans, Germans, and Brits—gather in their shorts and T-
shirts, slapping on sunscreen, gulping down water, fanning themselves
in the fierce Roman sun. When he exits the subway north of the Vat-
ican—a much less touristy area and, so, more Italian—all the women
dress in coats and scarves, the men in leather and hats.

"It's like I start my commute in Tunisia," he said, "and end in Norway."

A certain old-world charm and pomp attend these scenes of older
Italy: residents strolling down the Via dei Giubbonari in what seem to
me exaggeratedly heavy clothing for such a gorgeous late-spring day.
It's May now, and this week in Rome has been ideal: seventy degrees
and sunny. And that version of Italy, sun drenched and idealized, re-
mains the ghost with which I wrestle. I almost *will* the weather to be
beautiful, am willing to overlook what locals consider cold. They can
afford to wait. They live here. The extent to which I want my sunny pre-
conceptions validated is inversely proportional to the length of my stay.
Each day I spend in Italy trims off a little excess, a bit of stereotype.

It occurs to me that if I say I'm looking for inspiration, what I really
mean is a ghost, some specter, some rarity invariably writable, custom-
ordered from the rubble and odd columns surrounding the Marcellus
Theater in the Jewish ghetto. We walked by there yesterday, and here
it is, in this paragraph. But to what end? To serve as an example of the
ways I write my way into a culture, into a moment? Not exactly. More
how I tend to my own ghosts. I don't choose them; they choose me.
But once they do, the maintenance work is mine.

It appears the gift could not be refused.

Ischia / Not Being Original

Two hulking ferries rest at port below us, cars already lined up and dozing in the bake of the afternoon. Just nineteen miles from Naples, we are constantly reminded of our proximity to it, imposing and alive; are drawn, even on this island, to its mania. On Ischia, the real constantly intrudes: those ferries with their sleek black hulls, their anchors as they rattle and splash; the stippling of pleasure boats adrift on the water; the noise and lushness of the port town as it arrives mixed with the scent of bougainvillea, oleander, and motorcycle fumes; and the startling, sincere blue of it all.

We started our first day with a jog down the coast to the village of Lacco Ameno and then to Montevico, a rocky promontory above. Just a few miles, but the end was steep, a climb to a cemetery and thermal bath complex—competing desires for a cliff top. A month and a half in Italy now, and I have lost my running legs. Two months ago, I finished my fourth marathon. Now I run three miles and am winded, light-headed.

But this is not about running. It's not about my guilt or overeating. Not about Ischia, not exactly. Not that nagging sense that I'm getting older, that I have to try twice as hard to stay in shape, and for half the results, or that I'm in danger of losing something—an *edge*, we say, in fitness, in writing, in anything—only achievable through hard work. Well, maybe it's that final one, a little.

✈

I spent the better part of two years in my twenties studying and teaching in Bologna, birthplace of twentieth-century painter Giorgio Morandi, though I didn't know that then. And Morandi's art, too, might easily be overlookable. We remember him for a life pretty much devoted to still life, and not just any. Morandi painted bottles and vases. That's it. Bottles and vases on a table, over and over. Bottles and vases in this order, bottles and vases in that order. A few at a time, a lot at a time.

A few years back, I read a brief review of a retrospective devoted to Morandi and could not get those images out of my mind. Initially, they seemed utterly unoriginal, like many other still lifes I had seen: things on a table. In fact, at first blush, they didn't even compare to those lush, hyperreal baroque ordeals with the pheasants and the fishes and the dying hydrangea blooms. Bottles and vases: that's all you get with Morandi. Maybe a chalice, the occasional bowl.

Still, those spare images in the magazine almost seemed to shimmer. The things themselves—a ragtag group of common vessels and such—were less important to me in those initial canvases. Rather, the paintings themselves seemed to pulse slightly, not as if inspired by some throwback form of animism but, rather, by breath. *Human* breath. They were breathing. They were alive.

✈

Most any weekday, you are likely to spot me running around the small lake in Georgia on which Gwen and I live. The typical route measures 3.3 miles, unless I tack on a bit extra and make it an even 3.5 or 4. Running in the age of GPS makes me somehow passionate for numbers like those. The mind shrinks from a readout that says 3.37. I know the route to the tenth of a mile; I know, am convinced, that my usual loop around the shoreline (because I abhor the out-and-back) is easier counterclockwise; I pass the time inventorying houses that fly American flags in early July, give virtual awards for the tackiest Halloween and Christmas yard-scape mise-en-scènes, anticipate the gingkoes as they shed their bright yellow leaves in fall.

Weekends, when friends join me for longer runs, I have a route prepared—perhaps around the university, deep into the greenbelt, or up by the housing north of the lake, always different than the last. Or is that just a story I tell myself? Maybe these attempts at creating new routes simply emphasize the routineness of it all: the same movement, the same exercise.

But then running is not about exercise. Not exactly. Running, for those who have crossed over into obsession, is not about time or distance or health. Running is about the ritual, the pattern. The so-called runner's high, then, is a euphoria evoked by simplicity and routine.

⊹

Two days on the island, and we—John, Ben, and I—have already fallen into a routine: rise at seven thirty, run at eight, followed by a quick swim. Then pastries and coffee at Bar Calise, where we just can't seem to figure out the pattern. (Do we pay for the pastries before or after we sit? Should we choose our pastries and then order coffee?) After breakfast, we work for the rest of the morning and into the early afternoon, John and I scribbling in notebooks or on computers, Ben editing his photos. Here for some writing and photography and a good bit of enjoyment, we take our work semiseriously; we work until it's time to visit Gino in his shack on the beach.

Our rental owner told us that Gino served the best bruschetta in town, and after one visit, we were believers. Gino also helped us score some scooters (the best means of transportation on the island) and offered sound advice on local restaurants. In the afternoon, after bruschetta, we swim again, then work until the sunlight turns pink and maudlin, and we grow thirsty for prosecco and Campari.

Then we're out the door, in search of the next best bar in all of Ischia. First, we took to the volcanic bluffs of Monte Epomeo, the highest point on the island, with 360-degree views. We drank German beer out of mismatched glass steins. (No Campari, sadly.) Next, Castello Aragonese, a castle possessing roots back to Hieron I of Syracuse and sporting a somewhat dubiously intentioned torture museum. We sipped Campari while perched on its parapets, and we are not sorry. Today we

visited a tiny winery in the hills, which traffics in tart, minerally whites, the best of which coaxed from the Biancolella grape. We sat around a table with an American family now living in Lebanon.

"You should totally come and check out Beirut," the oldest girl told us, gesturing with her wine glass, a few fingers lightly holding it near the rim. "The Lebanese like their drink too."

Friends back home hate us. They see our photos online and seethe. We talk about the way their comments almost fall into a pattern, and we plot their vectors: from "Wow, that's amazing!" and "So beautiful!" to "I'm jealous!" and "You're living it up!" down to "Stop it!" and "I can't take any more!" Then they just cease commenting altogether. Radio silence.

Yet they see at best a quarter of our experience here, albeit the flashy part, the extraordinary—the unreal blue of the Mediterranean, the homey winery dug into foothill caves, the brilliant red (bloody almost) tomatoes piled on the bruschetta. The other part we spend sitting on this terrace, each of us working, committed to our self-imposed, arbitrary structure, silent and loving it.

Does pattern simply make possible the *breakage* of pattern? Does ritual remind us of non-ritual and, so, offer (strangely) variation, from entropy, from chaos, from the bland everybody-ness of a spinning globe? And if so, is tourism anathema to pattern? We are not tourists, we tell ourselves. We live here for a week. Rather, we *play* at living here. We already like one waiter over the others at Bar Calise, the witty one, the nice one. (He *knows* us, we think.) We are temporary locals, or at least we act like we are.

✈

Flaubert encouraged artists to be bourgeois in their habits and wild and imaginative in their art. I'm not sure *wild* leaps to mind with Morandi. I'm not sure any adjective does. Morandi's painting can appear as ordinary as the saltshaker on the table each morning but just about as necessary. And the sincerity too. If there's any irony in Morandi, it's not easily visible. The thrill I get from Morandi also comes in the sheer number: the same still life, over and over; the monastic servitude; the resilience.

Yet the more I look, the more each painting assumes a completely

Still Life, ca. 1955, by Giorgio Morandi. Copyright © 2021 Artists Rights Society (ARS), New York / SIAE, Rome. Courtesy of the National Gallery of Art, Washington, DC.

different attitude. Some are sullen, recalcitrant in color and form, with scarcely a sense of depth to the table, no shadows to speak of. They look as ancient as cave paintings and nearly as primitive. Others are bright, almost lit from within, with knifed edges, stark lineations. Some are spare: a few isolated items on a table. More space than content. (Space *as* content.) Some are crowded: fat-bottomed jugs and asymmetrical bottles—he "made" one himself out of a tin can with an upturned funnel on top—all of it crammed on a rectangular canvas just large enough to hold them and often not even that. Some are precise: watercolors and etchings. (He employed a range of media.) Others feature paint applied thickly, crudely, like cake icing by a toddler.

What bounty in sameness, what lush familiarity. I look at a Morandi, and I am confronted with the fact that he could paint the simplest of objects, over and over, and I would be hard-pressed to tire of it.

Il solito—"the same," in Italian, "the usual, the old hat."

"Il solito?" Gino asks us, after just two visits to his little restaurant on pilings above the sand.

Yes, we say, to the half-liter of cold, crisp white wine; to the bruschetta heavy with those otherworldly tomatoes. Routine, particularly when it involves running along the coast of Ischia, eating at Gino's, writing on a terrace overlooking it all, routine is a lovely thing. We know, though, that he's toying with us. Whatever *usual* we lay claim to is doomed to end, and soon. He tells us what we want to hear, that we are remembered, recognized, that our being in this place has left a small mark, that we broke through, and that we have somehow earned our sense of belonging. We have transcended the tourist.

But we *don't* belong. When we arrive now, running our scooters right onto the sidewalk like the locals do, when we enter and all the staff, in turn, greet us familiarly, everyone else—perhaps the real locals, those who actually do live there, or at least Italians, most likely from Naples, who speak the same language, who follow similar routines— they all turn to us with quizzical looks. Who are these guys, obviously foreign, foreign not only in the way they look but how they move, what they say?

Ben and I met in language school in Bologna twenty-five years ago and see each other often. We get by well in Italian. John is no slouch when it comes to foreign travel and knows Italy pretty well himself. Still, with the first words out of our mouths, we're noticeably different, significantly other, hopelessly not of the place. Playing games is one of the oldest rituals. And Gino, all of his staff too: they play the game exceptionally well. They allow us to feel at home, to feel ordinary.

Strange thrill: feeling average. Strange, too, how far we travel, to what lengths we go to feel that way. This week is a quarter-century in the making. We are, for that brief meal each early afternoon, on Ischia, *la solita gente*, "the usual people," which, in Italian, is singular.

That must be meaningful. We are, for the time being, a known collective.

First night on the island, we stopped before sunset in the port town and walked along a quay of pastel-painted restaurants to the very end, where a little bar clung to the side of the rocks. Beyond that, the Mediterranean, already deepening, losing its translucence, smooth as suede. We ordered anything with Campari.

If you haven't tasted it, Campari is difficult to describe, a bundle of paradoxes: syrupy sweet yet bitter as the pith of an orange; an unreal red color constructed purely in the imagination, reminiscent of cherry-flavored children's slushes and sodas, all red dye and stained lips. And yet, when you taste it, no hint of fruitiness, no wisp of childhood. Instead, a bizarre chemical experience. Campari is medicinal, metallic, and initially forbidding, like licking a penny. Once you gain a taste for it, if you do, you crave it.

John positioned his glass on the end of our table for a photo, the bay of Ischia in the background. I asked if he wanted me to hold the glass above the wrought iron railing, the only substance not instantly pleasing, instantly photogenic.

"No," he said. "You need the railing."

Ben and I looked at one another, uncomprehending.

"You need a little something ugly."

Pattern, to many, is that railing, that "something ugly." It's what we try to avoid. We're living well, for sure, but that iota of the real—the rusty iron railing that bisects the grand vista—tells us this is not a paradise. People live here, eat and drink here, even—it must be—die here. (We know. We saw the cemetery.)

People need a railing, regardless of what it's keeping them from, or in. For us, on this island for a week, that railing—the one John wanted in his photo—that railing keeps us from falling too deeply into reverie, into tourism, into the synthetic perfection of a completely imagined place.

A friend once told me about a former colleague who lived by strict scheduling: the same foods, the same reading hours, the same rituals

each day. This guy swore he was the happiest he could be—enmeshed in the particularities of repetition, a way to live one's life without the frustrations and annoying interruptions . . . of life. Most of Western culture, it would seem, is stridently opposed to such monotony: all our cults of the new, the restless searching, from Gilgamesh and Odysseus to the latest rover on Mars. The first ever, the exclusive. Photos of Pluto. This just in. The three most important words in advertising, I once heard, are *free, improved,* and *new.*

But what was new about Morandi's spartan canvases? And why do I linger in front of them? What did he improve upon? While surely no major rebellions, those paintings almost force me to stop and stare. I cannot look at a handful of his still lifes without feeling an enormous sense of sadness: the same everyday objects, the same table, at slightly different angles, in slightly different light. I imagine him painting those arrangements over and over, at dawn, during late morning, right after lunch, a few hours into the afternoon, at dusk, after dinner, late at night with a bare bulb glowing.

And sometimes I imagine all the other things—drinks with friends, vacations on beaches—all those wonderful things he wasn't doing.

<p style="text-align:center">✈</p>

Training for a marathon, even at my modest (if respectable) four-hour pace, requires several months of consistent running. The schedule's apex includes a few weeks at close to fifty miles each. I remember one run vividly. March, at some point, not yet spring, overcast sky. One mile into an eight-mile route.

You do a lot of running, I remember saying to myself. *What do you think you're running* from?"

I could have been at home writing. I could have been preparing myself for the day's work or tending to the house, which always needs it. I could have been doing a lot of useful things. Instead, I was out running, fulfilling arbitrary mileage goals in order then to pay money to run another arbitrary distance (26.2 miles) with thousands of arbitrary people in excessively colorful and fiercely nonarbitrary outfits, kitted out with bandoliers of gels and energy beans and nuts and carbs in

myriad sweet concoctions designed in laboratories for easy digestion, to get out of the way, to keep us running our self-elected marathons for no other reason than to run them.

My favorite marathon roadside pep sign: WAY TO GO, RANDOM PER-SON!

"I'm amazed that you do that," friends and family often say to me. "How do you find the will to keep running?"

To which I always want to respond, *How do you* not?

It doesn't take much will really. It actually takes some restraint or (in the case of Italy this year) a prolonged disruption of routine to *keep* me from running. And I don't mean that in some macho way. I mean it in the way an alcoholic needs a drink. ("Not that we need liquor," Frank O'Hara writes, "we just like it." I say, *What's the difference?*) For me, it's difficult now to imagine not running. I fear injury, have silly dreams close to marathons that involve twisted ankles and cheeseburgers. When I go anywhere for more than two days, I research running routes. I manage my packing carefully, with an eye always for the space that running shoes take. Running in foreign places: now that's living.

Morandi hardly left Bologna his entire life. He considered Florence—now just a half-hour away by high-speed train—almost exotic. He seldom visited other Italian cities and scarcely any farther afield. (I hear he once visited Switzerland.) We each live with our patterns, but how much do we control them? Do we set them, or are we, in some way, driven to fulfill them? Who is in control? Do we self-impose our rituals—our morning cup of tea or coffee, our daily run, our *work* in photography, in writing, in the meticulous rendering, over and over, in paint, in ink, of bottles on a table? Do we own our patterns, or do they own us? And does it matter either way? These rituals, they're just places to store our obsessions, bottles of sorts, like Morandi's assortment.

And bottles: they hold all sorts of things.

✈

I recoil a bit from the word *work* when it's in reference to one's writing or art or anything creative. *The work didn't go well this morning* or *My new work explores* x *or* y. Something pretentious about it all and at the same

time dismissive and generalizing. *Work:* if you are fortunate enough to make art for a living, chances are you may not know much about the word. *Work* makes art sound both overly important and also monotonous.

Some may consciously blur the line between work and play. Some don't know the difference. They are either lucky, or they are children, and it's best, I find, to remember which.

<center>✈</center>

Gino's restaurant is not a restaurant, if by that term you imagine an enclosed space with actual tables and chairs, perhaps even an inviting atmosphere. Gino's restaurant, rather, is a ramshackle hut-like structure, open on both sides: on one, a busy thoroughfare, part of the island's major roadway; on the other, the sea, once you look past the crowded beachfront his restaurant services. In fact, the actual name of his place is Bagno Gino, Gino's Beach Club. These *clubs*—often no more than a shack on a small stretch of sand—are fairly ubiquitous in Italy, establishments that rent beach chairs and umbrellas and also serve lunch fare, ice cream, cool drinks. The chairs in Gino's place are plastic, the tables covered in vinyl.

The entire structure sits on worn pilings under which old men escape the sun and chat about escaping the sun. It's not a foreign tourist destination by any stretch. Italian families fill the place each day, kids straight from the shore begging for gelato, which, they swear, their parents will be along shortly to pay for; taciturn couples idly sipping beers over the tops of their divided newspaper; some local guy whom everyone calls *dottore* and for whom they always politely brush the sand off a seat. The place is packed pretty much all the time.

Watching him serve this crowd each day, we wonder: where does someone like Gino go for vacation? If we lived on Ischia, where in the world would we go? And why? Mostly, he tells us, when he can afford to take a trip, he chooses South America, where the weather turns warm just as Ischia closes up for winter, where his euros go further.

He travels a third of the way around the globe to find what is right outside his windows. (He has to, in some sense. He has no time right now.) That sea, just beyond these weathered wooden railings, above

the men—leathery and jovial—who are, for all I know, discussing their next vacation (*to vacate,* to remove oneself, yes, but from what?); that sea beyond the kids busy building their own makeshift huts out of unused folding chairs, patterning their time; that sea, to Gino, is essentially unenterable precisely when it is most desirable to enter.

Sometimes we find ourselves in paradise, despite.

✈

"I hate writing," so the adage runs, "but love having written." I sort of hate that adage, that romantic vision of the writer as tormented soul, who might even detest the calling but adheres to it anyway, tortured by its insistence. I don't *hate writing;* I prefer it to the present perfect of *having written.* Completing an action signals an end—to an essay, a chapter, a run, a painting, a meal. I like the radical middle, the stringing of words together, of courses in a long dinner in a trattoria in the mountains of Ischia, of miles on a run with a friend, talking about what runners talk about (which is usually running).

"Italians," a friend once half-jokingly explained, "spend a third of their life talking about what they're going to eat, a third of it eating, and the final third talking about what they ate."

Right now, on the patio adjacent to ours, a young woman talks with an older woman (her mother perhaps), recounting a meal from last night, the highs and lows. The pasta, it seems, was slightly overcooked, which, the older woman notes, is a common problem with thin pasta, the kind often served with clams, which is what she had eaten. "Bisogna stare attenti," the older woman warns. (One must be careful.) The clams, however, were exquisitely executed, dressed in a light but tart white wine sauce, the perfect accompaniment.

A girl, from the sound of her voice no more than five or six, is doing laps around them on her push scooter. Endless laps. Out there, the beach teems with kids her age, splashing in the water, eating ice cream. We can hear them from the terrace over the buzz of the port.

"Basta, Angela," the woman says, "perché non vai al mare?"

We are asking the same thing: why doesn't she just go down to the beach?

The older woman is putting laundry out to dry; the other one, Angela's mother, we presume, smokes a cigarette. We can almost feel the frustration. Angela, however, is having a ball. She's doing laps on her scooter. She's involved in the process; she appreciates the routine.

We're getting annoyed at her. She's getting good at it.

<center>⇥</center>

A few years ago, I visited the Morandi museum in the center of Bologna. That summer was brutally hot, ferociously humid. And if ever a painter alone could provide an antidote to heat, Morandi might be the one. The paintings seemed calming, cool, refreshingly simple, particularly in that expansive setting: the imposingly tall white walls, canvases spaced far apart.

And yet for all that coolness and ease, my first impression of the gallery was one of sadness. There are no people in Morandi's work. There are no children playing (Morandi never married or had kids), no lovers, no revelers in the street, no dandies in full garb out for the cafés, no art admirers, no students, nobody looking into his life as I was doing. That's the eerie part of Morandi: I felt awkward looking too long at those bottles, almost as if they were desperately important to their owner and I had no business being there, peering in.

After a while, however, another impression arrived. At first, I felt a deep sadness, true, some barely fathomable shade of isolation. (He lived with his sisters in the same house for most of his life, rarely traveled, obsessively painted the same objects.) Then an overwhelming sense of transgression, that I shouldn't have seen this, that perhaps Morandi's work was not intended for us to look at. (Though what would be the alternative?) Yet after sadness and guilt at my being there, I felt an inexplicable wonder, a sense of the whimsy of it all, which is different than absurdity. A man painted common bottles and vases on a table, for decades, with little or no prolonged interruption. The audacity of it. The pure, intoxicating rebellion. *You want originality?* those paintings seemed to ask. *We shall give you none.*

But those still lifes were not admonishing; they did not flaunt their sameness or ask me to renounce some desire for difference. No, they

simply recorded, were given over—as completely as I think they could be—to the moment of composition, of rendering, of putting paint or ink on a stretched, white canvas. They were the record of their own process. They were the ritual itself.

✈

"The devil is in the details," we say. On a handwritten notecard, however, above the stereo, which sits on the cooler holding all the beers and sodas and sparkling water in this bar in Ischia, on our fifth day, someone has written the opposite: "Dio è nei dettagli." Not the devil but God is in the details.

Details—the particular light playing off the rim of that bottle on the corner as the sun sets in Bologna, the garden outside quiet; the old man I see constantly as I run around our lake, who used to run, too, but who, now, with a visible tremor (a stroke? Parkinson's?), just shuffles, barely moving, still with his bright-yellow running gear. Details—how we stick resolutely to our schedule of running and swimming and writing and eating and writing about eating.

And the details of what we eat—the slight hint of garlic on the bread and the very fact that, every time we order the bruschetta, Gino asks if garlic is okay. (Yes, yes, yes.) The bits of roasted rabbit in the tiny gnocchi I ordered last night, like nothing I had ever tasted. The white truffle shaved on violet-colored Ponza shrimp—who *does* that?—which John ate and I loved. The sudden becoming, the immersion in the act of eating or running or writing. If God is there, I might just be a believer.

As a kid, I thought my father made enormous sacrifices going off to work each day. To me, it seemed so dull. Now, however, I'm not so sure. The routine of it all—the suit laid out the night before, the coffee in the morning over paper, the serpentine route to work to avoid the traffic, the conference calls and meetings. Routine, I know now, was probably what made the actual work possible. We build routines because most of us thrive in them. Most of us thrive in them, that is, when we choose them. But do we *choose* our obsessions—the things we do over and over and never tire of? Did Morandi choose to paint those bottles? How did I, of all the various choices, choose writing or running or going to

school in Bologna that fall and meeting Ben, who's with me now on Ischia, a destination we chose this year almost at random?

Maybe neither of those silly clichés really works. We don't find the devil or God in the details. We probably find ourselves or whatever version of ourselves stewards all the miscellany. How we manage the details—the differences, the particulars—probably has to do with our habits, what we do routinely, what we have trained ourselves to do. Morandi chose, I now believe, that sense of repetition and ritual. Some choose monasteries and convents or any number of modern equivalents. Others choose from a smorgasbord of vice. They're all potential vices: art, running, writing, eating, drinking. But what do they become when repeated over and over? Or is that act of repeating what we think of as vice?

"The road of excess," Blake writes, "leads to the palace of wisdom." True, but that line appears in his *Proverbs of Hell*. The devil says that.

✈

What am I running *from*? Entropy, lethargy, the common slump? Heart attack, stroke, the slow decline of my body? I suppose that's all in the mix, but I can't seem to train myself to think of running in such vividly restorative terms. And I'm not one, either, for the meditative angle. I don't really find running to be soothing or reflective. Rather, it's more like conditioning, preparing the body for pain, for discomfort, advancing mile by mile my capacity, my threshold, until the action becomes vaguely pleasant. You learn to manage discomfort, as any runner will agree (even the semiserious, like me.)

In that regard, running seems every bit as much of a process-driven activity as writing. The endless strings of words across the page, the miles on the road: the fact that I enjoy these activities and not just the results of them—better health, better sentences—suggests that they possess, in and of themselves, attributes I find, well, pleasant, at least habit forming. If I happen to finish another marathon, even best my time? Great. If I get some writing published? Wonderful. These are not, however, the reasons I keep running or writing. They can't be.

Then again, I have developed generally what I consider a keener sense of metaphor. And my feet hardly ever tire from walking.

✈

"So, what is this sea called," Ben asks me one morning on the terrace after pastries, "this one in front of us?"

We both know that they're all part of the Mediterranean, but distinct names exist for various regions. This one, somehow I know, is the Tyrrhenian. I remember some vague reference to the Etruscans, which makes sense, since the region of Tuscany borders this part exclusively. I also remember Dido in *The Aeneid*. The mythic queen from Tyre, who would have reigned—at least in Virgil's rendering—in Carthage, just across this sea from Rome, in what is now Libya. Tuscany, Etruscans, Tyre, Tyrrhenian: names so old we forget their origins.

Behaviors too. Why Italians crave sweets in the morning, elaborate pastries with names that carry only as far as a province or region—*una sfogliatella, una graffa,* the delicacies here—and coffee and milk in any number of variations, often with sugar heaped in, from packets or gold chalices or vessels particular to place. There's a bar in Rome near the Pantheon where they whip sugar into all the espresso, turning it into an almost mousse-like consistency. You have to special order it *without* sugar. And then you're out of the routine.

In Bologna, in the train station, of all places—next to where a neo-fascist group detonated a bomb and killed eighty-five people, wounded two hundred, in 1980; where a violent fissure in the coolly tiled floor commemorates it—I recall a café where sugar dispensers were mounted on a steel runner above the bar. You simply positioned the pod—about the size of an American football—over your cup (the thing must have ridden on bearings, it was so smooth) and pulled a lever. One single dose of sugar fell into your coffee.

I imagine archaeologists and celebrity scientists of the David Attenborough type, thousands of years from now, trying to decipher these elaborate apparatuses found in excavation. *What were they used for?* And did those who built that café, with its resolutely capricious sugar

dispensers and bright, cellophane-wrapped boxes of chocolates on display, when they hatched the idea for that place, did they think of the incongruousness? Eighty-five people died nearby in a bomb blast. Still, I could sweeten my espresso without negotiating an unseemly glass shaker, an individual packet, or (evil of evils) the communal spoon.

I remember a freakish Baudelaire poem about men who carried chimeras on their backs. Weighted down by the enormous beasts, they didn't even seem to mind and, instead, "went along with the resigned look of men who are condemned to hope forever."

It's awful what we get used to, sure, but what we forget to get used to? That might even be worse.

I keep remembering that afternoon at the winery a few days ago, and I am not sure why. The wine was mostly average, the tour sympathetic in its slapdash way, the whole enterprise humble and light on pretension. When I asked our guide where the restroom was, she pointed me to a door on the right.

"Careful of the toys on the floor," she said apologetically. "My son is a monster." (The restroom was in her house.)

That afternoon, however—sitting around a table, as our guide explained each wine and offered some tasty bruschetta and eggplant as accompaniment—seemed infinite, capacious enough to contain even the most disparate conversation shared among complete strangers. We had nowhere to be but there.

The younger daughters and the adolescent boy of that American family living in Beirut—they mostly looked down at their plates and ate slowly, deliberately, out of boredom, I suppose, but also out of a sense of decorum—that a bunch of grown-ups were now engaged in what grown-ups do: sit around, drink, and talk seemingly about nothing and everything. The oldest of the daughters, however—all their names escape me—was a talker, with a slight Arabic accent and manner of speaking. She trilled her r's and often hesitated before longer English words, those perhaps a little shaky from not having been used for a while. She possessed a cadence that placed emphasis, a shallow spotlight, on otherwise common words. That was attractive, out of the ordinary.

"You should really come to Beirut," she said again.

We were drinking the second dry white, the Forastera—fruitless, thin, but not entirely unrefreshing. A slight gray tint to it, the color of ash at the core of a fire.

She studied art and was interested in the Lebanese civil war, which had plagued the country from 1975 to 1990. She came across old photos, she said, during her research at the university, horrible scenes that have become routine in such conflicts: mass graves and burned-out buildings, charred timber and smoking rubble. Among those gruesome, depressing, yet shockingly familiar scenes, however, she uncovered another group, decidedly *unfamiliar:* people waterskiing, right there off the coast of Beirut, even as bombs fell in the background.

"It was," she said, "I don't know how to say, so strange, so beautiful." Romanticism crept into her voice.

"These people, they don't care if it's dangerous." She swirled her wine a bit, then downed it.

"'Screw the bombs,' they say. 'We are going to have fun.'"

This sense of disregard, of audacity in the face of almost certain danger, this is what she pinpointed as characteristic of the Lebanese who live in and around the capital. These are the people she had grown to admire, being among them, these people who said, "Screw the bombs," then jumped in the water with their skis.

I can't decide if I agree with her, if I find it heroic or life-affirming or whatever she probably intended. Is boldness, even when horribly misguided, heroic? Were they breaking the monotony, the fear, the constant watchful gazes, by just standing up and exercising their right to have fun, to be frivolous? Or was it a sense of renunciation? "So be it," I can almost hear. "If I die, I want to die waterskiing." If ever there were a strange pronouncement to make.

And I still debate the scene in *The Odyssey* when the hero traipses up the mountain and invades the home of Polyphemus, the one-eyed giant. Our homesick captain, after finding plenty of food for his men, figures he will just go check things out, see what there is to see. Just because. Even when his men suggest that they should set sail and head home, Odysseus persists. We know what happens next: Polyphemus,

angry at their ill manners—who just waltzes into a home uninvited?—pens the Greek soldiers in, wolfs a few of them down, and threatens to eat the rest, until Odysseus, "master of all ways of contending," tricks Polyphemus into getting drunk, stabs him in the eye, and out he and his men go, grasping onto the underbellies of the giant's sheep. Odysseus begins his telling of that tale by remarking that the Cyclops are louts, with no sense of culture. "Who's the reprobate here?" I want to ask.

That brazen display in the face of imminent threat, bombs exploding while people ski: I tried to imagine those photos but just couldn't, still can't.

"You can come to Beirut," she said, "and see them."

It's amazing what we get used to, I think. Fifteen years of civil war, and maybe I, too, would say it. *Screw the bombs.*

Besides, those images—they must be extraordinary and, yes, beautiful. And I have to admit, she spun a mean tale.

✈

Last full day on Ischia. John left yesterday, and Ben talked me into scootering to the east coast of the island for sunrise. At the castle yesterday, Ben rhapsodized over the light he knew would arrive there, igniting the backside of the ramparts and then the entire port town in its various yellows, pinks, and oranges.

Traveling with other artists, particularly photographers and painters, I tend to see the world not in terms of imagery and language (as I am accustomed to do) but, rather, in terms of light and composition.

"We have to come back tomorrow," Ben had said, "so I can shoot that."

"Shoot *what?*" I asked. "Those boats and that road?"

He gave me a puzzled look.

"No, *the light.*"

And I realized just then how the sun, even at that afternoon hour, played off the slight chop, a feast of colors.

"Who cares about the boats?" he said.

And yet, just after 4:00 a.m. here, on a stretch of coast nostalgically

called "Spiaggia dei Pescatori," or Fishermen's Beach (we see decidedly few fishermen, unless you count the kitschy silhouettes on the bars and restaurants and boutiques), I first notice all the little dinghies bobbing like toys in the calm water. Castello Aragonese looms to the south, a few lights still burning inside it, remnants of the Ischia Film Festival, which we never got around to attending.

Below the castle, on the narrow causeway that connects it to the island, streetlamps throw their orange on the water, creating little splotches of sunlight in a blue almost sky-dark. I think immediately of van Gogh's *Starry Night*, my go-to, stock image of a mottled, hopelessly naive (yet beautiful), heavy-handed rendering of the firmament. I think of it out of habit.

Already the sky over Naples to the east begins to bruise. Save for where the sun casts a deep crimson on the mountains, scarcely any other difference remains between the sky above and the sea below. A man in a kayak cuts a swath through it all. Just visible above him, the mass of lights in the port at Naples. The ominous form of Vesuvius in the background presently takes shape.

Ben has lugged his gear (tripod, camera bag) onto the deck of a closed restaurant, one much like Gino's, called Bagno Lucia. And because I dedicate this dawn trip to light, I think of Santa Lucia, patron saint of the eyes, of the blind, of vision itself, of *seeing*. Already Ben is setting up shop in the chill outside the restaurant's backroom. Two black cats rummage through trash on the one public beach to our right, then look up, startled by our presence. A gang of gulls disturbs the calm, swarming to the cluster of rocks just off the beach. They're looking our way. We are all waiting.

We are waiting for something that occurs each day, no matter where we are. And it's always different, which is why we are here, on the east coast of Ischia, photographing it, writing it down, setting it, establishing it in our ritualized ways. We perform this ritual not as taxidermists might—who must first kill to preserve—but rather, as the Mariner in Coleridge's poem, who is doomed (or blessed, I could never tell which) to repeat his story to the merrymakers. To repeat his story, which is,

for all of its otherworldliness, a story about plain old ritual, or rather, a story about breaking one.

And then the story he must retell? Turns out it's penance for breaking the first.

Turns out we break our routines only by starting new ones.

Assisi / The Imperfect

John the Baptist was our landlord. I was on scholarship for the year in Perugia, attending the university. Gwen took language courses in town. We rented a tiny apartment in the city center.

"Buongiorno," he'd say over the phone, "sono Giovanni Battista Elisei." Good day, this is John the Baptist Elisei.

He drove over once a month from Assisi, where he lived with his wife, to collect the rent. From our tiny window, we could see Assisi shimmering on the far slopes, radiating more than heat during the cold winter that year, all those lights clustered on Monte Subasio. Once he even invited me to lunch in Assisi, then showed off a bit of his hometown. We ate quail grilled over open flames in a place tucked into a tight, side valley, down a dirt road. The restaurant, I remember it distinctly, was called La Stalla—The Stall or, really, The Stable. Such a place seemed fitting, too, for a town devoted to Saint Francis, who often slept on reed mats in makeshift shelters, sometimes even in barns.

John the Baptist, though, had money. Gwen and I agreed that it seemed the old kind of money, too, attached to a family of consequence: the quiet reverence with which folks addressed him in the streets, the clothes he wore, even the way he spoke—that soft articulateness, those refined, upturned phrases, as if to prove no dust or dirt existed under the hems of the words he used. In short, he fit neatly inside my growing definition of Assisi as a furiously devout (because Franciscan) place of furiously wealthy (and perhaps then non-Franciscan) people.

Each year, sometime mid-May, I board a local train in Spoleto with students in our study-abroad program and head to Assisi. Just half an hour away, Assisi seems another world from the lived-in, low-level commerce of Spoleto. I never see John the Baptist in Assisi, having lost touch with him after our time in Perugia, twenty years ago now. I don't even know if he's still alive. Besides, I bet he would think of Spoleto as crass, unrefined, un-Assisi-like.

Assisi's difference from other Umbrian towns—from other Italian towns, really—strikes me immediately as we exit our train. Italian stations—from the massive installations in Rome and Milan (almost towns themselves, those twenty-track monsters) to the single-track outposts (who has ever stopped at Gaifana or Giuncano?)—all advertise the town or city name on large, blue signs with white, sans serif script. All stations, that is, except Assisi's, whose in-station signs feature modified Gothic lettering on a dark-brown background, a bit whimsical really, maybe even designed to hark back to Francis's time. It's the only station I know that possesses anything other than the iconic blue.

My guess is that either the city pays a fine for this transgression, claims special rights as the seat of the Franciscan Order, or both. (Not even Rome—backed by its tacit papal authority—escapes the blue sign.) Plus, either of those scenarios should appear even stranger, given Francis's obsession for humility and poverty. His own town now enjoys a level of privilege rare in Italy and rarer still in woodsy, outback Umbria.

I have grown so tired of Assisi, its crowds and bauble shops, the relentless manufacturing of its own medieval incarnation, its sunny main square (too sunny, really—I squint, constantly, in its glare) and overpriced food. From Spoleto, too, we can see Assisi in the distance, robed in marble and fame. But how can I not take the students? Besides, they enjoy their time there, marvel at the twin churches devoted to Francis—the dark, brooding interior of the lower basilica and the airy void of the upper nave, with its striking, sky-blue vault and Giotto frescoes.

They can't see the fame anyway. They only see that pair of pretty churches at the town's lower end and the ceaseless crowds of tourists

(of which we form a part). They study the Franciscan complex's porti-coed base, the strange piazza-turned-elite parking lot, which provides entrance to the town, the unsettling emptiness of it (particularly for a town otherwise clogged with tourists and pilgrims, both parties search-ing for relics). I, though, just see differences, oddities both trifling and substantive: from the fancy signage at the station to the boutique stores with their intricately stacked and multicolored meringues, the confectionary equivalent of superfluousness, of nothing, sold in bland pastels. All that nameless sweetness.

✈

Imagine that a couple from the Midwest travels to Mexico, which is precisely the scenario that Walker Percy offers in "The Loss of the Creature." The destination, however, could really be anywhere—Italy even—so long as the place seems adequately "foreign" or "picturesque," full of "traditional foods" and "local folklore." Most of what the cou-ple sees, as the brochures all boasted before their departure, is indeed lovely: Taxco, Cuernavaca, Guanajuato. Maybe even too lovely, for the travelers harbor a sneaking suspicion that they're missing something—something inchoate, nebulously defined but somehow essential to the feeling of having traveled, having experienced a foreign culture, maybe even foreignness itself.

On the way back to Mexico City, however, they become horribly lost and end up in a remote village. As luck would have it, some sort of harvest festival is underway, a supplication to the indigenous rain god. This is *it,* they tell themselves, entranced by the authenticity of the scene before them, no other foreigners in sight. They have the quaint village to themselves. What's more, the experience does not disappoint. It remains unmarred by any intervention of the familiar, and they leave the village, after a glorious and unexpected few days, having—they believe—captured the *it* they were desperately searching for, which is now, as Percy puts it, "safely embalmed in memory and movie film."

They successfully transcended the barriers placed in their way by tourism boards and authorized culture brokers. They subverted—how-ever unwittingly—the crowds of tourists (people just like them) and

touched the real. They came into raw contact, so they thought, with unfiltered authenticity. The veil had been drawn.

<center>✈</center>

Saint Francis many times felt beset by demons. The Lord's minions (His *gastaldi*) lurked in the humblest of objects, waiting to contaminate and infect the devout and penitent. "For if the devil," wrote Francis in his "Assisi Compilation," "can have something of his own in a servant of God, he will in a short time make a single hair into a beam."

Once, while staying in a hermitage in Greccio and, by that time, gravely ill, Francis acquiesced to the gift of a feather pillow, which a friend had offered to soothe his insomnia. Small comfort, really, since Francis favored the Greccio hermitage, in particular, for its humility and even chose the smallest, crudest cell for himself. Nevertheless, the friend awoke to find Francis screaming that a devil had infiltrated the pillow and watched as his gaunt leader tossed the offending object out of his chamber.

Once, while visiting John the Baptist Elisei in Assisi, he surprised me with an exclusive tour of the archives of the Franciscan Order. There in the imposing base of those churches, a monk in simple robe (Francis demanded the humblest of garments) chaperoned the two of us to various prized possessions of the order, most of which—twenty years later—I have sadly forgotten. I remember only an old Dante manuscript and John the Baptist anxiously smiling at me.

"Guarda, guarda!" he prodded. (Look, look!) "Che meraviglia! (What a wonder!)

What I couldn't tell him then, and probably couldn't now, was that the entire scene—the fastidious reliquary; the precious archives; the climate-controlled stacks, card-swipes, and security doors; the entire structure; and most important, the basilicas over us—all of it just seemed wrong. Even then, I found the entire town at odds with its most famous native. A man who renounced his privileged life as the son of a well-to-do merchant, who handed over his fineries for a coarse tunic, a rope as a belt: that man is now venerated in churches of such extravagance that buses never cease to idle in the enormous lots below,

worshipped in a town where gaggles of the camera-clad trail behind their guides, trying to affix earbuds for a tour—"Is this on? I don't think mine is working"—while they trudge up the hill to the lapis lazuli of Giotto and the invisible, elective poverty of Saint Francis of Assisi.

I couldn't tell John the Baptist Elisei any of that, partly out of respect but also because my Italian would not have carried me through what seemed like dark, twisted corridors of an argument I was not prepared for linguistically, let alone theologically. I was captive to the limits of my own verbal poverty and too obsessed, anyway, with appearances to delve into meaty religious debate with John the Baptist. I, too, was guilty of the sin of pride. Besides, he had bought lunch, and it was good.

✈

My command of the language has improved some since those days. Continued study, coupled with eight straight summers in Umbria—managing a busy university program, tending daily to transportation snags and leaky faucets, chatting with gregarious landlords and restaurant owners first shocked but later very much pleased to have our large group in their midst—has necessitated that I become much more adept and nimbler in my communication. Yet despite my increasingly relaxed manner in Italian, I still take up private lessons to bolster it all.

One session last year involved my recounting events in the various forms of the past tense, all of which demand competence in the ways Italian parcels out the already happened: *As I was having a drink with friends* (imperfetto), *my sister called* (passato prossimo, at times identical to our "present perfect"). *I had just finished having drinks with friends* (trapassato prossimo) *when my sister called* (passato prossimo). Even the way we speak of our lives in the past, even then, this notion of perfection, imperfection. And I often guessed wrong, based on how English employs these tenses. I ended up perfecting what should have remained imperfect and vice versa. Sometimes it feels as if I could speak for hours and not err at all. Other times, like that session last summer, I trip over the simplest of responses, my inconsistencies in Italian freakishly consistent.

And my version of Italian is just the sum total of my experiences

in all the Italian cities I have loved, however briefly, imperfectly. Bologna, for many of those early years, but also Perugia and Rome, and in recent years Spoleto, Ischia, far-flung Pantelleria (that rock below Sicily), and, yes, even Assisi: all of them embedded in the language I try to hone, to refine, each summer. Some little trick or turn of phrase I learned originally in Rome I now deploy elsewhere, even if the utterance itself remains linked to one location in my past, to its place of origin. "Ammazza!" Romans say as an exclamation (a distant relative of our "Damn!" but actually a form of the verb *to kill*), and I do likewise, conjuring Rome in my mind no matter where I am. (Northerners always find it curious to hear an American use Roman dialect terms.)

Or the many times I have unwittingly learned a local (and thus dialect) word instead of the textbook Italian term. *Rusco,* in Bologna but pretty much nowhere else, means "garbage." (Standard Italian favors *spazzatura, immondizia, rifiuti.*) When I asked some friends, whose small apartment party I was leaving, if they wanted me to take out the *rusco* they—being transplants from the South—stared wide-eyed at me. What the hell was *rusco?*

Languages are like ancient cities, yes, and those cities themselves are amalgamations, composites, pastiches, of the old and the new, with vast swaths of history scarcely discernible. I am constantly constructing my own.

➤

Last summer, on the outskirts of Assisi's medieval center, we crowded around Daniela. Our guide for the past eight years, she was introducing students to Saint Clare, Francis's female counterpart and the namesake of the church we typically visit first, far from Saint Francis's basilicas. Huddled together in a wide, oblong piazza terraced high over the plains, we listened to her in a not terribly uncharacteristic May bluster. The students—stiff with cold, hands jabbed in their pockets—rocked from foot to foot. Explanations of churches, however, always operate outside the structures themselves, since Assisi's major religious sites are policed (eagerly, I might add) by proctors who ensure that everyone enters with shoulders and knees covered, that no flash photography

erupts, and that nobody (I mean *nobody*) talks. "Silenzio"—in the low, booming voice of a church guard over the loudspeaker—is one of the first Italian exclamations my students mimic and giggle at.

Daniela, a Spoleto native, also seems quick to critique Assisi and its zealous propriety. When she speaks of the town, she does so with mock pretension, singsonging its name with eyes closed, hands upturned. For her, whose job demands ceaseless visitations to the place, I imagine just how tiring Assisi must be, all those gawky crowds, the sanctimoniousness of every last Franciscan church cop. The more people the buses bring, the more exasperated that low voice becomes: "Silenzio, no foto. Silenzio, per favore." For me, the town seems more a billowy mirage or, better, a production, a holograph, shown each day at proper hours and then, when all the buses have departed, shut off, unplugged, the fantastic machine placed back in its felt-lined case.

The students, though—at least while we are there with Daniela, taking in the exceptional art—they make a go of the day, try out the local fast food, the *torta al testo,* a kind of sandwich (or *torta*) made from rustic griddle bread, so named for the *testo,* or flat iron pan on which it was originally cooked. And they adore the Cimabue portrait of Francis and Giotto's gorgeously rendered scenes from the saint's life: the stiff, Byzantine flatness of his characters so distant from the Renaissance, with its fleshy, cherubic chubbiness. At our remove from Giotto's age—some seven hundred years—those gangly, pre-perspective versions of Francis might just come across as pleasant imperfections, their falseness and superficiality strangely welcome in otherwise prim, manicured Assisi.

✦

Even if Percy's Midwest couple seemed to have enjoyed their chance encounter with what they took as the real, some anxiety remained. In fact, even as they witnessed the festival in that Mexican village, they felt a sense of precariousness, worrying that, at any moment, something overly familiar might contaminate that perfect encounter. True, they ultimately left feeling as if they had come into direct contact with their sought-after *it:* the unadulterated, local, traditional, folksy, and quaint. They left feeling that way but just barely.

"What is the source of their anxiety?" Percy asks. "Does it not mean that the couple are looking at the place with a certain standard of performance in mind?"

The entire event, the anxiety that attends the Midwest couple's gaze at the religious festival, he explains, must be akin to the feeling parents have while watching their child perform, perhaps on an elementary school stage or in a dimly lit recital hall. *Please, don't botch the lines; don't forget the proper fingering for G minor.*

"The village is their child," Percy writes, "and their love for it is an anxious love because they are afraid at any moment it might fail them."

✈

As I was having a drink with friends (imperfetto), *my sister called* (passato prossimo). *Imperfect* from *perfect: per* (total, complete); *-fect* (done, made). We are complete and whole, perfect and pristine, yet we are also imperfect, imprecise, muddied, and torn. *Sfatto, sformato.* The beauty of Italy seems so often couched in such studied juxtapositions of perfection and imperfection: the ruins of the Temple of Minerva in Assisi, squeezed between two medieval-era buildings (or so it looks that way to us); the wart on the end of the nose of the homely sculpture of the bust of a man, in a corner of the Montemartini Museum in Rome; the way that lion outside the gates to Spoleto seems still to snarl through all that age has done to his poor, stone face. He's deformed, yes, and the deformation—the out-of-the-ordinary, the shock of the strange and fantastic—tantalizes. The imperfect derives from the notion of perfection, but perfection—aesthetically, emotionally, even linguistically—relies itself on the imperfect. Perfection, in art, often simply implies some pleasant imperfection.

My Italian, too, is imperfect, just good enough to get me into trouble. Each year, I find some adolescent to envy for his effortless assigning of gender to the world, his conjugating of irregular verbs, his command of all the resources the language offers him. I want that agility, that unselfconscious mastery of the tongue, but my Italian is recalcitrant, stubbornly average. I chase an idealized fluency I will never reach.

I do have near complete control, however, over minutiae, over quotidian trials and restaurant picks. I'm a great relief pitcher in Italian—strong for short bursts, for predefined tasks. I have almost too clinical a sense of grammatical rules, though, which means I find myself wanting to correct native speakers (and sometimes, regretfully, do), and take a perverse pleasure in the complicated, at least for me, structure of tenses and moods (even if I still make more than the occasional mistake). I revel in regional dialect differences and do a decent impersonation of someone from Bologna or Rome: the soft, near lisp of the *z* in Bologna; that lovely lopping off of certain inflections in Rome. "Che ti devo dire?" (What can I tell you?), in Romanesco, becomes, "Chette devo di'?" Language as a marker not just of culture or country but of microcultures and former city-states. To be from Bologna or even Spoleto is to be from a universe all of one's own, and a part of me inhabits each. (To be from Rome, meanwhile? Choose from one of many universes.)

I founder, however, when discussions turn to abstraction, sentiment, aesthetics, deeply held philosophical beliefs. I worry too much about correct conjugations and social proprieties and—when I make a mistake—am overly conscious of my own voice in my head. I know intimately that look on Italian faces when my words strike them as wrong: that wince, that straining to understand my poor, linguistic striving. On the other hand, had I known twenty-five years ago how well I would one day speak Italian, I might not have fretted so much.

"I envy you," Bob tells me just about every summer.

A retiree from Florida, he and his wife now spend the better part of each year in Spoleto. The community of expatriates is tiny, and we run into each other often. He has almost given up trying to learn Italian, though he desperately desires it. I tell him my story, how improvement (after the initial gains) happens at a glacial pace, how learning a language—at least for me—simply required (and continues to require) a long apprenticeship. I offer him solutions, plans for how to build a habit of mind. Take more classes, chat up locals, turn on the regional television, subscribe to this or that magazine. I realize, however, that he may not *want* solutions, that I may just sound condescending. I am

underemphasizing the effort I have put into my knowledge. Nothing simple about learning a language, unless you're a toddler. (Even then it just *seems* simple to us bumbling adults.) Still, I must come across as cavalier at best, belittling at worst. *No sweat, Bob. No problem at all.*

Besides, the less admirable part of me, I know, enjoys the compliments, the same part that wants always to size up my competition. I assess quickly other foreigners (particularly Americans) when I hear them speak Italian and focus on weaknesses: overbearing accents, faulty verb declensions, how they simply overlay their scant Italian vocabulary onto English structures. I note any mistake, however minute, and tick off the infractions. And if the person in question speaks Italian more fluently than I do, I just as quickly rationalize. *She must have lived in Italy most of her adult life; he must be married to a native speaker.* I am prideful of my Italian, I admit, and also deeply insecure.

"Sei sicuro?" Italians say. Are you sure? I hardly ever am.

✈

Sortes biblicae was a strain of early divination using Holy Scripture. Descended from the Greeks and Romans (whose key epics—*The Iliad, The Odyssey, The Aeneid*—doubled as religious texts), the practice involved opening the Bible at random and using the passages found there as a spiritual guide and form of clairvoyance. If it sounds just one step above the occult, that's because it was.

When Francis visited the priest in his family's parish church of San Nicolò in Piazza, at the lower end of the marketplace in Assisi, on April 16, 1208, he had in mind precisely this *sortes biblicae*, a practice barely tolerated by proper theologians. At that point, though, Francis was probably desperate for guidance. He had recently renounced all his worldly possessions and his family's prized lineage. He even surrendered his given name of Giovanni (or John) and assumed Francis, which just means "the French guy," a nickname given to him on account of his singing in the French he had learned through his father's trade business. Without any effort on his part, Francis had even attracted a few followers—laymen, just as he was.

The lines given to Francis that day were as follows:

from Mark 10:17–21: "Go, sell what you have, and give to the poor, and you will have treasure in heaven";

from Luke 9:1–6: "Take nothing for your journey, no staff, nor bag, nor bread, nor money; and do not have two tunics";

and finally from Matthew 16:24–28: "If anyone would come after me, let him deny himself and take up his Cross and follow me."

Unable to read Latin competently, Francis would have asked the priest not only to recite these random passages but also to translate and interpret them. Though he most likely did not realize as the Latin washed over him, as the priest revealed Francis's future, those declarations of radical poverty and sacrifice would become the guiding principles, the *form of life,* for what we now know as the Lesser Brothers (or Frates Minores) of the Franciscan Order.

One of the most powerful and severe orders of the Catholic faith started essentially with a game of chance.

✈

Back home, the Midwest couple rave to an ethnologist friend about their odd encounter in the remote village in Mexico, how captivating and authentic it was (or so they thought). They even invite their friend to join them on the next trip, planned—they will plan it all, no doubt—to coincide with the following year's harvest cycle. Surely, as Percy hypothesizes, their behavior must testify to their generosity. They only wish to share their experience with others.

Are their motives so benign, though? Percy thinks not. True, they desperately wished that their friend had sat beside them during the first festival but not out of any friendship bond or desire to extend the great contentment they felt. Rather, the couple needed their friend—and this is Percy's language—"to certify their experience as genuine."

For when they return the following year with him, the couple look not, as they had the previous year, at the brightly colored ceremoniousness of the village goings-on but, rather, at their friend, gauging his interest, anxious for his appraisal but, more so, his stamp of approval. The

couple's perceived encounter with the authentic unfortunately hinges on authentication, confirmation, validation, from experts. They have renounced possession of the very *it* for which they had so desperately searched. Percy's word for this is *sovereignty*. They have experienced, he says, "a radical loss of sovereignty."

The couple's conundrum—that push and pull between the authentic and inauthentic, the way tourism often involves the act of subverting *the touristy*—is what Percy calls "the dialectic of sightseeing." I introduce this concept to my students every year. Are we guilty, I ask them, of reinforcing this binary between authentic and inauthentic Italy? Even my use of the word *guilty*, framing the dynamic as a social ill, even that tendency to equate the touristy with the retrograde is revealing. Mostly, though, the students remain quick to dismiss Percy's Midwest couple as hopeless tourists. The students—even just a few weeks into the program—quickly feel above such fragile relationships with foreignness. They identify with Spoleto rapidly and take to mocking the few tourists they encounter in town. Who are these embarrassing foreigners walking *their* streets, eating at *their* restaurants, sleeping in *their* town? The students absolutely burst with sovereignty, even—perhaps especially—the unearned kind.

✈

"Take nothing for your journey, no staff, nor bag, nor bread, nor money." Francis took that passage quite seriously, since he loathed handling money, handling anything, really, except donations of food (always in moderation), tools with which to conduct manual labor (he stressed good works, physical exertion), and his own breviary. Days before his death, his closest followers helped him put all his worldly possessions in order. Quite an easy task, since he owned only that tiny prayer book and the drab tunic on his back.

Or consider the brother who, given as alms more bread than he needed for sustenance one day, could not save his leftovers for the next, because Francis forbade even the soaking of vegetables overnight. For Assisi's most famous son, "the journey" mentioned in the passage from

Luke was one not only through space but also through time. Followers of Christ, he taught, could take nothing on their journey, not even to the next day.

✈

In my twenties, trying to support myself in Bologna, I took any oddball English-language assignment I could weasel my way into. I remember riding the bus back from an English lesson I had given to managers at a pharmaceutical company in the city's periphery. A couple, obviously foreign, stood behind me, stooped a bit under their enormous backpacks, noticeably anxious as the bus slithered in and out of the busy roundabouts and rattled over the cobbles. The woman touched my shoulder and asked in halting, guidebook Italian where the main piazza was, relieved when I responded in English.

They were Australian, and we chatted a bit over the course of the ride. I knew their hotel, had passed it a few times, and could take them there. (Why not show a little kindness? I had nowhere to be.) I even plugged my friends' bar, said it was close by, that foreigners were always enthusiastically welcomed there, which was true. They offered to buy me a coffee for my troubles, and I remember introducing them to my pals that afternoon, relaying how we had met on the bus by chance. One of my friends—Gigi, a guy my age—smiled at me from behind the bar, said, in Italian, "You love being a tour guide, don't you?"

And I did. I enjoyed being helpful, knew that, were I in their position, I, too, would have appreciated the aid of some altruistic stranger. I had, in fact, been just as hungry for help and companionship during my own backpacking trips through Europe a few years prior. I knew what it felt like to enjoy chance encounters, knew that, because of this experience, Bologna might somehow rank higher on the Australian couple's list of favorites when they returned home.

Then again, how much of that experience, that seemingly selfless act, was complicated by my own desires? Was I completely altruistic, or was I six months into my stay in Bologna, missing home, missing English, starved for more conversation than I could muster with my

Italian friends? More disturbing, though, was how much of my desire to help the couple seemed wrapped up in a need to show off, to perform my expertise and knowledge: of the city, of my cultural fluency, of my friends in local bars. Gigi knew all this—he must have—when he smiled at me, his comment about how much I enjoyed guiding folks around a recognition of that fault of mine, that need to preen, to verify my experiences abroad through notaries of sorts, witnesses who could confirm my permanence in a place, who could, if need be, under oath, swear that, *yes, he was there, he was good, he was damn good.*

I can't help but think that all my work, all the organization and time spent establishing the specifics of our summer stay in Spoleto now, is just a complicated way of reliving, over and over, that bus ride in Bologna. Am I guilty, like Percy's Midwest couple, of a strange need for certifying my experience through my students, who are—regardless of their perceived sovereignty—just tourists, dependent on me? Have I experienced my own radical loss of sovereignty, or am I systematically reclaiming it? Running this program, even helping those Australians on the Bologna bus—do these activities alleviate the loss or contribute to it? Who's more impoverished here? Who's more dispossessed?

When I read those random passages from the *sortes biblicae* now, I can almost trick myself into thinking of them as divine guidance. Francis surely did. After all, the priest on that cold spring morning in Assisi could have found himself explaining some much less dramatic bits of scripture to this man in rustic clothing before him, desperate for wisdom. To be fair, the priest read not from a complete Bible but, rather, from his own altar missal, which must have meant that his chances of landing a finger on something demonstrative, edifying, and portentous were that much greater. Still, how often we find what we want to find, hear what we want to hear.

Roman writers and thinkers of the Augustan age found etymologies—in short, meaning—where they wanted, no matter the veracity. For them, the fact that the Latin word *ignis* (flame) inhered in the word *lignis* (wood) seemed more than linguistic coincidence. Rather, they

believed that flame and wood were so interrelated—fire needing wood to feed, wood needing fire to warm—that even the spelling of the words reflected those bonds. They wanted their world to make sense, to be patterned and woven together, stitched into a discernible patchwork. To quote Hemingway, "Isn't it pretty to think so?"

And it *is* pretty. *And* poetic. It's just not *true*. Yet for Francis (for many, in fact, even as late as the thirteenth century), words possessed more than simple correlatives in the world. They were half-spirit, half-flesh themselves; hallowed objects to be revered, even when divorced from their literal meanings, even when fractured into isolated letters.

"For a layman like Francis, only marginally able to write," Augustine Thompson argues in his biography of the saint, "letters themselves were mysterious and somehow sacred." Indeed, when Francis erred in his writing, rather than violate language by crossing words out, he let them stand. Vernacular Italian, in some ways, starts with Francis, with these arresting imperfections, these idiosyncratic, Latinesque corruptions, these mistakes and half-truths left for us to read the way we want.

In Spoleto's Duomo, a side chapel holds an original letter written by Saint Francis to Brother Leo, a letter full of loving encouragement to his closest confidant and problematic grammar for the rest of us to sort out. Mostly, though, folks flock to the relic *as a relic* and not for any linguistic or syntactical information found there. The fact that the coin-operated lighting system is not well marked does not deter the faithful (or at least faithful to their guidebooks) from spending a few judicious moments next to that wall-mounted letter, in decent, if imperfect, penmanship, dated 1224, signed by Francis himself (if we are to believe the accounts and transfers).

Yet language—any language, really—relies precisely on such small faiths in the power of words. Given enough missteps and attempts, my chapters here, my essays (*essay*, from French *essai:* trial, attempt), these scattered scenes and travels, scraps of texts I've hoarded, will, I hope, stitch themselves together, forming some sort of manageable, meaningful whole. I know that I'm doing most of the work, but the reason I keep at it resides in the feeling that the entire process remains just outside my understanding, that something *does* lie beyond. Turns

Detail of Saint Francis from *Madonna Enthroned with the Child, Saint Francis and Four Angels,* ca. 1278–80, by Cimabue. Lower Basilica of San Francesco, Assisi.

out I might share something in common with Francis after all, however secular my disposition.

I might just bring this newly found appreciation for the saint to his birthplace next summer. I might stand in front of Cimabue's moving portrait of that strange, little man with long neck and scraggly beard, and when the church cops speak those sacred words—"Silenzio, per favore"—I might just listen.

✈

I keep placing these random moments down inside essays, providing only the most rudimentary lodging for them. My landlord all those years ago, my own struggles with Italian (hardly great sacrifices), the life of a saint I cannot properly square with the lavishness of his home-town, the beauty that stops me in my steps each summer (even in Assisi), the joy I see—I experience too—in my students' faces, the irreversible fact of their own private revelations. They will never be quite the same. Neither will I. How can I not think of a veil drawn?

There were three Francises, at the very least: Giovanni di Pietro di Bernardone, as he was named by his parents; Francesco d'Assisi, as he was known after his renunciation; and finally, San Francesco, Saint Francis, the stigmata-carrying, tonsured, drably dressed, unwitting leader of an austere Catholic order. The fact that we have come to dwell on that final iteration of the man, the saint himself: is that, too, mere chance? How many of us even knew of any other version of Francis than the last? How many of us have worn away—the way we would the covering on a lottery ticket—that identity to reveal his former selves? Then again, who among us doesn't also possess these different beings, each constructed from the last? And are we all made of such randomness and near occult auto-mythologies? Are the stories we tell of ourselves real, or are we real precisely because of the stories we tell of ourselves?

But they *are* random, these instances I'm recording. The act of writing cements them in place, makes them appear as if they had always belonged side by side. Innards of a sacrificial animal or egg yolk in a bowl, tea leaves and Homeric epic, the Bible itself, my book here: near chance encounters, which are situated, interpreted, to appear other-

wise. We see what we want to see. I see what I want to see. And I want to see my mother again.

<p style="text-align:center">✈</p>

As I was having a drink with friends (imperfetto), *my sister called* (passato prossimo). And that's how it happened. In Washington, DC, for a conference, I remember sitting in a cramped hotel bar, in a secondary room, wood paneled and pretentiously pub-like, when my sister called.

"You should come quickly," she said. "The doctors aren't hopeful."

I'm paraphrasing, since I can't remember what she actually said. At this remove, I doubt that she would remember either. Besides, what does it matter? What did anything matter at that point? My mother was dying in a hospital outside Fort Worth, and the very air around me suddenly felt heavier, denser. Up until that moment, all her worries about the ulcer surgery—complicated, we knew, by her sarcoidosis—all her pessimism of the outcome, just seemed a bit of drama to me. She had grown far more fatalistic, it's true, and in conversation always circled back to her health. She had a pacemaker by then. But my mother (I know it's corny) just *couldn't* die. That happened to *other* people's mothers or at least would not occur to mine until it seemed age appropriate. She proved me wrong. She was not yet sixty-six.

I did make it out, was there, in fact, when she died. As if that's supposed to make the entire event more bearable. As if that changes anything. I remember the terrible snows that winter, too, which canceled classes and stranded me in Texas for a week. Such a strange meteorological event: that's the only way folks talked about it. But the storms also gave me a bit of reprieve, some extra time to grieve (which meant doing nothing, staring into space, cooking for my father and brother and sister).

Friends wrote to wish me well, joked about the way a few inches of snow had shuttered our little university town, locked everything under a veneer of white. In Texas, the sun carried on, a dull, blinding banality cracking the roads and bleaching them. Still, my friends said, it was beautiful to watch the snow descend and so freakish on the college grounds, the parking lots under winter hush. Nothing in transit, the

silence, mercury sinking, as Auden wrote of winter, "in the mouth of the dying day."

Besides, I was glad—surely a perverse word—to be among family. *Closure,* I hear it called, as if we could somehow mend that rift in the familial fabric, that imperfection; as if we could tend to—successfully, it always seems—a fissure or tear.

I felt the opposite. I felt as if the sky had been torn open.

Bologna / On Relics

I am thousands of miles away, down an alley just south of the main square, hugging the right hip of the Basilica di San Petronio, squat and imposing, if also unadorned, plain in its massiveness, in the center of Bologna. Some part of me, at least, is almost always there, or in some version of Bologna I overlay on my surroundings, half-Italy and half–everywhere else I find myself. In one sense, this kind of pseudo-travel is miraculous, imaginative, expansive. On the other hand, the Bologna I've conjured, the comforting past now twenty-seven years ago: that city is not quite the capital of Emilia-Romagna but a copy of it fossilized in memory, not perfected or modified into something unrecognizable but, rather, preserved, cordoned off as an exhibit available only on request, contingent on the schedule of the docent, me. Cost of entry? Five thousand lire.

That's a one-time fee, though, and I paid it long ago. A weekend night at a pizzeria in the hills around the city. Friends from language school (Dorian from Hamburg, Ben from Portsmouth) and two Italians (Gigi and Jenny) who ran a bar down the street from our language school. There was some debate about money, one of those absurd, awkward moments when new friends—we foreign students had known each other for only a few weeks, had known the Italians for even less—try to pay more than they should, the ham-fisted humility and mock shock that makes us say, "No, of course not; keep the money," and "No, no, no; we insist." The fact that the amount was inconsequential—five thou-

sand lire, even then, came to less than four dollars—made the entire scene more comical, our throwing the note to the Italians, the Italians tossing it back. That exchange of the 5,000 lire, we knew, was hardly monetary. We were each, with the same measly note, purchasing nearness, yes, but nearness to otherness. Amazing how little it cost.

Anyway, Gigi and Jenny ended up with the money. On the way back to the city—after we had said our awkward good nights half in English, half in muddled Italian, and gotten in our separate cars—they in their blue Fiat, we in the beat-up Audi that Dorian had driven down from Hamburg—Gigi and Jenny pulled up next to our car at the first stoplight, motioning for us to roll down the window. When Dorian did, they threw the wadded-up 5,000 lire note into our car and sped off, hands waving from both sides.

It was cold, foggy. (I had to purchase a heavy jacket in my first few weeks, unprepared as I was for the Emilian winter.) And yet in my memory of that night, I can't retrieve any sense of *being* cold.

✈

Here's what I remember about heat transfer: six, worn, life-size terracotta figures encircling a seventh, prostrate at their feet. Though the configuration and precise placement have changed a few times over the centuries (with much scholarly debate attending), nobody doubts the occasion memorialized in this early Renaissance tableau or, much less, the figure with crossed hands at the gathering's center. In many respects, Niccolò dell'Arca's *Lamentation over the Dead Christ* adheres to tradition, includes almost mandatory actors: Joseph of Arimathea, Mary Salome (the Mother of John the Evangelist), John himself, the Virgin Mary, Mary of Clopas, and finally, Mary Magdalene, all present—to which biblical sources attest—at the deposition of Jesus. That's all compulsory.

What seems novel and a bit unsettling, however, at least as dell'Arca has fashioned it, is the sense one has of the tableau's heat. Maybe that's just the nature of terra-cotta—literally "baked earth"—to radiate warmth. Or maybe that's an easy way of explaining away the unsettling power of these sculptures.

And though I—like most anyone else in the Western world when confronted with such an iconic scene—instantly recognized the gaunt, bearded man in his crown of thorns and could have guessed, perhaps, at the Virgin Mary (though rendered much older here and less idealized), the other women attendant on this tragedy I could not have identified in the tiny Sanctuary of Santa Maria della Vita, near the main square of Bologna, in 1994. I knew only that after I had entered, after I had noticed a few faint flashes from cameras in the far right corner of the apse and wandered over, curious more than anything, I had never beheld a religious scene more immediately transfixing, more exhilarating in its realism, its drama, its heat: the horror etched in Mary of Clopas's face as she rushes toward Jesus while simultaneously shielding herself from the ghastly sight (compelled and repulsed in the same instant); the cries I could almost hear from the mouth of Mary Magdalene, her robes billowing out behind her (or seeming to, anyway, carved from clay). Gabriele D'Annunzio referred to the work as "un urlo di pietra" (a scream of stone). But this was not stone or marble or even wood. This was mere earth, clay, formed, sculpted by hand, and baked, like one might a loaf of bread. No wonder the thing exuded heat.

I remember leaving the church a bit weak-kneed that early-winter morning. Language classes would begin shortly, but I felt sick to my stomach. What had I seen, and why had it caused me discomfort? I sat down on the steps of the entrance to the portico opposite the church to catch my breath. More than any physical sensation that entire winter in Bologna, I remember most the cold and how unprepared I came for it. (A few fevers cycled through me, a cough I couldn't shake.) That morning, though, I felt oddly warm, stuffy even. I'm not a religious person in the least and claim no spiritual dimension inherent in the experience. That would be cheating, anyway. What I experienced, in fact, were quite human emotions, portrayed there in terra-cotta, more realized than I had ever seen.

We are biologically empathic, I know. When we see others in pain, we often grimace, even tear up. But when we confront pain in a static, representational form over a half-millennium old, how can that be? We can be *moved*, we say, by art, stirred to contemplation. Typically, what

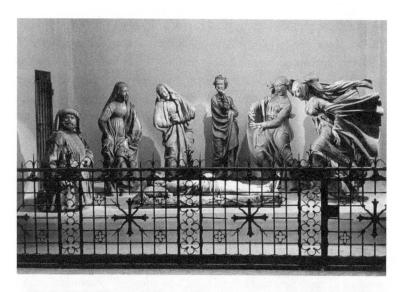

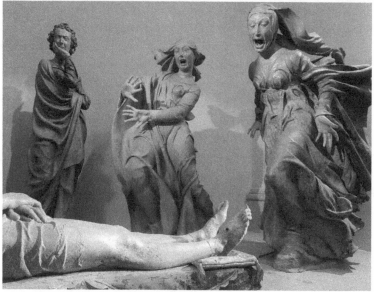

Above: Lamentation over the Dead Christ (Compianto sul Cristo morto), ca. 1460 or 1485, by Niccolò dell'Arca. Terra-cotta sculptures housed in the Chiesa di Santa Maria della Vita, Bologna. Detail *below.* Photo courtesy of Antonella Galloni.

we contemplate, though, is how masterfully the artist manipulated the medium. We can appreciate and admire craftsmanship, artistry. Dell'Arca's sculpture was different. Rather, I was different for having seen it. I even felt a little like a voyeur. I was not deserving of the right to see what I had most definitely seen. I had trespassed. At least that's what my body told me, my stomach churning, the cold Bologna air whipping through the ribs of the porticoes.

✈

I was twenty-four and had never heard of Bologna, unless I count the kind my grandmother fried and placed in an English muffin with egg for my breakfast when I was young, the sappy jingle spelling out its name in the Oscar Meyer commercials. As an undergraduate, I had taken a few mostly useless Italian classes from a semi-senile Swiss professor who smelled of dampness and solitude and who coughed continually into an off-white handkerchief. By the time I graduated, with a degree in English, I could count to fifty or so in Italian, knew some basic food items, and could ask where the library was. That summer, I backpacked through Europe with my friend Vince and thought I was cultured, global, sophisticated, with my first-grade Italian and menagerie of European coins.

After returning home and not knowing really what to do, I dreamed of those narrow Italian streets I had walked, could almost hear the language again, at times felt foreign in my own skin. (Funny, looking back, how I simply wanted to trade one state of exile for another, adulthood for xenophilia.) I scoured local colleges and grants for any possibilities of scholarships and finally found the Institute of Italian Culture in Los Angeles. In promotion of all things Italian, they offered minor scholarships for language training. "If you go to Bologna," they said, "we will pay for your schooling."

I remember calling my mother that night. "Looks like I'm going to Bologna," I said, proud of the whimsy, the carefree attitude with which I was poised to register for a small bit of prepaid Italian lessons in a city about which I knew absolutely nothing. I enjoyed my mother's easy exasperation, her low-grade amazement at my capriciousness. Secretly, I knew she was proud of me, or whatever shade of pride we reserve for

mothers who witness their sons do something slightly reckless with the best of intentions, slightly reckless because it was based on not much more than the sound of a city name and the chance discovery of a small scholarship that would unlock a winter abroad and, greater still, ceaseless fascination with the entire country.

The institute established my homestay with a prim, austere woman and her teenage daughter, whose apartment lay off a main thorough-fare in the Santo Stefano quarter, with porticoes stretching into vanish-ing points in both directions. The language school was a solid half-hour walk, right through the frenetic center of Bologna. I passed the complex of churches known as the Chiese di Santo Stefano—seven, all told, one built on top or adjacent to the last (religious equivalent of the Winchester Mansion), off a gloriously asymmetrical and tilting piazza, paved in tiny bulbous stones like small animal skulls. A rowdy university crew congregated there late in the evenings to toss Frisbees, their Heinekens and thick bottles of Peroni littering the steps of the church.

From there, I headed inward—I can still see my path clearly—toward the Asinelli and Garisenda towers, two of the fewer than twenty fortifi-cations remaining in a city that once boasted nearly two hundred. And while many Italian cities possess a leaning tower or two, Garisenda did more than lean. Rather, it seemed to defy gravity, lifting the pavers as if they were skin around a wound, almost falling for centuries, caught in its own awkward slant. Asinelli, iconic and plumb, is still open to the public, at least to those who tackle the 498 wooden steps to the observation deck, under which the warm, tiled roofs of Bologna sprawl in the characteristic haze.

I passed through the frenzy of the old markets—fishmongers and fruit stalls, butchers and the oddball barker selling cheese graters, shops with massive legs of prosciutto crowding the rafters. I passed the time capsule of Osteria del Sole, more English pub than Italian bar but redolent of old Italy still, the one I only glimpsed in the 1990s, the country's accelerated travel into contemporary capitalism long under way, swallowing up establishments like del Sole, where, on any given evening, someone might get drunk and sing (impressively, I might add) opera arias or strum Fabrizio de André on a distressed acoustic guitar,

all around a tableful of clinking wine glasses—the old kind: those squat, short-stemmed affairs, Coke-bottle thick.

And the market streets themselves, like those of Rome, reminiscent of the old trades—the myriad fish stalls in the Via delle Pescherie Vecchie, jewelry makers down Via degli Orefici, and, my personal favorite, Via Clavature, devoted to the lockmakers. To this day, the word for "key" in Italian is *chiave*. And on this street, Lock Makers' Way, the quiet, unassuming church I passed each day those fall and early-winter months, as the cold descended and rain slicked the porticoed walkways.

Though the Sanctuary of Santa Maria della Vita interrupts the uniformly earthen tones of the stucco-faced shops to either side, it otherwise calls little attention to itself. Brick columns rise from a foundation halved by the staircase that leads to the sanctuary entrance, the tympanum above it unremarkably baroque. The whole thing remains mostly invisible, concealed from view in the claustrophobic alleys. It's about as inviting from the outside as a bank or elementary school: pragmatic and forgettable. I passed five or six such churches on the way to language lessons.

At night, however, the face of the church transforms, at least the statues in scalloped niches to either side of the tympanum. On the left, Bonaparte Ghislieri, from a noble Bolognese family and linked to the foundation of the hospital once attached to the church (hence the *Life* in the sanctuary's name). On the right, Raniero Fasani, a Perugian by birth (early thirteenth century), associated with the formation of the Order of Flagellants, *i battuti,* they're called in Italian, related to the verb *battere:* "to hit, to strike."

I knew nothing of those biographies at that time, nothing of the church, its founders, its links to a well-regarded hospital, even the age of the thing. Yet even in my early twenties, in Bologna that season, ignorant of most everything but my own unwarranted self-regard as a traveler (a doer, a worldly connoisseur), Fasani's statue stopped me each evening I passed that small sanctuary in Via Clavature. With his hooded head and heavy robe, the greenish hue the streetlamps cast down the length of his penitence, hands meeting on his chest, he resembled any number of haunting, zealous followers of lost faiths. Peering at the over-

stuffed, tortellini-bloated rich and the privileged student crowds (including me), Fasani the flagellant, Fasani the *battuto*, the struck, struck me as the very essence of the world I wanted to inhabit, not one of religious fervor and discipline, exactly, but one steeped in ruined history. Leaning towers and a cobbled-together church complex, the telescopic effect of Bologna and its seemingly endless porticoes (forty kilometers in the city center alone): I wanted all of it, not knowing what it really was.

✈

I am conscious of the fact that I write now from the other half of my life, the half from which I look less with hope toward some imagined future and more with wistfulness toward a real, if unrealized, past. I am no longer the kid in Bologna that autumn and early winter of 1994. I am a grown man reverting to my past, inhabiting it again. I can't tell anymore if that's a triumph of the imagination or a tragedy, if this is a version of travel or just some photo negative of it.

I do know that our 5,000 lire note traveled quite a bit that fall. We asked Gigi's mother, who also worked at the bar, to slip us his car keys one afternoon. I remember searching my dictionary for the word *tape.* That night, after closing, Gigi found the money affixed to the inside of his windshield. Once, he and Jenny came to dinner at our flat—three other students and I had, by then, rented our own apartment, gotten out of the awkward homestays with awkward Italian families—and we found the 5,000 lire late that night, stuck to our bathroom mirror. We responded by sending it in the mail, addressed to Gigi at his bar. He countered by stuffing it in our cereal box.

And so it continued that fall, each exchange accompanied by some comment we'd scrawl on the bill itself to mark the occasion. I don't really remember much of what we wrote on that tiny bit of paper. The artifact, though, the actual bill, slowly but surely accrued significance, gathered history, became a relic. When we possessed it, we felt its weight, conspiratorial yet loving. When we gave it back, we missed it.

It's how I felt of my time in Italy, in those early days: by equal measure heavy and buoyant. When I was idling in classrooms in greater Los Angeles County, counting down the minutes as a substitute teacher (not

much older than the students I was proctoring), I dreamed of Italy. When I was in Italy, I often felt alone, not part of the culture, and more than once wanted to go home. I would have never admitted that, but I know it's true. I had spent a great deal more than 5,000 lire to be in Italy that fall. It almost made me sick to desire home. And yet I did. It was as if I were the unwitting star of my own history abroad, which nobody else back home would see. I was living, yes, but I was too aware of it all: each Italian word I learned, each bartender I befriended, each time the 5,000 lire returned to me.

The film of my life was running, but nobody could see it. It was passing from my hands as ephemerally as did that note, that wrinkled bit of paper with Vincenzo Bellini's suave sideways glance just above the accumulating graffiti left from our childish pranks. They were messages, yes, across frontiers of foreignness, but they were also much simpler. They were records of our presence. They were a story.

✈

What I remember most of dell'Arca's tableau, even now, is the shocking verisimilitude of the anguish, the amber throats of those figures, mouths wrenched, contorted, hollowed out for five hundred years. Mere clay, sculpted into the form that air provides for the folds of their garments, the furrows in John's brow, minute fissures around his lips as he winces.

Looking at digital images now, however, I can't take my eyes off Joseph of Arimathea kneeling near Christ's head. I guess I'd say that he's kneeling but in a manner deprived of any spiritual valence. Instead, he carries himself as one might while fixing a flat. Not in the least bit shocked by the tragedy, as the other figures clearly are, his task is simply to tend to the aftermath. Laborers like him, it seems, have little time for transcendence. The way in which an arm of his pliers, appalling and oversized, catches in his simple belt suggests he has learned to make do with very little. In his right hand, a claw hammer much like my own, *too* much like my own—a gift from my grandfather, whose name, Thomas, I carry in mine still. Joseph's grip, though, has loosened, the work—the hideous if, for him, tragically common work—of wrenching

Detail of Joseph of Arimathea from *Lamentation over the Dead Christ*, by Niccolò dell'Arca. Photo courtesy of Antonella Galloni.

nails out of a man's wrists and ankles and somehow lowering him to the earth again, complete.

He's the only kneeling figure of the six, yes, but more important, he's the only one whose gaze rests elsewhere and not upon the body of Jesus. While the others lament, grimace, and wail in agony, their eyes fixed on Christ, Joseph stares calmly, measuredly, away. More specifically, they are all looking inside the tableau, too caught in their own private pain to see out; Joseph of Arimathea, though, is looking straight at us. He is gauging our response and, by extension, inviting us to participate in that pain.

That's not quite right either. This is no reception. He's not inviting us. He's indicting us.

<p style="text-align:center">✈</p>

When I was young, I loved the smell of solder: sweet like pipe smoke but heavier, denser. It hung like cotton fiber in the air around my father, as he loomed over circuit boards in his workshop. He built a personal computer of sorts before such things were commonplace, and I remember not only the solder itself but the tool that manipulated it: the slender iron with its coiled sleeve, even the small, yellow sponge to clean its nib. Like the smell of gasoline, that of solder allured simply by its danger. When my father waved the smoke from my face, I just leaned in farther.

Solder, from French *soudur:* a curious word, at least in our treatment of it, how we later re-Latinized it, placed that central *l* lovingly back in the word. Call it a dream of an uptight grammarian bent on etymology. Call it a form of love, of origins, of relics, and our connections to them. The original Latin *solidare*, "to make solid," is still evident in modern Italian *soldi:* one word for "money"—that which is weighty, tangible, like my memory of the smell of solder or that 5,000 lire note. Memories have weight, too, but what is their value? They are currency, after all, since we often trade them. We can also give them up, offer them to the air, let them float around us like smoke in the darkening interiors of the present.

Once at a professional basketball game, we put the 5,000 lire in a cheap wallet, along with one of Gigi's business cards from the bar,

and turned it in to the authorities courtside, asking them to announce the owner over the loudspeaker. The Bologna team then was called "Fortitudo," and Gigi's fandom reached feverish highs and existential doldrums. Incorporating our 5,000 lire note into his basketball team would surely constitute a supreme victory for us.

When the security detail refused, we stumbled our way through what must have been one of the most inarticulate explanations of a joke even we barely understood, and could they please just announce Gigi's name, ask him to come retrieve his wallet? To our shock, they agreed, even laughed a little, though probably more at our awful Italian paired with the earnestness of our ruse. (Can ruses be earnest? Must they be?)

After they announced Gigi's name at halftime, that they had found a wallet belonging to him and would he please come courtside to retrieve it; and after Gigi, sitting next to us, holding his own wallet in his hand, showing it to us, said, "It *can't* be mine"; and after we convinced him to *just go anyway, see what it's all about, who knows?* After all that, from the high bleachers, above what they called the Lion's Den—where die-hard fans struck tribal drums and chanted their silly, infectious, and sexually explicit taunts at the visiting team—we watched our friend descend to the court, retrieve a wallet not his own, open it as he walked back to the sideline, look up at us smiling, and shake his head. *You bastards. You got me.*

And we did get him, we understood him, understood that he was the kind of friend who, even knowing (he must have known) that the wallet, the loudspeaker announcement, all of it was fake, still went down and closed the circle, provided the punch line. We understood that friendships can even be constructed out of such marginalia, such rote choreographies, such apparent meaninglessness. Perhaps they even need to be.

Gigi once told me that his grandfather remembered a single *soldo:* worth just five cents of a lira before World War II. Unimaginably small sums. A fraction of a fraction of a penny. And yet Gigi's grandfather remembered it, even the weight of it, the way I do the evening I met him, infirm by then, hobbling over from the adjacent apartment, where he lived with his oldest daughter. And when Gigi introduced me as "the

American," his grandfather's eyes widened suddenly, as if taking in more than the mere room, far more than the young, awkward foreigner in front of him. He held my hand in both of his (clammy and rough, of another age, another era) and told me of the time, near the end of the war, when American soldiers entered Bologna, liberating them from both the Germans and the Allied bombs that had flattened the city.

That Bologna is nearly gone. How many buildings, how many churches and shoe stores and newsstands were duplicated and erected in the footprints of their shadows? Estimates after waves of Allied bombings suggest nearly half of the historic center was destroyed. Memory, though, is far stronger and more resilient. Every time I saw Gigi's grandfather, he would inevitably reference *gli americani* arriving in tanks, with provisions and, let's face it, hope for all the partisans holed up and desperate. Memory is powerful that way. I was two men simultaneously, and larger than myself, forever—at least half of me— an American soldier in 1945.

✈

Two men, biblical sources agree, were present at Christ's deposition: Joseph of Arimathea and Nicodemus. Both are traditionally depicted with beards and turbans; both extracted the nails; both worked to lower the body to the ground. How are we to know which of them dell'Arca intended as his kneeling figure? Was there originally another sculpture in the tableau? Given the immense medieval popularity of the Gospel of Nicodemus, in fact, many early commentators believed the kneeling figure to be him, not Joseph of Arimathea, a hunch surviving into the twentieth century and reinforced by a parallel narrative concerning Nicodemus himself as an artist. Legend claims that the Gospel writer also created the *Volto Santo di Lucca* (*The Holy Face of Lucca*), an early Crucifixion sculpted from wood. Together, these bits of apocrypha fed the notion that the artist of the tableau, Niccolò dell'Arca, had rendered this Nicodemus—swelling with medieval lore—after his own image, the sculptor thereby stepping into his work. That wasn't Joseph; that was the maker of the thing himself, Niccolò dell'Arca, *disguised* as a Nicodemus.

Viewed this way, the static figure peering out at us, instead of at the tragedy unfolding before him, becomes shockingly contemporary, the artist traveling centuries into the future to call us still into the primacy of his terra-cotta work and the hardening processes of grief. He is both within the scene and without it, part of it yet part of the space, too, that houses them all; in that historic moment and yet outside of it.

As I am both within and without this history unfolding again. December by then, and all of us—Dorian, Ben, a small group of other students, and me—had already extended our stays as long as we could. Shortly, we would all return home. A thick fog had descended on the historic center, blurring strings of white Christmas lights spanning the streets, smudging wet cobbles in reflection. *Nebbia:* "fog" in Italian; hence, our word *nebulous:* "foggy, unclear."

On this point, though, my memory is lucid. I accompanied Ben to the store (he was stocking up on bitters and olive oil to cart home) when, in the detergent aisle, we spotted the American star of the Fortitudo team. "Wouldn't it be perfect," Ben had rhapsodized earlier that week—"if we could get one of the Fortitudo players to give the 5,000 lire to Gigi?" It was our turn, anyway. Gigi had mailed it to us or hidden it in our Italian homework. I don't recall now how we had it, but we had it; or rather, it had us.

How, though, did we approach this man? Who spoke? What did we say exactly to convince him to participate in our adolescent prank? On that, my memory is nebulous. All I remember is that he agreed to meet us later the next day and, when instructed, to enter Gigi's bar, order a drink, and pay for it with our 5,000 lire note.

✈

I was not only envious of Dorian's Italian skills—communication in restaurants, with our landlord, in just about any circumstance, fell to him—but also his lovely English, which carried a slight British inflection. Envy so often assumes the form of mimicry in me, and I found myself almost unknowingly copying some of my German friend's verbal mannerisms, for example his signaling affirmation with a clipped *yeah*. I remember one night speaking to my mother on the phone. "What is

this 'yeah' you keep doing?" she asked. Why was I so keen (to the point of unconscious mimicry) to dissolve into other people?

I felt embarrassed by such permeability, such lack of self, as if I were a void, a child simply soaking up all that was around me, with little in the way of a critical filter, of gauging just how much I absorbed and why. On the other hand, such perforated boundaries of selfdom may just be a requisite for travel. Besides, in most respects, I *was* a child.

Last week in my writing workshop, we discussed the dangers of *relatability:* that breezy, half-critical remark when students feel at a loss for offering commentary on a classmate's draft. *I like this story,* so the line goes, *because I can relate to it,* as if the narrative's merit mainly resided in how well it mimicked the life of the student reader. I argued the opposite, that it's the student, not the writing, who needs to relate. It's the reader who must relinquish her very control of self and enter wholly into the world the writer has created, even—and perhaps especially—if the setting, the time, the action, and the characters remain utterly foreign to the reader's experience.

Maybe the same goes for travel. It's not some quest for authentic cultural immersion or, worse, a search for one's true self. If it's anything reducible to axiom, it's the dissolution of self into the myriad people encountered, an erasure (or at least diminution) of our tiny, isolated pasts among the vast cathedrals of history we encounter, a wearing of other people's garments.

Travel is a bit of theater. We're the actors; we just haven't yet learned the script.

✈

Dorian and I met the basketball player the next day in the main square, not far from that sanctuary and its mute terrors. We gave him the 5,000 lire, walked with him to the bar. Ben was already with Gigi, strategically filming, under the guise of wanting to record with his camera our final days in the city. In the footage, both Gigi and Jenny carry on as they usually did, as the world carried on outside: all those people in the grooves of their patterns, the church opposite his bar having long ago been concealed in a copy painstakingly erected after the war.

And when the player (Dan Gay was his name) entered the bar with some innocuous greeting and ordered an orange soda, Gigi froze, stared in wonder at this local hero, himself a transplant, a traveler.

"Guarda, Dan!" Gigi said (Look!), gesturing toward the Fortitudo poster above his bar, the team scarves woven through wine bottles atop a display case, sports pages on the back counter, still open to Bologna's last win. The bar was a shrine to Fortitudo, and Dan performed his ecclesiastical role perfectly, acted pleasantly shocked. A bit of chatter followed, Ben introducing himself, all of them, in the frame of the camera, enjoying what seemed a chance encounter.

And when Dan went to pay, when he offered Gigi the 5,000 lire, *the note*, Bellini slyly peering atop our graffiti, when Ben's camera trained on the exchange, awaiting the reveal, the revelation, a tearing away of the veil, in this case the culmination of that silly joke that had taken the better part of that season and all our tiny lives converging to construct; and when Gigi took the offering, *accepted* it, and the entire free world seemed to hold its breath—it's on the footage, I swear—he simply placed the bill inside the register, didn't even look at it, didn't notice, too caught in the fervor, nearly religious, that had filled that tiny bar, transforming it into a somber, austere, mountaintop hermitage.

✈

Tradition holds that both Joseph and Nicodemus—those burly, bearded laborers behind the scenes of tragedy—pulled the nails that held Christ to the cross. We have come to think of them perennially in that act, hammers in their hands, which is why the terra-cotta likeness of whichever worker we choose holds forever the tool that touched Jesus's body, iron on skin. Tradition holds, and yet.

The myth that dell'Arca fashioned a terra-cotta Nicodemus after his own likeness—that the artist inserted himself into the work—grew steadily, as myths often do, as traditions do, such that, in 1922, restorers actually substituted for the claw hammer in the figure's hand a *mazzuolo*, or "stonemason's hammer." A reassessment of dell'Arca's fabulous tableau, spurred by a more general atmosphere of nationalist pride in the early twentieth century, inspired restorers not just to restore but

to reimagine, to dream a little. They fashioned replicas of missing body parts, broken fingers, and snapped-off bits of flowing gown rendered whole again. Where there were questions, they answered as best they could, so Joseph became Nicodemus became Niccolò, the sculptor. Story altered history, changed the artwork's physical particularity, some might even say deformed and defaced it.

But hasn't this bending of fact to fit a story always been the case? I look aghast at photos of the hand of this Joseph-Nicodemus hybrid, which, in 1922, held a new tool for the first time in five hundred years. But am I not applying new tools, too, to the history I inhabited, in which I played a supporting role? The diligent grammarians back-correcting some silence in the language, making it solid again, whole; or these overzealous refurbishers of faith, under cover of conservation, enacting their desires, giving their dreams shape: does the danger lie in the alterations we force on our histories or in the way we easily forget we're altering them at all?

That turbaned worker kneeling at the head of Christ carried a stone-mason's tool—one for an artist, not a grunt laborer—through most of the twentieth century, even through World War II (when the entire collection was ferreted outside the city and concealed in a castle, far from the concussive waves of bombing, the shaking and burning), all the way to the last restoration work in 1985, when the hand was stripped of its anachronism, the claw hammer placed back (fashioned, really; reified) tenderly, if scientifically, in its palm.

A deeper tradition won, we could say, but traditions are always simultaneously these kinds of continuities and ruptures. From Latin *tradere,* our word *tradition* has embedded in its past more than merely the sense of betrayal but also that term's etymological origins. Tradition is both a handing down—*trans* (across) + *dare* (to give)—and a taking back. It's how history works, at least this minor note in the annals of art and autobiography, in the center of Bologna, in 1994. At least in the way I came into contact with history all those years ago, somehow altered it but was also altered by it.

✈

I think of how much my time in Italy has hinged on something just as precarious, just as cavalier as the exchange of that hammer. How did I end up in Bologna? For an excuse to go, almost *because* I had no reason. What about Spoleto? Because I wanted the university program to avoid big urban centers (like Rome or Florence) as well as notable smaller towns (like Assisi or Orvieto). Spoleto was merely one of a handful of options and happened to offer the most competitive price. I have now spent eight straight summers there. *Chance*, I'd call it, partly because I can't bring myself to say *fate* or *destiny*.

Still, all that history with Italy has worked out exceptionally well—perfectly, in fact. To this day, I can't imagine another city in the country (in the world really) feeling to me as Bologna does when I return to it annually for a visit, not even the California town in which I grew up, so much having changed there. I've *let* so much change there, let it occur, accrue, with no accounting. California often feels more like a foreign country, while Spoleto, Bologna, even Rome, they feel as comfortable to me now as my present home in Georgia, perhaps even more so. They invite the same patterns, same behaviors, yes, but also the same blind spots. The degree to which a place disappears, becomes invisible, even as we inhabit it, I suppose, is the degree to which it has become home.

Chance: from French *cheance*, from Latin *cadens* before that, related to Italian *cadere*, "*to fall*." Chance is what *befalls* us, falls *to* us. Modern Italian possesses *caso* (*case* but also, in certain circumstances, *chance*) and also what seem more clumsy, polysyllabic solutions to this bit of French expediency. Words such as *possibilità, opportunità.* You can obviously see the English equivalents, but they hardly capture the fleet-footed, willy-nilly nature of *chance*. Indeed, one way of translating *chance* into Italian is not to translate it at all, not even the pronunciation. It is a word robed in its own genesis, in the garment it takes on its travels. Strange how a word like *chance,* with all its provisions, its doubts and elevated heart rate, all its cult of gambling, remains inextricably attached to its language of origin, unchanged as we carry it across linguistic and national boundaries.

It was chance, I am sure, that brought me to Bologna. Chance that placed the language school down the street from Gigi's bar, which he had

opened mere months before. It was chance that the bill at a pizzeria in the hills caused us to quibble over payment, that we saw Dan Gay in that Bologna market, and that he agreed to conspire. Chance, all of it.

All of it except the rest of my life, which I've spent in apprenticeship to the culture, to writing, to that brief period I keep returning to, every day, as one might return to a small church, even after (or because of) an absence of belief, or to the plot of land on which the small church stood before the fire, the bombing, the razing, the erasure.

<center>✈</center>

How we told our story to Dan Gay in the market that day I can't remember. How we somehow, over the course of that fall, communicated our story to Gigi and his family in that cramped bar in Piazza San Francesco, how by the end of that four months I felt not as if I were family but as if I had simply enlarged mine: I can't recall any of that in detail, only this story of the 5,000 lire, faded as that note itself, a note that Dan persuaded Gigi to retrieve from the till, promising to autograph it.

What followed you can probably imagine: Gigi's disbelief as he stared at our 5,000 lire, *the* 5,000 *lire*, delivered to him by this emissary of the absurd, Dan Gay, American basketball star and bit player in our comedy in the old sense of that word, a story in which everything works out, in which the crew of us, patiently (but barely) containing our excitement on the stoop, came rushing in at the sound of Gigi's wonder, Ben capturing it all on film, Dan, all of us really, all smiles in that tiny bar in the center of Bologna.

We decided soon after to retire the game, relegate it to our collective memories. Besides, Gigi claimed only Bill Clinton's delivering that 5,000 lire note to us personally, only that would suffice. I mean, Dan Gay? Fortitudo? The actual note, though, Gigi kept. Upon my request, which was every single time we saw each other, he would remove it from a flap in his wallet, unfold it, and present it to me as a veteran might a medal from its silk-lined box.

Every time, that is, except the last. On Ischia for a week, Gigi, Ben, and I had rented a house overlooking the botanical gardens and the

splendid Spiaggia San Francesco, with the streetlamps of the provincial capital of Forio glittering in the evening distances.

"Let's see our money," Ben and I said on the second night. "Let's see our 5,000 lire."

Gigi smiled, actually more like winced.

"I don't have it anymore."

Winds were furious at times that week, toppling a massive, anchored umbrella on the terrace of our rental house, scattering the plastic chairs, spilling our spritzes. That evening, however, was calm. Sacrilege was in the air, at least the suggestion of it, as Gigi looked blankly at us, his empty hands open like bowls. *What do you mean you don't have it?* The tide caught scraps of light from the restaurants clustered white on white on white, on the shores below us.

"Stolen," he said, it along with his entire wallet on a Berlin subway a year ago. "I don't have it," he repeated, raising his palms to the cool Ischia evening. Ben looked incredulous. I must have too.

These days, I possess so few possessions I am in any way possessed by. My material life is, it seems, infinitely replaceable, expendable. Computers, cars, running shoes, phones, the simple reproductions of paintings and photos on our walls: almost everything is easily substituted or floats in digital ether, everywhere and nowhere. That note, though, was concrete, its very existence heartening to me, to all of us who shared that time in Bologna, warming ourselves around the stories lit within it.

Later that night, after we had solaced ourselves, after we had reenacted the entire story once again for the few other friends among us, reinterpreting the script, I kept imagining a confrontation with Gigi's thief, what I would say. *Keep the money, the real money, anyway. The credit cards are worthless, as is the license, the identity card, all of which are easily replaced. Just give me that stupid, folded, parchment-like, outdated, outmoded, worthless 5,000 lire bill.* Dispossessed of it, we were suddenly and strangely saddled again, all three of us, with the burden of its narrative maintenance, keeping the story pulsing under the currents that separate the rare times we see each other. Absent the artifact, we could only stare into the empty reliquary of our shared past and imagine it all again.

This, though, is always how the past has worked, always, at least, how we have treated it: as outdated currency, meaningless to anyone but the owner. Immateriality is almost a precondition of worship. The things we initially cherish (baseball, bracelet, family photo, happy-face gumball given on a very first date) disappear, too, into the walls of our homes, the bottoms of dresser drawers in spare bedrooms. We own them, which is a prerequisite of habituation, assimilation, and finally oblivion.

That 5,000 lire: its vanishing was a rupture, like any death, any dispossession. I see it in my memory now more clearly than I ever did when Gigi revealed it once every few years. It was immaculate, not just resistant but impervious to mutation. It could not change, was the opposite of my memory of it, which continues to expand, pulling in, attracting (as a magnet to iron shavings) spare details: the beanie Dan Gay wore that night and how he—as I think of it now—was actually on his scooter, barely moving, as we shuffled beside him to keep up in the porticoes headed to Gigi's bar; the fact that Jenny—Gigi's girlfriend at the time, who had moved from Turin to be with him and who, after they married and not five years from then, would leave him for another man—was eating potato chips from a small bag, asking Ben, his camera aimed at her, if he wanted any, that they were good.

All these details, even the uncomfortable ones—the stupid coat I bought and hated but wore every day; the insistence, the ubiquity of cigarette smoke; the German girl from our school whom I treated badly, more like a trope (my European fling) and who told me as much before I left (which I deserved)—all these details *good*, good in the sense that they not only exist but that they grow, are enhanced, fleshed out, returning in waves that feel nourishing to me. They're breathing again.

All because of a meaningless joke between friends over twenty-seven years ago. Because of a pittance of a sum of a defunct currency. Because not even that. Because that 5,000 lire note is gone. Because those terracotta sculptures are not. Because not having the artifact renders the artifact desirable again. Because this story is all I have to replace it.

Pantelleria / On Elegy

We were simple ghosts robed in gray-white, insubstantial, wearing sunlight like a second skin. We gave off—how do I call it?—an aura, a sheen, some glint on that monochromatic shore, a shore of myth, shorn of the contemporary, save a few clusters of mere mortals disturbing the water with their wading and beers, covering themselves with that silken, volcanic mud. In the photo Gwen took, Vince and I lay prostrate, part of the beach itself, since we, too, had coated ourselves in the island, almost disappearing into it, into the margins of a green-blue caldera on the northern shore of an island flung into the sea south of Sicily: Pantelleria.

I can't remember now if Gwen, too, applied beach mud like a balm; if she then walked, as Vince and I did, into a lake in which no vegetation grew, no little fish darted by the ankles, no living thing disrupted its heated, spring-pocked, lunar floor. My sense is that she didn't, that she only snapped the photo of us laughing, hopeless tourists in search of something to fill up a week on that island with not much else to do. I remember some other group had carted down a boom box, that American pop music haunted the vicious silence. So close to a large body of water, and yet it offered little sound or, rather, absorbed it all. I remember, too, that we didn't stay long, that we couldn't. Early afternoon, and the blank stare of the southern sun almost bent the road, angled it in spikes and leaps. The caldera itself—Specchio di Venere (Mirror of Venus)—became a prism, refracting emeralds in waves of heat that caught the far shore and lifted into the sky.

Vince and I had purchased a paddleboard set earlier in the trip. We were getting proficient, with all our downtime. We exchanged a few rallies, but even the thud of the soft, blue ball on our racquets (I still have them: thick, pink, perforated plywood, like pegboard), even that seemed too insistent, too terrestrial. I remember that afternoon fondly but not in the way I easily recall a Sunday at the beach. Rather, I remember it as one might a freak snowfall that renders the day eerily isolative. I remember feeling pleasantly not of the place—a foreigner, sure, but not because of nationality. I felt like a stranger of species.

✈

Capperi. Capers. Flinders rose. That's essentially why we went. Edible flower buds brined and explosive on pastas and seafood, faintly floral yet of the sea itself. From a cooking show, we knew that the very best, the most prized capers, came from Pantelleria: a speck of rock closer to Africa than to Italy proper, a forty-minute flight south from Trapani at Sicily's far western shore. That Pantelleria was an island, and a remote one, proved irresistible to Gwen, lover of marginal lands, connoisseur of the wind-tousled outposts of the known, the incognitas stitched into our psyches. Reader of Samuel Johnson's exploits in the Outer Hebrides and Shackleton's disaster in Antarctica, she saw the chance to visit one of Italy's most remote places, to train down deep into Sicily and then leave even that removed land for isolation on another order of magnitude.

Vince's wife, Julie, with us for most of our meandering travels from Lake Como down the boot (we had a few weeks together) departed in Rome, after which our train hugged the coast through Campania and Calabria, where we finally boarded a ferry across the Strait of Messina. Sicily for a week, followed by a final week on distant, alien Pantelleria.

Lover, too, of the plan and schedule, Gwen took to her job, had rented us one of the traditional Moorish dwellings, called a "dammuso": thick, cobbled walls with a whitewashed, slightly convex roof, the entire structure, like bleached pumice, sunken among the hills. Our *dammuso* lay down a steep drive, clinging to the sides of the rock, clutching them really, with a private cove below. An architectural oddity, the house was mostly one large, misshapen room, the back of which narrowed

into a staircase whose glass sidewall faced a tropical garden niche and outdoor shower.

Beyond that, lemon trees punctured the earth in rock-lined pits to shield them from the winds, which were furious. The name Pantelleria derives from Arabic and means "Daughter of the Winds," an identity it fulfilled for us that week, with siroccos constantly arriving on African heat, entire olive groves—bent double like armies of the dead—lining crags of the sundered coast, incessant whitecaps paring the inlets, and the unsettling rattle of glass in the frames of every window, every night, in that place. The first page of our *dammuso*'s welcome pamphlet instructed us on how to reset power after an outage. We did so twice.

The wind turned everything around: deck chairs slid from the terrace, toppled into the arid, cactus-lined tract between us and the sea; bamboo blinds strangled themselves in the nooses of their pull cords; a spilled bag of charcoal etched its nocturnal rivulets in blacks and grays on terra-cotta. And the cuisine, too, whipped into haunting hybrids of Moorish and Italian: the preponderance of couscous rather than pasta; the insistence of lemon, of toasted bread crumbs and almonds rather than cheese (precious little grazing land historically); and of course, the insouciant sting of those capers swollen in brine yet which, growing wild, left green streaks down the side of our rental car, their gangly stalks lining, almost reclaiming, every other road on the island.

The wind altered even the land itself, obliged farmer and vintner alike to carve innumerable terraces into the island's bulbous hills, which—from the side of the road, on our trips into the high plains at the island's center—resembled those of Southeast Asia, wind turning the island into an imaginary Vietnam.

There are many foreigns in Italy: the cartoonish land of the *trulli*, for example, gessoed Hobbit-like structures in Puglia; or the Teutonic chalets of the South Tyrol, with their gingerbread corbels and high-pitched roofs; even the sudden antiquity of exhumed Roman insulae at Ostia or in the belly of the lost city of Herculaneum. Pantelleria, though—with its mishmash of Arabic and Italian, its terraced fields like Laotian rice paddies, its wind-ravaged, nearly treeless plains—was another world apart.

The first day, as the rental manager left us on our terrace, I looked at Gwen.

Vince was out near the edge, in full sun, hands resting on his hips, slowly shaking his head.

"Bull's-eye," she said.

\rightarrow

Pantelleria, the first week of June 1943. A week probably like the one we enjoyed, one full of sun, a sky eager to rest its blue on the surface of the sea and, in so doing, blur the edges. A week like the one we enjoyed but heavier, four thousand tons heavier, to be exact, parceled out in fourteen thousand bombs from some five thousand sorties by Allied bombers and destroyers targeting the island's artillery and communications. The goal: to see if Pantelleria could be brought to submission without a land invasion, if bombardment alone could force the Italian garrisons to give. With its position between Africa and Italy, the island proved obviously strategic. Capture it, and Sicily would lie a short flight away. Fail to do so, and Axis power threatened any incursion from the south.

The operation was successful, as far as destruction on a mass scale can be considered that. Most of the island's infrastructure lay in rubble. Visiting Pantelleria, even those sixty years later, we were struck by the port town, a ghost itself, its buildings shabbily dressed, unevenly stacked like boxes in a closet. Not wholly brutal, in its ivories, pinks, and yellows, but not delicate either, not worn naturally, like so many other Italian coastal clusters.

The difference? Age. These port buildings were new, products not of the preservation of the past but, rather, of the necessity of their postwar present, which became the future we were seeing, a future the islanders could not have imagined as they raised these concrete blocks from ruins after the war, after those weeks of bombardment, nearly a month in all.

An *operation*, we call it, though with none of the curative connotations of the word, none of its bedside manner. When the Allied troops finally came ashore, what was left of the Italian forces—pale, tattered,

and shaking—surrendered immediately. Winston Churchill famously remarked that the only Allied casualty was an officer kicked by a mule.

Walking the port town's streets that first day, stocking up on supplies for our *dammuso* an hour away, even before we learned of the island's history, we could tell something was off. In my memory now, I can't retrieve much else: the people we spoke to, the things we bought. Mostly what I haul back is a shade, a register of imprecise, free-floating loss. The entire week, really, is blurry, in the way of old photographs.

The name of the mass bombing of Pantelleria in the summer of 1943: Operation Corkscrew.

<div align="center">✈</div>

Among Italo Calvino's invisible cities, none is stranger and more haunting in my mind than Eusapia, with a carbon copy of the entire city buried underneath it. This underground Eusapia, though, is no mere industrial exercise but is, rather, a permanent resting place for every citizen of the upper city after death.

Neither is this copy just a glorified burial site. It's more of a diorama, where skeletons, "sheathed in yellow skin, continue in some ghostly simulation of their former lives." The clockmaker, for example, "amid all the stopped clocks of his shop, places his parchment ear against an out-of-tune grandfather's clock." Others, who may have wished for more from their lives, aspirant celebrities of sorts, live out their dreams in death. "The necropolis," we quickly understand, "is crowded with big-game hunters, mezzo-sopranos, bankers, violinists, duchesses, courtesans, generals—more than the living city ever contained."

More unsettling still about Eusapia's underworld facsimile are its caretakers and custodians, "a confraternity of hooded brothers." They alone among the living are allowed into the lower city, to place the dead in their desired positions. I imagine them as faceless, de Chirico–like automatons, or denizens of an Escher drawing, descending staircases at odd angles, defying perspective and even geometry in their shadow world of possibility, of this plane but perfected, allowing the dead their own eternities. Trouble is, none may know if the wishes of the deceased

were actually carried out. The hooded brothers, Calvino tells us, are secretive, inscrutable.

<p style="text-align:center">✈</p>

From our *dammuso*, the Mediterranean sparkled out the long, narrow windows. In one corner of the great room, we found a battered guitar, somewhat fit to play, which Vince did daily, usually in the morning, with coffee and a slight hangover. Campari, Campari every night.

Luxurious but odd, our isolated *dammuso*: magnificently spacious, yes, but laid out with the exasperation of an unfinished jigsaw puzzle. To begin with, the entrance to the structure—a wide, imperious deck offering uninterrupted views of the Scauri coast (no other house, no other human, in sight)—remained half-finished. Concrete pillars rose like exposed ribs from the terrace's edge, supporting a few bamboo panels, which covered only a fraction of the deck's immensity. Once inside and out of the wind, the great room enticed with its cool, white walls and white furniture, its nearly antiseptic expanse made greater by the thrum and whistle, like a buzzing hive, of its windows from the wind. To the left, a kind of kitchenette or utility corner, what Italians refer to as an "angolo cottura" (cooking corner), which seemed a profound afterthought. (Who, after all, thinks of cooking in a place like that?)

To the right, a massive, almost glandular white couch, which followed the misshapen contours of the *dammuso*'s wall like the swim bladder of a fish. To the rear, the glass-sided stairs, narrow and large-stepped as a Mayan temple, ascended to a stuffy, tiled anteroom, which opened on the right to the outdoor shower and, to the left, the *dammuso*'s only bathroom, leading, in turn, to the bedrooms. We had to pass through the bathroom, in other words, to get anywhere.

Vince took the first room, a large space with two single beds angled in a corner, one small end table at their heads. Nothing else in the room, not an armoire, a floor lamp, a chest of drawers. The other room, for Gwen and me, was blindingly white, with closets lining two sides. It was like a shoebox with a slender bed in its center. We climbed over one another and our suitcases to get out.

Our room terminated in an arch with a large glass-paned door,

through which we accessed a smaller deck with low, concrete walls. It was beautiful but mostly unbearable, with just a bit of that bamboo weave stretched over it. (Not much else could withstand the wind.) The sun beat furiously until we worried that, staying too long out there, we might grow dizzy, trip over the low wall, and boom. Once or twice, after a few drinks, we dragged some awkward wooden chairs out there and spent ten minutes in silence, watching the moon fracture in the surf, threads of a few grayish clouds in the sky. Mostly, though, we kept the door closed and listened to the constant chatter of its grooves, its glass shuddering through the night. Even in June, nightly temperatures dropped. We shivered and searched for more blankets.

In a side closet—it must have been the second day—I found a few photo albums, made odder still in that odd place, since, other than the ratty guitar and a bookshelf of yellowing paperbacks, a few oversized art books on the coffee table, nothing personal or human remained. Just a smattering of mismatched pans and plates, silverware drawer of misfits and odd couples, generic art in generic frames rendering those massive white walls both more imposing and strangely claustrophobic. We had rented, and were living in, a museum between exhibits.

Those photos, though, embodied the familial and familiar: five or six middle-aged people, in shot after shot, what seemed perhaps three couples, crowded amid the rocks of our natural cove, half-naked, wine glasses in hand, all smiles. Many, too, of a young woman, maybe late twenties, short black hair, in a sleek, tightly fitting bathing suit, a racer's body. Some photos taken at the shoreline, her mop of hair tucked into a cap. Others presumably of her as a faint disruption of the water itself some fifty feet out, swimming what I imagined some mythic distance: Byron's crossing of the Hellespont, Odysseus and Seareach at the court of the Phaiakians. I envied that freedom, yes, that mobility, but also such comfortable inertia. Which is to say, I envied the lives in those photos rather than any one facet. Such a place to vacation at, to spend time in, to swim away from but also back to.

But were they vacation photos, or did those people—the happy older couples, the lithe swimmer in her twenties—did they *live* here? And did they live here *still*? Were we simply helping them pay the mort-

gage, finish the construction? Was this their dream retreat or their long-desired home? Had they gone broke trying to build what seemed to us an eccentric palace in a distant land, where contractors surely proved scarce? Were they from this place or, like us, from far away?

I lugged the albums out, and in the blank, long afternoons of a few days, Vince, Gwen, and I traded stories of them, invented their pasts. The young one with the swimmer's build: she was a second-string Olympic athlete, strong enough for Italy's national team but not among the top performers. She was envious of those who filled the premier spots but, as an alternate with this *dammuso* and her own private cove, content to let herself be content. We let one slimmer volume, holding her wedding photos, reinforce our inventions. "To hell with competition," we imagined her reasoning. "I have this place. I won."

The other people—the older couples—seemed mostly interchangeable: a Nordic-looking gentleman with yellow trunks and a leathery tan; a frizzy-haired woman with reddened cheeks and nose, slightly bloated from what we guessed was too much wine. Others seemed like definite couples, arms always looped around the shoulders of each other, always with wine glasses in hand, bodies half-submerged in the summer tide.

One woman, however, was ubiquitous. Nondescript, at least in my memory, she seemed both faintly foreign (paler than the others, a red tinge to the hair and wide smile under her small, shallow nose) and also perennially happy. Smiles, smiles, wine, the sea beneath this *dammuso* on the northeast coast of Pantelleria. This is her place, we thought, and that is her daughter.

"*Step*daughter," Vince suggested, pointing to the ace swimmer.

He knocked back some Campari, swilling the remains around until the orange rind clung to the side of the glass.

Always these refinements, these addenda and complications. We were imagining their past, even their present, creating narratives, relationships, chains of belonging, concatenations.

✦

Whatever affiliation the port town shared with its prewar version, however those two places converged at least in name, seemed as pale

and precarious as the buildings themselves. On the third day, stunned by the midday heat, we strolled among the cluster of shops near the market at its center. Grocery bags in hand, we noticed a small bookstore at the end of a row of bleached, cement facades, along an equally unremarkable and drab quay. An uneven postcard rack squeaked and rocked in the wind. In its turnstile, images of the island in black-and-white, with neat, handwritten script floating on the surrounding sea, explaining what was there.

These were no tourist shots; they were reconnaissance photos, wartime intelligence rendered desirable, at least emblematic of an island known for not much else but its near complete obliteration during that May and June of 1943. It was almost as if the postcards were more for the inhabitants, an archive, rather than projected nostalgia for visitors, camera-quick folks yearning for the beautiful.

We were still in low season. Holiday Italians would not materialize until August, until the winds died and the waters warmed. That postcard rack was wishful thinking, we all thought, since we had seen precious few tourists (few foreigners of any stripe) in our days there. Those black-and-white postcards, British spy plane fodder and military-issue images, seemed themselves freakish, remnants of the human in that alien, urban maze of port shops emptied of almost everything but the wind.

Why was it that the entire island declared such urgent solitude? Why did those boats of leisure moored off the coast call out to us as relics rather than potentialities, as debris rather than spoils? Why were we drawn to those photos, otherwise a bit imprecise, lacking contour and detail, photos that could be of pretty much any coastline, except that they weren't? We knew that, had already learned some of the place names on the island, names steeped in loss and separation: the high cliffs at Saltalavecchia (Old Woman's Leap), the Bay of Five Teeth, Bay of the Moon. We recognized those names floating on the grainy sea in the reconnaissance images and in the large-format book inside, which featured all of them, all of those military photos.

"Bull's-eye," I said, holding up the book to show Gwen and Vince. Its title: *Mediterranean D-Day*.

We bought it immediately.

Photographs—at least those that feature family—capitalize on distance. We look at images of ourselves as kids, and we are transported back but also curiously estranged. There's a photo of my sister and me, from the late seventies. I'm maybe eight, my sister twelve or so. Nothing hints at where the photo was taken. The entire scene, in fact, is out of time, out of even a *scene,* since we're almost superimposed on the white of—it must be—snow, most likely in the San Gabriels above our house at the time, in Southern California.

It must be snow, but only our puffy jackets—mine, crimson with blue-and-white stripes on the upper arms; my sister's, emergency orange with what appears to be multicolored chevrons on the shoulders—suggest it. Concentrating, I can make out little flakes on my beanie and plaid, flannel pants. Otherwise, the entire frame is pure white, no contour to the land, no suggestion of terrain underneath. Though my legs presumably rest under some snow or behind a low bank, it looks as if someone simply ripped them off and plastered what remained of me on a blank canvas. My sister—the bottom halves of her legs lost in the vacuum, her hands (snug in white gloves? shaping a snowball?) also erased.

Then the bizarre web of blues, blacks, and purples behind her. It's difficult to tell what that is, really, since the photo seems corrupted, overexposed. It has lost not only the texture of the snow but also any sense of depth. My sister, probably some ten feet behind me, seems rather to float above. And that strange cluster of darkness behind her, which spreads out in either direction from her shoulders, looks like—there's no getting around it—wings.

We laughed about it when I placed the white-framed slide into the projector a few years ago. We were at my father's place, rummaging through some boxes.

"It's like you're some angel of death," I said, and we both laughed.

We're all smiles, though, in that white dream of what was a rare snowfall.

It must be tree branches veining out from the center of the frame, into the matte white of the photo. Whatever it is, though, that web is

the reason for my love of the image, which sits on my bookshelf here, the only photo of my sister in the entire house.

<center>✈</center>

The preface to the book on the bombing of Pantelleria is more a celebration of the images gathered inside, with text in both Italian and English. As with other somewhat obscure research projects, however, the translation is less than accurate. The author speaks, for instance, of the importance of the bombing to the history of the island, which is, in the translation, "still alive in the mind of our inhabitants" (so far, so good) "and in the fantasy of the tourists, who arrive on the isle."

Fantasia, in this case, might have been more accurately translated as *imagination*, since *fantasy* reads almost like *wish fulfillment*. Yet perhaps there's a deeper truth to this slippage, that what the tourists—what we too—wish from Pantelleria is precisely that: a history, however dark and nearly forgotten. Or maybe the dark and nearly forgotten are precisely what we think of as history, at least the kind we wish for, the kind we fantasize about.

I'll be honest: that week on Pantelleria was not precisely what any of us had wished for or expected. Vince probably imagined an analog to Lipari—another Sicilian island, which he and I had visited with Ben a few years earlier. He found Pantelleria's unearthly strangeness, the mania of its terracing, the *dammusos*—like blobs of meringue dotting the denuded, windswept coast—all of it not exactly beautiful though not exactly *not* beautiful. And Gwen, though struck by the starkness of the place, couldn't quite understand much else about it and flinched constantly in the passenger seat, as cars passed us on those narrow roads. Our most familiar response that week was one of shock. It looked, behaved, maybe even felt, like no other place we had ever seen.

Except I was often struck not by the island's strangeness—its mash-up of North Africa and Cambodia—but, rather, its quicksilver, ephemeral familiarity. Absent the *dammusos*, the mazelike terracing, the yellowed tufts of whatever grew everywhere among the capers, and the hardening dome of cobalt pressing down; absent all that, I was transported not to Southeast Asia or Tunisia (the harbor lights of which

winked at us nightly) but, rather, to Southern California, to the parched brown hills of my childhood, to the same ragged vegetation carpeting the foothills of the San Gabriels, to the penetrating clarity of the sky.

I wasn't just imagining California. I was there again, transported from that volcanic bluff back to a road cut into the lemon groves in San Antonio Heights. Even the odor of Pantelleria carried a version of a familiar past: hot asphalt, desiccated scrub, and a faint but insistent char in the air. Controlled burns, most likely, difficult to see in the wind but ever present to the nose, everywhere and nowhere at once, like a California brush blaze carried by the Santa Anas.

Even when we drove to the port town to pick through the markets and grab a cinnamon gelato, even then I would catch some glimpse of home, not through architecture or accent or food or anything tangible. Nothing so apparent, recognizable. Whatever familiarity I felt that week was fleeting, provisional. I'm doing my best now to parse its particularities, but even Vince—who grew up with me among those wildfires and tightly packed houses, among the olives and lemons and suburban strip malls, the four-lane highways that crisscrossed like rattan the muted gray greens and boulder-strewn, California washes— even he found it difficult to feel precisely what I was feeling. There was room enough, it seemed, for just one person's nostalgia, one person's sideways recollections.

Odd couple, the three of us, each experiencing some personalized Pantelleria: Gwen's Johnsonian edge of civilization; Vince's slightly off-kilter Mediterranean paradise; my strange California double exposure. Even packed in our tiny yellow Fiat, windows rolled down, the dry air in our hair, mingling us, all three carrying the same scent of desert and smoke and sea, even then we were all on our own islands.

✈

Far from a static necropolis, a storage place for corpses, the lower Eusapia in Calvino's reckoning remains dynamic, ever changing. The same hooded brothers exist among the dead, for example, begging the question among Eusapia's upper city as to whether the orderlies they know—those attendants to the recently departed, those caretakers of

the underworld—might themselves already be dead. Surely not, since the confraternity continues to shuttle back and forth between the two worlds. And yet these brothers relay to the living that they continually find small changes in the underworld. Little differences, almost imperceptible, and yet.

"The dead make innovations in their city," Calvino declares. "Not many, but surely the fruit of sober reflection, not passing whims."

╼

Our rental agent, Giovanni—long, wiry hair receding from his forehead, draped in beads and loose-fitting natural fabrics brightly striped—could have walked out of a documentary on Vietnam protests. He possessed a wide, toothy smile and jaunty Sicilianized English: nasally vowels and excessively (brilliantly) trilled *r*'s. He drove a beat-up Fiat, like everyone else on the island, and managed a clutch of rentals along the island's north shore. We instantly took to him and he to us. Early on, he invited us to a vineyard in the hills. The wine of choice on Pantelleria, the one that put the island on the map in the 1920s, is a sweet *passito* made from the Zibibbo grape, which we drank around a small wooden table, in the company of the vintner and another American couple.

The wine was unmistakably sweet but also floral, acidic, honey touched, like a grape candied or steeped in rose water or the first bite of a ripe pineapple: blossom, sugar, and astringency together. Weighty and viscous on the tongue, it somehow left my mouth clean and parched, wanting more.

I kept drinking, while Giovanni roughly translated the vintner's detailed pitch for all of us sitting there: Vince, Gwen, and I, and the other couple, whose names I have forgotten. There for a few months, renting a *dammuso* from Giovanni, they freelanced for the American government, studied beehive and ant colony behavior, talked eloquently about its potential applications in robotics. "Itsy bitsy machines," they said a few times, as if they'd rehearsed it, "acting as a collective."

I remember the winery's other products too. The honey, the cheeses sharp and chalky, a bit of lemon preserves on a piece of rustic bread, all that rendering and concentrating: grapes to raisins to the slightly

chilled tang of the wine in my glass; bees in the foothills robed in wild-flowers, producing that amber honey spooned out of a mason jar; the slow, steady pressure of a cheese mold on something as ephemeral, as quick to spoil as milk—all the condensation not just of the food and wine we enjoyed but of the language pressed into near English equivalencies in Giovanni's improvisations. Of that week itself, compressed, as if we were living years in a matter of days. I felt aged by the end.

But I don't want to misinform, render Pantelleria a complete backwater, out of time, out of context, pure myth. It's not as if the island didn't have its behemoth hotels and raft of celebrities. At the time, I recall both Sting and Madonna supposedly owned property there. And when we visited the other American couple, the robotics specialists—their *dammuso* perched high on a bluff overlooking the sea—we could still make out a corner of the massive hotel under construction below us, its white walls rising from the cliff side, rebar in turn rising from it to puncture the otherwise meandering coast behind. We sat on their terrace one evening with some Campari in chunky tumblers, along with Giovanni and a friend of his.

This must have been five days or so into the trip, nearer the end. We had by then tired of our inventions of a past for those people in the photo albums of our *dammuso*, so I asked Giovanni to set us straight. *Who was that ubiquitous woman, that trim swimmer?*

"Ah, yes," he said, licking his fingers clean of the olive oil, which had seeped into the grilled bread we were nibbling at, his gesture not of delight but, rather, of sober reflection, a kind of reverence and solemnity that required cleanliness. "A wonderful woman, much loved."

And foreign, too, it turns out. She was Spanish, Giovanni said, had come to Pantelleria on vacation, had fallen in love with the place. A notable architect designed her *dammuso* (our *dammuso*), which she had dreamed of living in for years before taking the plunge. Her daughter—I was right, it turns out—mostly grew up there among the turquoise coves and cactus, the shore rocks shot through with lichen. I don't remember his saying anything about the father.

Turns out we were mostly right, all except the fact that the woman, the owner of our *dammuso*, had recently died.

"Cancer," Giovanni said haltingly. "The daughter"—Cristina was her name—"she doesn't know what to do with the place."

We didn't know what to do either and so just focused on our glasses, orange rind floating on the surface of the iced Campari.

"Can't let it go but can't stay there either."

This is all so distant to me now that I am straining to piece it together, what we said, what we did. I retain sensations more than actual words.

"You are lucky, though," Giovanni said. "That place is a masterpiece."

And it was, our *dammuso:* the oddest, most beautiful, and most eccentric place in which I have ever stayed but perhaps not for the reasons he imagined. We were living, at least for that week, in someone else's half-finished version of paradise: idiosyncratic, hopelessly individualized. We couldn't really access the joy. We mostly just felt distance, from each other slightly, yes, but from the people who called it home. From that home, too, and from the island itself.

✈

Marco Belogi, the author of *Mediterranean D-Day,* the one who gathered the photos and produced the accompanying text, seems strangely defensive in the book, arguing constantly for the project's legitimacy. Early on, he offers a few reasons why the artifact should prove of interest not just to serious scholars of history but to lay readers as well.

First, the reconnaissance photos offer glimpses of the island before it changed forever, before it became a kind of large-scale necropolis. (Most of each year, the island is half-deserted, dreaming of late summer.) Second, in the words of Belogi, "What becomes evident is the contrast between the beauty of this Mediterranean landscape and the cloud of smoke, which on June 11th, covered the island." Such clouds on a volcanic island are nothing new, but this one he speaks of did not originate in some shifting of the underworld, some minor eruption. This cloud, instead, was delivered by B-17s, B-25s, and B-26s, a cloud that turned the entire island black. A nickname for Pantelleria, darkly ironic now (as Belogi was quick to remind us): *the black pearl of the Mediterranean.*

Bombing of Margana Airport in Pantelleria by US Army Air Forces in 1943. Photograph No. 204918210; Records of US Air Force Commands, Activities, and Organizations, 1900–2003, Record Group 342; National Archives at College Park, College Park, MD.

One particular photo of the Margana Airport bombing, May 10, 1943, offers a detail of the island's coast around what appear airstrips (difficult to tell given the height from which the photo was taken). At the top of the image, the shore, which curls around to the east, is blurred, like half-erased graphite on canvas. This, of course, is due to the 500-pound bombs that fell—246 of them on the airport alone that day.

The western coastline, however, remains in focus, seemingly untouched, with what look like tiny inlets and bays, maybe even a deep harbor cutting into the island, a part of which continues into the upper left margin. For a moment, the bombing seems isolated, targeted,

surgical. I can dream of less destructive tendencies, less errant stewardships of weaponry. I can dream, until I realize that what appears a western coastline and deep harbor is, upon closer inspection, actually an enormous billowing of black smoke carried up into the atmosphere from the carpet bombing of the airport area, smoke (and the shadow it casts) so black it resembles negative space, resembles the sea itself, smoke that rises toward the plane from where the photos were taken, from where, presumably, the bombs were dropped, smoke returning to its very origins.

<center>✈</center>

Two stories compete for the etymology of the word *couscous*. One claims that it derives from a Berber term meaning *well rolled,* gesturing toward the shape of those tiny, pasta-like pebbles of durum wheat. We ate more couscous that week than I had ever eaten in Italy, ever eaten period, alongside fish with aggressively sweet and sour sauces, toasted nuts, bright citrus and capers. Vince still talks about one fish he ordered there—the names are impossible to remember, to disambiguate—when Gwen and I lacked courage and ordered pizza, not knowing the name or even the accompaniments other than the couscous.

I have a hard time, though, imagining couscous as well formed in any way. To me, it resembles something broken up, milled, fractured, multiplied, almost pulverized (from Latin *pulveris:* "powder, dust").

I prefer the other etymology, from Arabic. The word *couscous,* in this line of reasoning, derives from *kuskus,* itself from the verb *kaskasa:* "to pound small."

<center>✈</center>

I'm trying. Since my mother died, memory is a DMZ, a landscape fraught with mines, threats, promises. Family photos are hard to stomach, and yet I have been more inspired lately to confront them. But what exactly am I confronting? These photos saved from heaps of slides in a cardboard box among the trunks of Christmas decorations in my father's house: what precisely do they represent, and what am I accomplishing in my retrieval of them? A colleague of mine in public history told me

last week that the purpose of any historical display is either to celebrate or commemorate. Which is it, my salvaging of these photos?

In looking at this one of my sister and me on that surreal blankness, it seems I have simply selected it for its strangeness, its accidentally artful composition, its out-of-the-ordinariness. It's a moon rock, of sorts, not so much commemorating my childhood or in celebration of my family. This photo and the others I keep coming back to: they all strike me now as diversions, oddities, family photos without being *familiar*, absent of a palpable past. They reside on a plane all their own.

The synthetic colors in a photo of my mother as a young girl, for example, pulling a string that's wrapped around her tooth; the wry smile of my father, in his midtwenties, hiking gear slumped to his side; my brother in his Fozzie Bear sweatshirt, head cocked toward the camera; that freaky snow shot of my sister and me—they're less nostalgia than they are retrospectively aesthetic, quirky in their deferral. Celebration or commemoration? I'm not celebrating much of anything but my own selection process. And commemoration? Insofar as photos simply remind us of having been younger, I suppose I am commemorating that, even if it seems more like eulogizing.

\rightarrow

It's not like we had a bad time on the island either. In fact, ours was the kind of trip that does what trips are supposed to do: it transported us away from everything, most crucially our own expectations. And even if the water was mostly too cold to swim in, the sun too hot to stay in, and the wine too sweet to drink much of, we did so anyway, singeing our skin, waking with headaches, cursing that final glass the night before. When we did brave a swim—the one day when the winds relented—turquoise water refracted the sun off the shore rocks, until we were swimming in bands of light spun out of the air itself.

We joked about the cuttlefish we spotted, compact as a football, pulsing its chameleon, neon shock. It seemed to follow Gwen as she snorkeled through the volcanic channels whose tidiness belied that tumbling, craggy shore. I followed the cuttlefish, too, as it followed Gwen, pursued her, really, but at a safe distance. I kept waiting for it

to turn away, but it didn't, just kept cruising behind her through the shallow, if chilly, tidal shore. I gave up the chase before it did, but the story kept pestering us the entire trip. Gwen talks about it still, in fact: that time the cuttlefish tailed her in the waters off Pantelleria.

Thinking of it again, this far away, I can't help but imagine that we were all pursued that entire week, not by some curious cephalopod but by history itself. Pursued in the forms history assumes in concrete, yes, but—more urgent still, more tenacious, impervious—also in memory. And it's not fair, really, that I have somehow managed to link a week I spent on Pantelleria in 2004 with my mother's death seven years later. Not fair to capitalize on an unknown woman's death, to project onto her and her family my own grieving. They'll never know, but I do. That island has proven the ideal spot to sequester the loss, deep in its bunkers, far from view. It's not fair to that woman or her house, that *dammuso*, its imperfections and quirks, in whose strange whiteness we spent those long afternoons, sensing—even before we knew of her death—the ghosts around us, the history of the people who lived there.

It all feels now like practice, a set of drills for how to deal with loss, how to detect its coming on, what it looks like, how it pursues us. It always finds us, though, no matter how we try to outrun or elude it.

✈

"Then I addressed," recounts Odysseus in book 11 of *The Odyssey*, "the blurred and breathless dead."

As Circe had instructed him, he has come to the shores of Erebus, pouring his libations to invite "the nations of the dead," Tiresias among them, to learn of his passage home. It's a spooky book, one fraught with danger for the hero. (He keeps his sword drawn and ready for "the surging phantoms.")

And yet the emotional dangers far outweigh any physical menace. Odysseus's mother, for example, appears to her son out of the gloom and mist, a vision that surprises him, absent, as he's been, from Ithaca some twenty years. She tells him sadly that worry over his fate was her demise. Nothing, really, to point to as the culprit, "no keen-eyed huntress with her shafts," she says, "no true illness wasting the body

to undo the spirit." Rather, just a mother's loneliness and worry for her son. *That* was her undoing.

"The blurred and breathless dead": it's how I think of the Italian garrisons in those Pantelleria photos, half-naked bodies washing themselves in the waters of the port town, in whose shelled remains British soldiers stand guard, calmly smoking cigarettes. "The blurred and breathless dead": that's not entirely accurate, though, since most of the Italian soldiers look emphatically alive, relieved. They're skeletal and unshaven, pale as sheets, sure, but the nightmare is over. They're saved.

It's the British soldiers who seem careful, vigilant, arms tensed over the barrels of their guns. They're looking warily at their bathing prisoners, who are, in turn, oblivious to anything but the refreshing innocence of water. None of them—not the soldiers nor their giddy captives—look at the shattered buildings behind them. What's there to look at, anyway?

"From one year to the next," Calvino continues, "the Eusapia of the dead becomes unrecognizable. And the living, to keep up with them, also want to do everything that the hooded brothers tell them about the novelties of the dead."

The living, in other words, want what the dead have. It is the *upper* city, the Eusapia of the *living*, that is a copy of the necropolis.

Am I, in remembering my mother over and over—reifying her in these stories of travel both across landscapes but also across history—constructing a copy fit for the dead? Or am I living inside that copy already, in the upper Eusapia at the top of the stairs, under the furious real of the sun?

"Actually," Calvino writes, "it was the dead who built the upper Eusapia, in the image of their city. They say that in the twin cities there is no longer any way of knowing who is alive and who is dead."

That's what Odysseus must have sensed, too, as he tried to embrace his dead mother, who—as shades must do—"went sifting through his hands, impalpable as shadows are, and wavering like a dream."

But I'm projecting again. Losing my own mother, I felt old for the first time. Everything was the same, sure—the house, my friends, everything. And yet everything was different. And when I write now, I do

so from a place much like Calvino's Eusapia, elegy obsessed, projecting loss onto landscape, onto Italy itself. And memory, too, is warped and tinged by her absence. Because Pantelleria is buried in those days before her death, when I look back now, I am aware of the ways she washes over the scenes in the port town and how the scenes themselves wear away at the corners, rounding the edges of that week until all I have are some fractured memories of a *dammuso,* a few parties with people I have long lost contact with, and these books—one on Pantelleria's history, the other on my own—in front of me here, each a record of erasure.

Venice / On Exile

Early April in Georgia, and the azaleas wake to another spring. The surface of our small lake ripples like oil, weighty and obscure with each paddle stroke I take. Before the day's heat descends, I pause in the middle. The houses, from this vantage point, betray their modest brick fronts, low and unassuming. From the backside, I see where the money goes: high-ceilinged A-frames; multilevel decks like those of old-world ocean liners, cedar lined or painted oxblood red; retaining walls and paths of stone and slate, gazebos and ski boats. We show our best sides to the water itself. In the absence of wind, reflections of these houses along the western shore do not flinch. If I stare too long at the water, the effect becomes disorienting.

A pontoon boat with a family of four motors away from the public launch opposite me. I wait for their wake to arrive, which offers pleasant undulations to my kayak, then stare down at those houses as they fracture and warp with dazzling regularity. The surface of the water itself—almost like a billowing sail—seems to carry its own velocity. That pontoon boat, though, has irritated a pair of nesting herons in a nearby pine, and their prehistoric, guttural squawks pull me away from the water toward the bright sky. The spell has been broken. I wait for the houses to reform in the water's sheen, as if from ether.

It's how I imagine Venice must have appeared on the horizon to wary travelers long before photographs, airplanes, cell phones—as a

mirage becoming ever clearer, an entire city shaped out of the horizon, rising from the sea itself, water concretized. The lake here, however, remains opaque, brown, shallow, dusted in a coat of yellow pollen, like dry dye in a drum of matte finish paint. This water has nothing in common, not even salt, with the Adriatic. I know that, and yet—observing the split ranches reconfigure themselves, smelling that curious mix (not wholly unpleasant) of boat fuel and decaying vegetation, listening to the lap on the public launch, the small waves rushing at the bulkhead—even this small, inconsequential body of water, for me, conjures the city of Venice.

Conjures, not just *recalls.* Venice is its own spell, its own nowhere and everywhere at once. There may be no city more a permanent fixture in our collective imagination. We all carry around some version of what Venice is or should be, even—and perhaps especially—if we have never been there. And the actual city? Caught in amber centuries ago, the place has persisted more as museum than functioning urban center. And I don't intend specific museums *in* Venice—the Doge's Palace or any of the myriad galleries floating in the lagoon. Not even the grand Biennale, which I am attending this year for the first time and am eagerly awaiting, that lush garden of pavilions featuring artists from across the globe, travelers themselves, like me. Lorenzo Quinn, I hear, has summoned two massive forearms and hands from the sea. They rise from the waters of the Grand Canal, touching delicately the historic Ca' Sagredo Hotel, as if to stabilize it, as if it were a stack of blocks in a child's menagerie.

Yet what city manages its iconic status better, preserves it in our minds as much as in its stone and wood and wobbly pilings, the entire city *as museum?* And though the staff changes from time to time and an occasional traveling exhibit blows through—a ludicrous cruise ship hugging the contours of its outer islands; the pontoons stitching the lagoon for Venice's yearly marathon; even Quinn's giant hands, ripped from fantasy and on show for the Biennale this year—the key artifacts, those most of us travel there to see, never change: the stone stained with lichen, those hoary beards of algae on the battered and bleached

wooden doors, their boards dipped and strangely desiccated by the water's ceaseless ebbs and flows, the ingenuity (the nerve) of a city built on nothing, and the nothing itself.

If Venice is a museum, it must be the first one suspended over a sea.

✈

Venice does not traffic in anticipation, has no patience for subtlety. Even Rome, drenched in baroque, allows us time to acclimate. Arrive at the capital by train, snake through the suburbs, sunken in a river of tracks and graffiti, and you might think, *Where is the history? Is this the Rome I imagined?* Even once in the station and having navigated the crowds and busy islands of ticket kiosks, the stalls selling newspapers and bus passes, and having emerged out of the wide, squat mouth of the Termini depot, the Rome found there resembles nothing special at all.

Indeed, the Rome we anticipate—the city of empire and intrigue, the city of Bernini (whose fountains erupt out of the piazza's cobbles), or any number of other versions nestled in that characteristic bend of the Tiber—most Rome worth roaming is nowhere near the station. A stifling bus or cab must take us into the city we have constructed in our imagination, and by then, we have had time to adapt. We temper the idealized iterations formulated in our minds. The Rome of wonders and beauty, when we finally experience it, is as much relief as awe.

Florence, too, on arrival, is not the Florence we think we know from the occasional Rick Steves broadcast or art history book but, rather, a train station leading to what amounts to an unremarkable subterranean passageway-turned-mall, a way to bypass the swollen, chaotic terminal entrance and proceed directly to the historic center, maybe even pick up a Fiorentina soccer jersey along the way. The same goes for Spoleto, Assisi, and most any other Italian town that I can think of: the station is not the city. We have time to orient. The first surprise of most any Italian journey is the fact that we are not surprised at all and so must journey on.

Venice is different, though it may initially deceive. Arriving over the narrow isthmus that connects the lagoon city with its mainland hub

in Mestre, we see only the Adriatic on either side, pilings jutting out at regular intervals. Most of the times I've visited, no matter the season, I remember clouds in hazy, marbled grays; and the water—with pale sunlight washing over it—a kind of tin, such that scarcely a difference remained between sea and sky. Joseph Brodsky noted this, too, what he called the peculiar "porcelain aspect" of the city, "zinc-covered cupolas resembling teapots or upturned cups," he wrote, "and the tilted profile of campaniles clinking like abandoned spoons and melting in the sky."

The train then pulls in to an otherwise typical station: the same bustling, characterless café; the old-world decadence of the ticket purchasing area vaulted and boomy; identical, rolled-metal benches. In short, if it were not for the blue, sans serif signs saying VENEZIA everywhere, we could imagine ourselves in any decent-sized town or small city on the peninsula.

We are not, however, in any other city, a fact immediately recognizable upon exiting through the front of the station, the steps of which fall right into—it sounds inconceivable—the canals of a city built on water. The train pulls within one hundred yards of the sumptuous marble and stone of the floating city: Venice, Venezia, or—its longtime nickname—*la Serenissima,* "the Most Serene."

Almost as immediately, we are faced with the conundrum of Venice: all that spellbound feast, that incomprehensible beauty, as our eyes take in the domes dotting the lagoon and the arches of over 400 bridges over 177 canals, which slice and suture the city into 118 distinct islands, all of that must contend simultaneously with the glut of knickknack kiosks, barkers with their water taxis idling, and the throngs of tourists—most just like us—swollen from the archaic beauty, yes, and slapdash seafood, overpriced and probably shipped in from the South. Venice is expensive, hopelessly human infested, absolutely overrun: a maritime version of the Vatican museums. And like a museum, Venice even appears to shut down at night, when cities such as Rome and Bologna start to thump and thrive in their clubs and bars. To walk Venice at midnight is to feel like a trespasser.

Yet the city exists. We can't believe it until we walk its narrow alleys and cross a canal or two. Even then, at any moment, we believe it could

all be mere mirage, spectral and dreamlike, more a part of the air and water that surround it.

✈

"Ghostly." That's what Gwen said. We'd spot the animal intermittently in our backyard or crossing the street adjacent to us, slinking off in the underbrush at dusk. Gray and white with a straggly tail, her eyes—an aged ivory, jaundiced and haunted—peered into and through us as she paused to look back. We don't see many strays around our house, and our road seldom sees cars (only those of the residents on this side street, this cluster of homes). Glimpsing that spectral cat, almost always at dawn or dusk, captivated us not because of her potential danger to our own two cats but, rather, because of her eyes, the dull yellow of sickness and fear, her coat the color of clouds set to storm. If anything, she embodied not danger but ephemerality, her slender form disappearing into the culvert off Almon Road.

For months, we traded stories of seeing her, like people do with ghosts. We conjectured and hypothesized, invented history for the poor girl. (We even guessed at the sex, since we sometimes spotted her close enough to our male cat to suggest some attraction.) She must have owners, we thought, if we keep seeing her in the area. Then again, look at how gaunt she is, how frazzled her coat. No way she's being fed. No way an owner would starve her.

Somehow we forged a bond of sorts, one built on nothing but random sightings, some imagined goodwill with one of our own pets, and a bit of empathy with her plight. Then nothing. She disappeared. After a while, so did our talk of her. Our cats, too, went back to lounging by themselves on the deck. Maybe her owners wised up to her wanderings. Maybe she was dumped but later picked up by someone kinder than we were, ready to care for another cat.

Those eyes, though, peering at us from across the road after she scurried through the pine straw and under the azaleas; those dull yellow eyes staring at us are what I remember. Looking back on those months of sightings, I have to think that simply the act of being *looked at* that way, that plea for help, even—especially—if she was wary of us, pro-

vided the source of our bond with her. She had identified us, singled us out, not the other way around.

✈

Abandonment and being lost: some places invite it. In Venice, loss is embodied. Subtraction becomes a destination. The Adriatic is slowly, painstakingly reclaiming its lagoon, and never has deterioration felt so paradoxically rich and edifying. A city with water for roads and thoroughfares, for alleys and passageways; buildings almost etched into the low-slung clouds crowding the horizon; water, water everywhere.

We link Venice with other tourist mainstays in Italy, Rome and Florence most often. Together they form a familiar triumvirate of marquee destinations. But compared to Venice, Rome and Florence seem, well, just cities. And for as walkable as Venice is, all its constricted alleys down the flanks of hidden canals; bridges arched over the black, lacquered prows of gondolas; all that slot canyon depth and narrowness renders navigation nearly impossible. Even cell phones prove mostly useless, with coverage lost in the labyrinth. Venice has no north, south, east, or west, as Brodsky argues in *Watermark*—his tribute to the floating city; "the only direction it has," he says, "is sideways." The next conundrum of Venice lies in how much mystery and disorientation one feels in so small a place.

And almost every narrative I attach to my time in Venice revolves around being lost. Many of the stories also end with frantic runs to the station, some with missing trains back to Bologna. More than one culminates with being forced to sleep in Venice and not in a hotel or even hostel.

Once, after a winter gondola ride, after hurrying to the station only to miss the last train out, after the hostel would not take us (we had no money for a hotel, having spent it on the gondola) and after we even tried a monastery at midnight (ringing a side door, an official did answer but declined to give us shelter), after all that, four friends and I from language school in Bologna found a boat docked in a side canal, with a deck wide enough for all of us. November chill and mist. Lamplight leaking in water. We boarded, ducked under a loose tarp, and

after much grousing, laughing, and shivering—that attempt to find the proper admixture to voice our exasperating, exhilarating trespass—we fell asleep. Waking before daybreak, we noticed on disembarking that down the other side of the vessel was painted POLIZIA.

Then again, maybe such small scandals are fitting, since Venice is a city essentially founded on theft. Some merchants, the story goes, ferreted the remains of Saint Mark illegally out of Alexandria in the ninth century, a spurious tale of how the evangelist had foreseen his own burial in Venice providing, in turn, a rationale for the thieves and their crusade before crusading. And the four bronze horses over the entrance to Saint Mark's Basilica? trophies from the sack of Constantinople in 1214, stolen by Napoleon and only reclaimed two hundred years ago. (Fitting, then, that the actual bronzes—the first theft—are now kept inside. When we stare at the basilica's facade, we are looking at copies.) This is a city built on deals and swindles, a testament to the mastery and exploitation of exchange, but—unlike other monumental metropolises to wealth and commerce (New York, Tokyo, Dubai)—a city borne not up, into the sky, but rather out, like tendrils, into the sea itself.

✈

In his *Travels,* Marco Polo—son of an ambitious Venetian merchant—inventories many of the wonders he encountered in the vast geography under Kublai Khan's control. And nowhere were the radical differences between Polo's Venice and the Mongol Empire more severe than in the Great Khan's constructed capital of Cambulac. Laid out with the exquisite order of a chessboard, the emperor's fabled city would have sounded unfathomably large to European audiences. (Polo claims that its outer walls ran eight miles square.) Rivers, canals, even well-stocked lakes, nourished the city and provided Polo with an array of wonders to relay.

The mastery of Mongol urban planning, though, seemed to the impressionable Venetian not merely aesthetic in its scope. Gates at strategic points allowed for a swift cordoning off of whole quarters of that gigantic urban experiment. And he recalls with amazement the great clock that tolled each evening, "so that none may go about the town after it has sounded." Sentries stationed themselves at each of these

critical bottlenecks and patrolled in packs of thirty or forty through the city streets in search of anyone out after the bells rang. Amazement, at least to Polo, was often linked to safety, to protection.

Having grown accustomed to Venice, where urban life meant the careful avoidance of danger around every corner, in the crooks of oddly shaped buildings, under dark bridges at night, and down clotted alleys, where thievery was—let's face it—almost celebrated, Polo most likely found such furious order and lawfulness nearly unrecognizable. And on the scale of Cambulac—whose great hall on feast days supposedly accommodated six thousand people—the degree of urban order he witnessed would have seemed all the more implausible.

No wonder Polo's readers had difficulty believing him. (He must have barely believed himself.) And to be fair, he was essentially admonishing his fellow Venetians, even as he recorded dutifully what he experienced in the empire of the Great Khan. Marco Polo's book was a glimpse into the future as much as it was a travel narrative, and the Mongol enterprise, to a twenty-year-old son of a Venetian merchant, was indeed the future. Venice—already in the thirteenth century—was becoming a relic.

✈

At least a year passed before we caught sight again of the spectral gray cat with piercing eyes, and the year was not kind. Emaciated, even more ragged, skittish still but without the wildness we had sensed in her before, she simply drooped away when we came close, resigned, it seemed to us, to a life of suffering. She was broken, so it didn't take long for her to tolerate some free food we left on the patio, some water and milk. Watching her frantically gulp down whatever we gave to her brought a strange sort of pleasure to us. Our own cats—never having known an empty stomach—watched with what had to be disbelief. *What's all the fuss about? It's only food.* After she finished and slinked off again, our cats would sniff her bowl as if trying to understand.

Around that time, we watched a documentary on Tibet, in which a film crew mounted a camera on a rocky slope, with the hopes of catching footage of the elusive snow leopard. What they captured, instead,

was a Pallas's cat, about the size of a stocky domestic but with thick, plush fur and shallow-set ears. The way the animal slinked over the rocks and peered curiously, anxiously, back into the lens: it resembled, in many ways, our ghost cat. We said as much simultaneously. Were we drawn simply by the sense of need, by our own desire to extend mercy? Or did she in some way mark us and our home, intuiting some sense of fidelity, based on so very little? We didn't consider any of that at the time, just wanted to help.

After a few weeks of leaving food and water, which she greedily took each time, she would even stick around for some petting. As I stroked her back, I felt the washboard of her ribs, the mats in the wisps covering the tops of her hind legs, the ratty tail mottled gray. She possessed an egregiously loud purr too.

But I should say *he*. Turns out we're not the best guessers of feline anatomy from a distance. Our ghost cat was male.

✈

I once spent a day in Venice with my friend John, who had never seen the city before. At dinner that night, the staff sat another couple close to our table, Americans like us, and before long, we were trading stories. On honeymoon, they invited us to celebrate with them, even asked us to choose a special wine for the occasion. "Amarone," I suggested. John and I had split a bottle of it before dinner. A bit of a splurge, really, even in those days of the cheap lira. A specialty of the Veneto region, amarone is produced by means of a characteristic drying process of the grapes, so that they yield sugarier—if less—juice, all of which means the wines typically begin at 15 percent alcohol and travel upward, with prices to match.

John bragged about how much I knew of Italian wines (I didn't), and soon we were toasting the newlyweds with a bottle. That bottle led to another, for which the guy—a reaper of dot-com fortunes—always offered to pay. I could tell, though, that the woman—I don't remember either of their names—grew slightly less enthusiastic with each glass. Kind, yes, but perhaps foreseeing a long night in the company of almost complete strangers mooching off her husband. (The Italian verb for "mooching" is *scroccare*. I learned that in Venice.)

The second bottle led to a third, and at that point, John and I had a decision to make. Less than an hour separated us from the last train back to Bologna for the night. We had no money, having spent what little extra we had on our predinner wine. The guy noticed us hesitate at the offer of the third bottle, so we explained the dilemma.

"No problem," he said. "We have a hotel room big enough for you to stay with us. The couch folds out into a bed."

The guy's new wife hid her dissatisfaction but barely, wrapping it in a half-smile while darting glances at her husband in what I could fool myself at the time was pleasant surprise but which was obviously shock mixed with outrage. Like idiots, we accepted. How many times, we thought, will we have the chance to drink what appears to be limitless amounts of amarone?

After dinner, after the guy insisted on more alcohol, we could find only a sad, forgotten disco, with pumping bass, strobe lights, and very few revelers. We tucked into a corner booth in the anteroom, and he ordered. The fact that I can't remember what—though surely not more amarone—proof of how far we had gone, the distances into oblivion we had traveled.

What I remember distinctly, however, was the entrance to their hotel, near Saint Mark's and right on the water. If ever one wanted to guess at what must be the most expensive hotel in Venice, this one would surely contend: cool, wide marble tiles; carved woodwork; and a stunning, vaulted atrium—almost a cathedral itself, this hotel—around which unfurled a wide staircase. My friend and I—two drunks from Bologna—were poised to spend the night in what was without question the most luxurious hotel we had ever seen.

We *were*, that is, until the manager stopped us.

"It's okay," our new friend said. "They're staying in our room tonight."

And if the sight of us in our rain gear and drunkenness was not enough to convince the manager otherwise, the sheer sumptuousness of that hotel would have never allowed for dorm-style bunking on a foldout couch. And how could there even have been a foldout couch in that place?

The guy pleaded, said that we had no place to stay, all of which, in the manager's reckoning, probably worsened the situation. (Not only drunk but indigent too.) The woman, at least in my fuzzy recall almost twenty years later, seemed somewhat worried for us, if also a bit relieved.

John, however, was stoic. "That's fine," he said to the couple.

They offered to pay for another room (so large a figure I can't even—don't even want to—think about it anymore).

"We knew what we were doing," he said. "We decided at dinner."

Now it was I who stared a bit in shock.

"We'll be fine."

And that is how, at the age of twenty-eight, after sharing four bottles of one of the more expensive wines in all of Italy, at about two in the morning, we bedded down, John and I, on a narrow walkway connecting a row of doors to private apartments. We slept on the streets of Venice.

Whatever sleep it was—if I can call it that—was shallow and fitful. Late winter, then, and the cold pestered me, not to mention the concrete. Once or twice during the few hours we spent on the ground, I thought I felt folks step around us on their way—who knows?—most likely home. "Poveretti," I could almost hear them say from under my tightly cinched jacket. *Poor little things.*

When we woke up, relieved not to have been arrested, we realized the next train out left in a little less than an hour. Why are trains always almost leaving *la Serenissima*? How is that in any way serene? Even then, even after resigning ourselves the night before to misery, even then we had to hurry to the station.

Without maps, we were at the mercy of the large yellow signs at various intervals, which offer simple choices. (*Saint Mark's this way; train station that way.*) I have never been more resolutely sure of anything in my life than the absolute fact of those signs leading us on the most circuitous, doubling back, convoluted, least serene passage to the train. With knowledge, with even a modicum of navigational aid, the station was probably no more than a quarter-mile away. Following the signs, though, took us almost an hour. And for much of that time, John could not, would not, stop laughing. A particular kind of laughter, too, espe-

cially from a very close friend and specifically when it seems slightly out of character for him. A form of laughter deprived of even the slightest varnish of comedy or whimsy. I simply could not take part in it, was not invited to, and so could not understand it.

Only later—after we had slept off our hangovers on the train back to Bologna, after we had stumbled back to my crappy apartment—did he tell me why he could not stop laughing.

"You and I," he said, laughing again, trying to control himself, "we drank two hundred dollars' worth of wine and then slept in the streets."

At that distance, with that dank Venetian alley safely behind us, I could finally laugh too.

<p style="text-align:center">✈</p>

Always these trespasses, time spent *passing across* or *through*. For John and me that night, the line was one of legality (albeit nothing serious), decorum, and stupidity. For Marco Polo, tapped by Kublai Khan as a tax collector and sent to the ends of the largest land empire in history— that of the Mongols in the thirteenth century, from the doorstep of Europe to the Persian Gulf, stretching out over China and down to Vietnam and beyond—always the outsider, resolutely foreign, he was rarely the person whom locals wanted to encounter.

Indeed, Polo often felt in danger on the road and with good reason. Occupied people rarely take kindly to foreigners carrying banners of the oppressor, much less those who collect the oppressor's taxes. Polo prominently displayed his *paiza*—a kind of tablet or rudimentary passport verifying his Mongol credentials—wherever he roamed in the empire's hinterlands, a talisman against the world in which he walked.

And thus, through visiting radically distant and divergent cultures— many of which proved much more advanced than his own or that of the Mongols—Polo produced a most extreme account, so extreme, in fact, that mostly his readers didn't believe him. Scribes took to including disclaimers in their copies. They simply could not attest to the veracity of such tall tales.

The book originally went under the title *Il Milione—The Million*—in reference to the sheer number of strange places the Venetian claimed

to have seen. But *did* he see them all? Immediately after Polo's death in 1324, a ruffian character began to appear in the Venice carnival who horsed around, entertained by way of gross exaggeration and gesture. The clown's name: Marco of the Millions.

Polo's claims, however, have largely been vindicated. He was right about the existence of printed books over a century before they appeared in Europe. Right, too, about paper money in circulation. (What could be as incredible as otherwise worthless paper given in lieu of goods, gold, silver, or livestock?) The fantastical beast he called a unicorn: a rhinoceros, most likely, at that time unknown in Europe. And the strange, utterly captivating black rocks that, he swore, produced intense heat and light, burning, it seemed, forever? We know that rock now as humble coal.

The most unbelievable fact of Marco Polo's book is that it appears to be mostly true.

<div align="center">✈</div>

I once kayaked the canals of Venice. I had read about it in a *New York Times* piece. A Danish entrepreneur had started a company guiding visitors through the city. Leaving his home base on Certosa Island east across the lagoon, we spent three hours—a friend, the guide, and I—in the almost claustrophobically narrow secondary canals, sliding under laundry hung between buildings.

At times we had to bend backward, our spines almost touching the flat sterns of our kayaks, to pass under footbridges, stone lions perhaps at the apex. We entered the famed Arsenal, where, at its height, workers cranked out fully outfitted galleys with unprecedented precision and efficiency. Photos by our guide show us all smiles, paddling under the Rialto Bridge, gondoliers and the tourists aboard left to gawk. Brodsky claimed that the gondola was the ideal vantage point from which to contemplate Venice. "We see," he said, "what the water sees." He would have appreciated the kayak even more.

At one point, stretching out, taking five, enjoying a beer in a café, I texted my friends in Bologna. "Guess what I'm doing?" They didn't— they couldn't—believe me. Later, when I sent them photos as proof, they were still shocked.

"Leave it to a foreigner," they replied, "to show us what's in our own backyard."

The next summer, in Florence with friends who had booked a small apartment in the center, my kayaking expedition came up. They were hooked, so the four of us, along with a friend from Bologna, headed to Venice. I made reservations in the car, and we ate up the rest of the ride dreaming of where we might eat dinner afterward, if we'd stay or try to return at least to Bologna. Venice shimmered in our imaginations as we parked and boarded the train in Mestre. The world was expectant. We were privileged, yes, about to kayak through one of the most beautiful cities in the world. Latter-day Marco Polos awash in our future narratives, we were already busy framing our day for friends and family, the stories we'd tell.

On the train, though, the company called me.

"Haven't you heard?" the owner asked.

I remembered his voice from last time, gruff and growling.

"A tornado just touched down. Our kayaks are strewn everywhere. The island is a mess. We are completely shut down."

We were fifteen minutes out but more than a world away from any tornado, or so it seemed. The skies were stretched taut, lucid but (in that way before or after a violent storm) too beautiful, too strikingly etched with oranges and pinks on the horizon, the water thick and inky.

Luckily, the tornado spared Venice proper, skirting it, tearing up the outer islands. Still, we were not kayaking. We spent the afternoon pondering our bad luck in that city, its inhabitants going about their business, trancelike, carefree, as if a tornado hadn't spun around them.

You tell me, in all seriousness: do you believe me? A tornado in Venice? How do I make you understand that it really happened? Have I created a spell, or have I broken one?

✈

The cat quickly acclimated to his adopted domestic life with us. He had to have come from a home, Gwen said, the way he easily accepted existence inside. For the first two nights, though, he whined when we closed the cat door. (With predators around, we keep our cats safely

inside until morning.) We had him neutered, paid for a full battery of shots. His coat, right away, returned to a gloss, and he even allowed us to flip him on his back to brush the mats in his thick neck fur. He purred loudly, forcefully, desperately.

He loved a little plastic ball, a small cage, really, with a bell inside. We'd throw it down the hallway, and he'd sprint after it, bat it around in the dark, and then strut back, howling with content, the tiny ribs of it caught on his incisor. He was proud of the spoils he returned to us, and we acted the part of contented parents.

Still, we could not keep him. We didn't need a third cat and told ourselves as much daily. Fortunately, a photo we posted online during the first day of his captivity paid off. A friend of a friend wrote to say how beautiful our ghost cat was. "Look at those eyes," she wrote. She had recently lost a cat and was eager to seek out a stray in search of a home. *What good fortune,* we must have all thought. She even offered to reimburse us for the vet bill. "No need," we said, happy enough to see him go to a decent home.

The next evening, our friend's friend arrived as expected, teared up when she saw the cat. He immediately let her pick him up. (By then, he was putting on weight, looking much healthier, purring at the least provocation.) We exchanged phone numbers, and I asked her to post photos every so often.

She sent one later that night. Crowded into the frame of her camera, the woman's face was in profile, pressed against the cat's wide head, his eyes looking directly into the camera. I was momentarily in Tibet. Fittingly, too, she named him something silly with a veneer of mysticism, after a character from a fantasy series I wasn't familiar with. Someone else commented on how fetching the boy was, how happy she looked to have him. We felt pleased, too, to know that we had found him a good home, had done right by our ghost cat, even if—secretly perhaps—we both already missed him.

✈

"Sire," Marco Polo says to the Great Khan, in Calvino's rendering, "now I have told you about all the cities I know." The Khan's attendants are

poised to light the way to the emperor's chambers in the Pavilion of August Slumber. Uncharacteristically, however, the Khan hesitates, instead posing a final question to the explorer. One more city remains for the Venetian to describe to him, he says: Marco Polo's own city, Venice itself.

Calvino's *Invisible Cities*—a most curious collection of urban profiles, to be sure—also showcases the Venetian's savvy way of packaging his travels for the Khan's consumption. And what I can't get over as I reread the book in preparation for my summer travel writing class—having now read Polo's own book—is how closely these vignettes adhere to the originals, at least in spirit. Calvino was not improving on but, rather, contributing to Polo's travels, fleshing out the Venetian's journal. Polo surely must have seen more than what he recorded, more even than he was capable of recalling to Rustichello, over the course of their year together in that Genoese prison.

The Khan asks Polo again, near the end of Calvino's book, to tell him of Venice. "What else do you believe I have been talking to you about?" Polo responds.

The emperor is confused. In all those reminiscences, the Khan has never heard this young ambassador mention Venice's name.

"Every time I describe a city," Polo responds, "I am saying something about Venice."

"When I ask you about other cities, I want to hear about them," the Khan says. "And about Venice, when I ask you about Venice."

I can almost see the emperor's furrowed brow, how perplexed he must be, unwilling to settle for what appears elliptical answers from his worldly officer. Yet Marco Polo is equally unwilling to compromise, relaying to the emperor the fact that one city alone—Venice—must remain the implicit, assumed model against which he may then describe, appraise, and ultimately judge all others.

The Great Khan responds with a possible remedy, a process: "You should then begin each tale of your travels," he tells Polo, "from the departure, describing Venice as it is, all of it, not omitting anything you remember of it."

I admire Calvino's pacing in these brief dialogues. Here he breaks from the interrogation, which seems ever more heated, to offer a fleet-

ing description of the lake's surface beneath the Palace of the Sung as "barely wrinkled," with the reflection of the Khan's great home "shattered into sparkling glints like floating leaves."

What at first appears a passing detail of scene—a deferral, a postponement, and, thus, a heightening of tension—reveals itself now to me as a consequence of the Khan's having listened to Polo's travels. Even the emperor's abode—his own city—is now fragmented, warped by the Venetian's myriad tales. To know of other cities changes the cities we know. Plus, we gather that other reasons exist for why Marco Polo hesitates to tell the Khan about Venice, why the narrative stalls a moment before Polo's final response. "Memory's images, once they are fixed in words," Polo says, "are erased."

Though Calvino, in this brief dialogue, does not again mention the Khan or how he receives this observation, I like to think that the wise emperor at least tacitly understands, maybe even empathizes. When Marco Polo left Venice with his father and uncle in 1271, he was seventeen years old. The year of his return was 1297. No matter the specific age we imagine him as he recounts to the Khan these fantastic tales, he must be at least middle-aged. The boy is gone. How much of Venice would he—could he—have even recalled?

"Perhaps," Polo continues, "I am afraid of losing Venice all at once, if I speak of it. Or perhaps, speaking of other cities, I have already lost it, little by little."

✈

Clarity becomes its own ruse. Marco Polo's account of such alluring foreignness—the strange beasts and customs, the odd foods and spectacular garments (not for nothing do we keep *the Silk Road* alive in our lexical consciousness): they come vividly to life in Rustichello's rendering. Call it luck—either good or bad—that Marco Polo happened to find himself in prison with a Pisan romance writer who likely recognized the traveler's marketability. Time Marco Polo had as well as the resources of a seasoned author. And to be fair to Rustichello, the writing seldom tolerates excess. Was it the ghostwriter who curbed the Venetian's fantastical stories, or did that Pisan author embellish what otherwise may

have proven nothing but a great deal of sand, isolation, and camels? The final conundrum is how the remove of Rustichello's words—coming from him and not from Polo directly—may have simply contributed to the sense that it was all a bunch of nonsense.

Friends and family, desperate for the well-being of Polo's soul, as the great traveler lay dying, pleaded with him to, please, recant, retract those obviously fictitious stories. He couldn't possibly have seen all that he claimed in that book. Deathbed utterances, I know, are perennially dubious, but I like to believe Polo's is true. He simply responded: "I have not told half of what I saw."

<div align="center">✈</div>

"I don't know what to do," that friend of a friend wrote to me the next day. "I was sitting on our balcony last evening, when he jumped from the ledge."

From her second-floor apartment across town, our ghost cat had leaped and disappeared into the pine forest surrounding her complex. She and a roommate spent the better part of dusk and into night, flashlights in hand, searching for the cat, with no luck. Foxes, raccoons, and coyotes patrol the area. Neighbors, not a month ago, had lost their own cat after it escaped through a door left ajar. Even around our lake, poorly Xeroxed photos of pets (which make them even sadder) occasionally appear on telephone poles. LOST. MISSING. REWARD. HELP. She said she'd keep looking, had left food by her door. I told her to keep me updated.

I suppose by now you can guess what happened next, where this thread of the story is going. And if so, you will probably understand how, lying in bed, early morning, three days later, when I heard the soft, magnetic catch of our cat door in the kitchen, I was not surprised when that gray cat walked calmly down our hallway and jumped on the bed. Three and a half days it took him to find his way back, just shy of ninety hours, about three miles in distance, having successfully navigated a predator-rich, forested area, two busy thoroughfares (including a two-lane highway in both directions), and any number of vigilant dogs, ornery domestic cats, and stupid people.

How did he do it? Nobody knows much about how either cats or dogs find their way home after distant separations. Some theorize magnetism at work, that particular animals (most notably birds) register slight differences in the Earth's magnetic pull and can utilize them as navigational aids. Others consider the requisite tool to be sunlight, how shadows slant, thereby giving these travelers subtle cues of latitude and longitude. But this cat was taken three miles away in a solid-sided carrier, in a car, in complete darkness. How?

I might ask myself the same question: how do I find my way back to Italy each summer? I don't mean the actual logistics of it—the programming, the planning, the finances. I mean the deeply psychological part. *Why* is perhaps the better question. I have structured my life around these travels, these self-imposed exiles, really, but why?

Why did that cat find its way back to us? The *how*—in both cases—is ultimately less satisfying. The *why,* however, has given me these essays. Maybe it's even given me the travels themselves and a twenty-seven-year relationship with a traveler who goes by my name but who—at least when he's in Italy, speaking Italian—is not quite the person I recognize at home.

A year ago, I realized that I had lived in Georgia for more of my life than anywhere except my childhood home in California, and yet I still feel a bit like an interloper here, an outsider on this lake. Living on water has always seemed to me a grand privilege. (Did Venice cause that too?) I feel at once fortunate but also a bit like a squatter. No extended family, no expensive boat moored below—just Gwen and I and the cats, and my cheap kayak, garish blue and bought on clearance.

Azaleas cover most of the back of our house. They thrive in our acidic soil. The lattice beneath our deck has yet to be painted to match the rest. I'm supremely unmotivated. Besides, most of our money does not go to fancy decking or cedar, to a stylish boat with racks for water skis. It goes to plane tickets and apartments in Italy each summer, where we're headed in a few weeks, and to Venice by mid-June. I can almost smell the fried squid and brine of the canals, see the tourist shops laden with cheap carnival masks and glass tchotchkes, the legions of pigeons peppering Saint Mark's Square.

Exile in Italy? Can I call it that? So I missed a few trains and once slept on the streets of Venice, which really means that I lay on the ground for a few hours out of boredom and drunkenness, surely in no real danger and in no way a permanent condition. Besides, saying "the streets of Venice" renders the situation much direr than it was. The thrill I had as a boy on the Pirates of the Caribbean ride at Disneyland, imagining I could jump off the boat unnoticed and spend a night in that fabulous place: that fantasy transgression is more akin to my night in Venice. My misadventures are exceptions that prove the overwhelming rule: that I am privileged, that I travel out of desire, out of my fortunate position.

Is exile even possible to me anymore, the kind that Dante knew, at least, the kind foretold to him by Cacciaguida in *Paradiso:*

> You are to know the bitter taste
> of others' bread, how salt it is, and know
> how hard a path it is for one who goes
> descending and ascending others' stairs.

Dante had no choice. The Polos (at least his father, his uncle, and Marco himself) chose their destiny, out of commercial interest, dreams of wealth, yes, but also a sense of adventure. They, too, were privileged (if being absent from your home for a great deal of your life is a privilege).

I have been gone from California now for almost longer than I lived there, yet I still instinctively call it home. I left by choice. I wanted to leave. I was tired of the traffic and the prices and the overwhelming sense that California was too bright, too cheery, too full of people working excessively in order to play excessively. Now when I visit, I feel an intense sadness. All those places I used to love, all the mountain trails I hiked and restaurants and bars I frequented—they're all the same. The only difference is me.

That's not quite right. The only difference is *time.* I am twenty-six years older. "How salt it is."

Then again, I've spent a great deal of time trying to define precisely what significance home carries and in which place—California, Georgia,

Italy—I feel that sense most acutely. I'm not sure I can answer that. Call it an occupational hazard, the forced (if for some of us desired) itinerancy of academia, the migrant professor. Exile, even when it's what we want, is still a sobering condition. I was hooked on travel, however (and on Italy), before any tenured job. My invisible cities long ago ceased to be recognizably American. I have traveled to them all, though—I swear, hand to God—and can tell you about them, which is what I have been doing here.

But in my recounting of each destination, the contours become less barbed and jagged. My cities soften in the wax of retelling. They are beginning to lose shape in my mind, becoming more a part of the waters around them. The shores are eroding. The reclamation has begun and, with it, my sense of home, whatever that may be.

Turns out you can talk yourself into exile, but by that logic, you can also write yourself back into the text called *home*.

By the way, we kept the cat. He chose *us,* we thought, and we were not about to exile him again. He's right here next to me.

We also changed his name. We call him Marco.

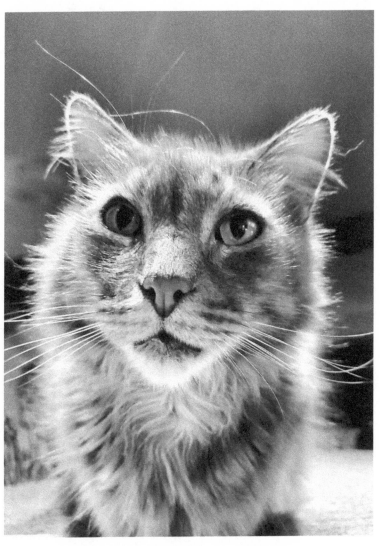
Marco the cat. Photo by the author.

CPSIA information can be obtained
at www.ICGtesting.com
Printed in the USA
LVHW100017230722
724095LV00003B/242

9 780807 177877